George,

You will be deeply missed by all of us at Avalon. Thank you for many years of a great relationship— all the trips to Santa Fe and for going to bat for us with conference Invites. It's been wonderful to work with such a professional— and a great guy.

Keep in touch!
All the best
Christine

George,

It has been our pleasure working with you over the years. Thank you for your many trips to Santa Fe and the invites out to Chicago. Much luck and all the best!!

Ariel

GEORGE,

THANKS FOR ALL YOU'VE DONE FOR US OVER THE PAST DECADE—ANALYST SUPPORT, CONFERENCE INVITES, AND ADVICE. IT'S BEEN MEANINGFUL TO US AS WE ADVANCE OUR CAREERS FROM TINY LITTLE SANTA FE. YOU WILL BE MISSED.

BEST OF LUCK IN YOUR NEXT ADVENTURE,

Dan & CHRIS

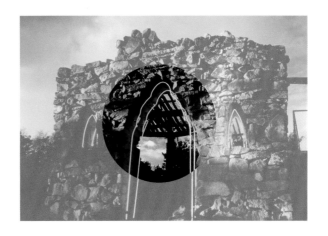

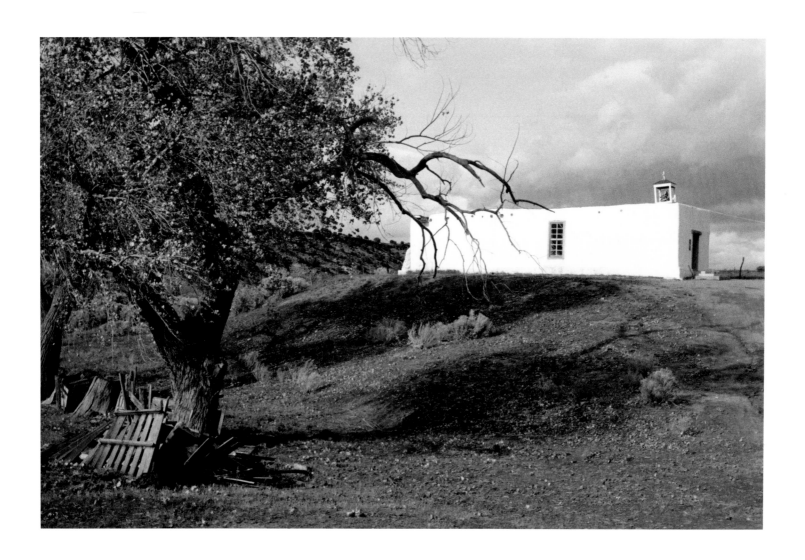

BERNARD PLOSSU

LA CIENEGILLA, 1982

ELIOT PORTER

SANGRE DE CHRISTO MOUNTAINS AT SUNSET, TESUQUE,
NEW MEXICO, JULY 1958

THROUGH THE LENS

CREATING SANTA FE

Edited by Mary Anne Redding

Photographs edited by
Krista Elrick and
Mary Anne Redding

MUSEUM OF NEW MEXICO PRESS
SANTA FE

Project director: Mary Wachs

Design and production: David Skolkin

Composition: Set in Univers

Manufactured in Singapore

10 9 8 7 6 5 4 3 2 1

Library of Congress Cataloging-in-Publication Data

Through the lens : creating Santa Fe / edited by Mary Anne Redding ; photo-
graphs edited by Krista Elrick and Mary Anne Redding.

p. cm.

Includes bibliographical references and index.

ISBN 978-0-89013-550-1 (clothbound : alk. paper)

1. Santa Fe (N.M.)--History--Pictorial works. 2. Photography--New Mexico--Santa
Fe--History. I. Redding, Mary Anne. II. Elrick, Krista.

F804.S243T48 2008

978.9'56--dc22

2008032754

FRONTISPIECE:

MIGUEL GANDERT

NORMAN MAUSKOPF, SPANISH MARKET,
SANTA FE, 2006

CONTENTS

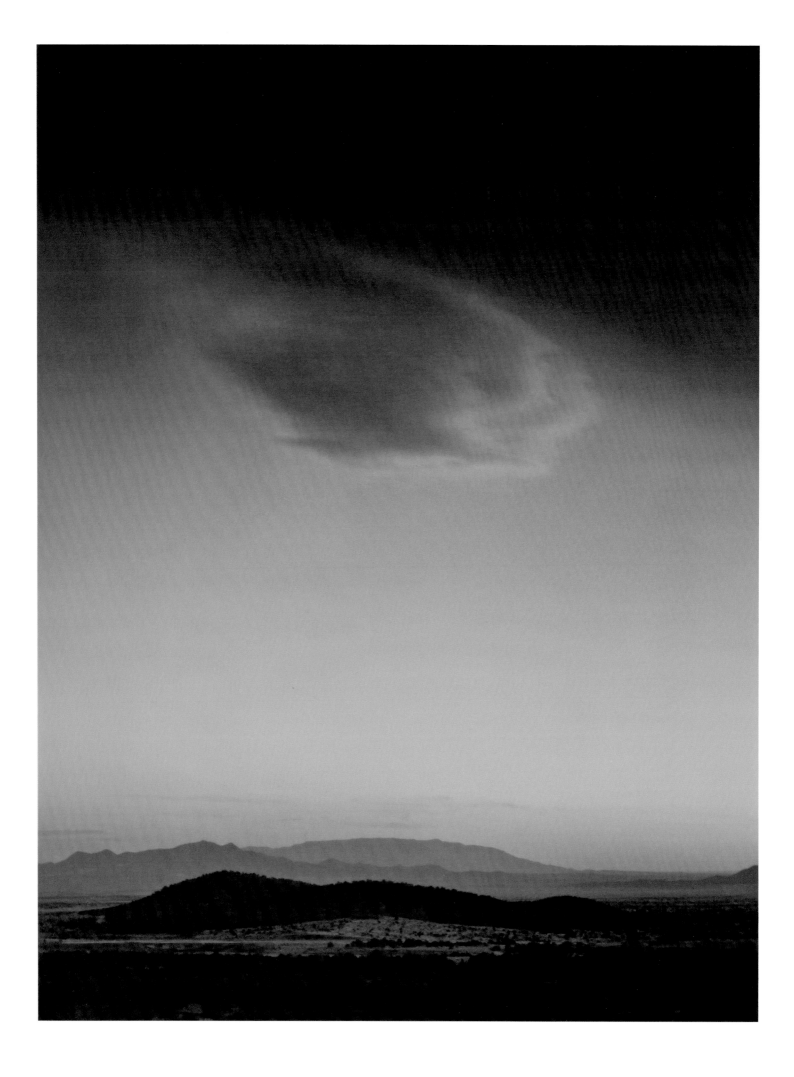

CURATORIAL STATEMENT

KRISTA ELRICK AND MARY ANNE REDDING

Since the arrival of the railroad in 1880 first brought artists to promote the land-scape and peoples of the Southwest, specifically to bolster economic development through the coffers of cultural tourism, Santa Fe has actively promoted its image as a leading arts destination. UNESCO designated Santa Fe as the first "Creative City" in the United States in 2005. Much has been written about the contributions that painters and craftspeople have made to attracting diverse peo-ples to the region, lured by images depicted in paintings, woodcuts, and engrav-ings and by indigenous textiles, ceramics, basketry, and jewelry. Until now, however, little has been written about the contributions photography has made to the creation of Santa Fe in both its public and private personas.

From roughly 1850 to the present, photography has been used effec-tively both to document and to promote Santa Fe. *Through the Lens: Creating Santa Fe* is the visual story about a place—Santa Fe, New Mexico—at the moment it celebrates its four hundredth anniversary as the oldest capital in North America. The selected images illuminate the multiple meanings of place given to this evolving landscape and its various inhabitants. Although photogra-phy has documented only the past 160-odd years of Santa Fe history, beginning with the American occupation of the New Mexico Territory (1846–48), it pro-vides a unique (although largely Anglo, as writers Rina Swentzell and Andy Lovato remind us) visual representation of the complex and challenging open-ended place that continues to feel Native American, Spanish, Mexican, and multi-Anglo influences. Since early photographic technology was not available to the native peoples of the Southwest or the Hispanic inhabitants of nineteenth-century Santa Fe—then a remote outpost far from major cities—its introduc-tion depended on photographers with European surnames, such as Andrews,

PAUL CAPONIGRO
SAN SEBASTIAN, NEW MEXICO, N.D.

Bennett, Bliss, Brown, Chase, Curran, Gaige, Harroun, Hillers, Hook, Kaadt, Martin, Rudy, Sabine, Seligman, and Wittick. Today, however, photography is a ubiquitous medium used by all cultural groups in the region, as well as by nearly every culture in the world, for recording family events, documenting public affairs, and creating fine art.

The essays in *Through the Lens: Creating Santa Fe* provide contextual perspective on how photography has been used over the years to document, create, and promote Santa Fe's image. Dr. Frances Levine provides a brief history of the Palace of the Governors Photo Archives and discusses the origin of this exhibition and book. Lucy Lippard offers her personal, and always astutely political, overview on what creates this place or, more to her liking, the "senses of places" that comprise Santa Fe. David Grant Noble introduces the history of the region that is the subject of this survey: Santa Fe proper; the various subdivisions and townships within the county; Aqua Fria; the Pueblo of Tesuque and Tesuque Village; Lamy and the Galisteo Basin; and the historical routes into the city—the old Santa Fe Trail, La Bajada Hill, and the Turquoise Trail. Rina Swentzell discusses how photography has been used to document Native Americans and how various images distort native culture. Andrew Leo Lovato comments on how photography has been used to characterize Hispanic identity in touristy Santa Fe. Siegfried Halus connects the early historical evolution of photography to the history of the Southwest, with an emphasis on Santa Fe. Mary Anne Redding gives an overview of how photography has both reflected and helped promote Santa Fe's image over many years.

In selecting these images of Santa Fe, we have deliberately ignored the usual distinctions between fine art, documentary, and historical photography. These distinctions are limiting at worst and arbitrary at best. We have asked each essayist to write from his or her own cultural perspective about the content and style of images selected, focusing on what information can be gained from thoughtful observation rather than simply using the images as illustrations for text. Therefore, this book is not a typical history of Santa Fe interjecting various images to illustrate points. It is, rather, a visual record of transformation in Santa Fe over the last 160 years that reveals existential experiences resulting from shifting boundaries, differing patterns of cultural behavior, and changing perspectives of natural, man-made, and symbolic environments. While some of the photographs provide a broad perspective on these transformations, the book also contains photographs that reveal a more personal side of the city's history, such as images that photographers have made of each other here in Santa Fe. They underscore the long tradition of photographers being lured to the "Land of

Enchantment" by light, lifestyles, and fantastic opportunities for making images, whether about or inspired by Santa Fe.

The success of this exhibition and publication is due to the generosity of spirit of many of our colleagues. Director Frances Levine has been a courageous and patient supporter of this project since its inception. Deputy Director John McCarthy always issued wise counsel and insightful advice with welcomed humor. Assistant Director Rene Harris and the small staff at the Photo Archives of the Palace of the Governors offered invaluable support during the two-year duration of this project, particularly during the task of distilling the eight hundred thousand images in the Photo Archives into a cohesive group that expresses a comprehensible history of the city. Archivist Daniel Kosharek provided valuable insights into the range and nuances of the collections in the Photo Archives and supported the project by minimizing other responsibilities when we were under deadline pressures. Interns Nicholas Chiarella and James Wood spent innumerable hours scanning and preparing historical images for both the exhibition and the publication. Mark MacKenie for expert conservation advice. Educators Erica Garcia and Galla Purwin seamlessly incorporated exciting educational programming into the exhibition context. Tim Rodgers, chief curator at the Museum of Fine Arts, lent his support to this project from the beginning; his openness to creative collaboration between the museums is refreshing and much appreciated. Michelle Roberts, chief registrar, spent many hours showing us images from the collection at the New Mexico Museum of Art. Museum photographer Blair Clark made beautiful reproductions of many of the images in this publication. Andrew Smith and John Boland of the Andrew Smith Galley spent numerous hours showing us portfolios, assisting with identification of nineteenth-century processes, discussing ideas, providing collegial support, and lending images. Likewise, Janet Russek and David Scheinbaum of Scheinbaum and Russek Ltd. warmly threw open their gallery and personal collections to us, offering their years of community knowledge and professional expertise. Gerald Peters and Melissa Totten of the Gerald Peters Gallery also made their collections readily accessible. Darius Himes from Radius Books, Rixon Reed of Photo-Eye, Reid Callanan of the Santa Fe Workshops, Jim Enyeart, M. Susan Barger, and many others provided historical insights and ideas about the selection of photographers for exhibition and publication. During research trips to Tucson, Terry Etherton and the staff at the Center for Creative Photography welcomed us, and Debra Hughes and Gary Tyc graciously opened their beautiful home to us. For their many hours of research, we thank Carol Becvarik, Kira Becvarik, Brian Edwards, Gregory MacGregor, Melanie McWhorter, Rebecca

O'Day, Alan Pearlman, Rachael Pullin, Richard Saunier, and Joan Zalenski. Finally, we are eternally grateful to John Scanlan for his kind and wonderfully understated but absolutely crucial support. We are also indebted to the publication team of the Museum of New Mexico Press—Mary Wachs, Anna Gallegos, and David Skolkin—who worked hard to make our dreams for this publication a reality. We extend heartfelt applause to all the photographers who over the years have made Santa Fe the subject of their creative aspirations, in turn making this book possible.

Individually, there are others we would like to acknowledge. Krista Elrick: Thanks to my father, Harold Elrick, for encouraging me to pursue my passions; my mother, Maya Sapper, for helping me find community in Santa Fe; my daughter, Maya, whom I encourage to live with roots and wings; and, most importantly, my husband and best friend, John Blanchard, who has supported my creative endeavors with unconditional love for over a quarter-century.

Mary Anne Redding: Thanks to my mother, Joan Lonergan Redding, and my aunt, Mary Lonergan, for their invaluable editorial skills, knowledge of art history, and unconditional belief in me; and, most importantly, to my husband, Roger Atkins, for his sage counsel, patient and loving support, and ready laugh.

Through the Lens: Creating Santa Fe has been funded in part by the Scanlan Family Foundation, the New Mexico Council on Photography, the Santa Fe Art Foundation, the Palace Guard, Museum of New Mexico Foundation, and the Palace of the Governors/Museum of New Mexico, the parent institution of the Photo Archives.

NORMAN MAUSKOPF

JERRY OLSON AND CHIEF, SANTA FE, NEW MEXICO, 1984

INTRODUCTION

FRANCES LEVINE

New Mexico is a photographer's paradise. The incandescent quality of the light, dramatic cloud formations, and expansive landscape have attracted photographers to our state since nearly the beginning of photographic history. Santa Fe's adobe architecture, meandering streets, and historical place in the artistic, literary, and anthropological canons have brought many distinguished artists and thinkers to "the City Different." According to a conservation survey completed by M. Susan Barger in 1992, the Photo Archives of the Palace of the Governors houses one of the oldest collections of photographs in the western United States. Today, this impressive historic collection consists of more than eight hundred thousand images, including original and copy negatives, daguerreotypes, tintypes, ambrotypes, more than thirty thousand glass-plate negatives, stereographs, postcards, panoramas, lantern slides, and color transparencies that document both the history of photography and the history of New Mexico and the greater Southwest. Importantly, the scope of the collection places it within the context of the larger history of photography.

The earliest collections housed in the Photo Archives were acquired by the Historical Society of New Mexico, operating between 1859 and 1861 and then revived in 1880. These were formative years for photography as well. The photographers, anthropologists, and writers who visited New Mexico in this early period shaped, in large measure, the American image of the region through their interrelated bodies of work. It has even been suggested by noted architectural historian Chris Wilson that their efforts led to the creation of a mythical Santa Fe by focusing on a specific combination of regional customs and architectural details that became known as the Spanish-Pueblo or Pueblo Revival style. Photographic images, incorporated into tourism brochures and the Museum of

New Mexico's own publication *El Palacio,* disseminated the romantic image of the city and the region. Early literary works, many of which were diaries and travelogues, often told more about the writers' experiences of a new culture than about the place, but these writings, the photographer's lens, the architect's eye, and the archaeologist's typology melded into the social biography by which Santa Fe was represented to the nation and the world.

Originally, the collections of the New Mexico Historical Society were the foundation of the Museum of New Mexico collections now held by the four state museums in Santa Fe (the Palace of the Governors, the New Mexico Museum of Art, the Museum of International Folk Art, and the Museum of Indian Arts and Culture). Consequently, the earliest images in the Photo Archives of the Palace of the Governors were acquired by the Historical Society. However, records of the Historical Society do not describe the holdings in sufficient detail to allow us to determine which specific images were acquired at that time, or how they were selected. Among the earliest images of Santa Fe the Historical Society acquired were the glass wet-plate collodion negatives made by Henry T. Heister. Heister's images span the first decades of American control of the region and are the earliest street scenes of the city. Other early photographers with work in the Photo Archives include William Henry Jackson and William H. Brown, who, with his father, established a commercial studio in 1866

HENRY T. HEISTER

KNEELING BEFORE THE ALTAR, A VIEW OF THE PROCESSION OF CORPUS CRISTI, OCTOBER 18, 1878

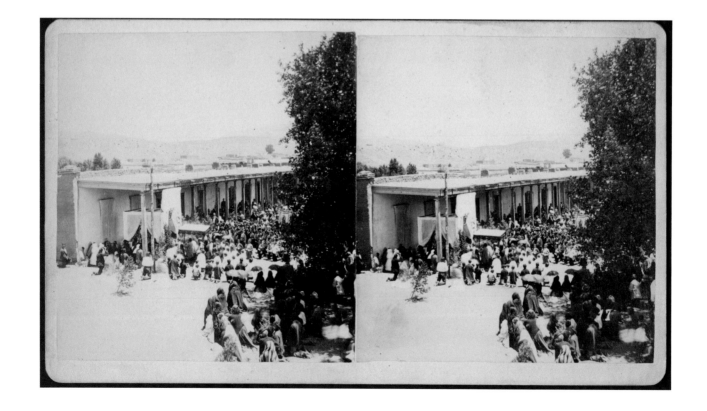

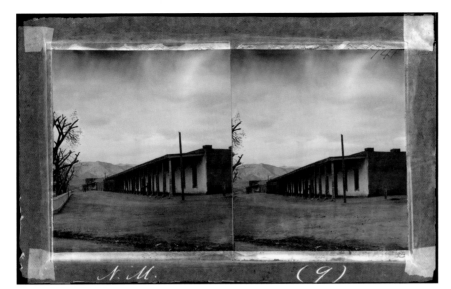

NICHOLAS BROWN
PALACE OF THE GOVERNORS, SANTA FE,
NEW MEXICO, 1868

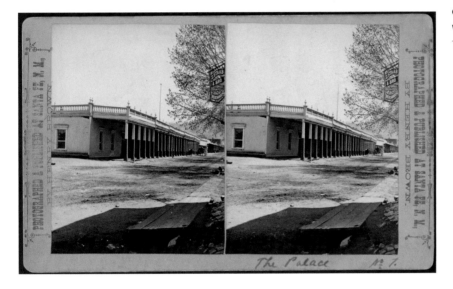

GEORGE C. BENNETT AND
WILLIAM HENRY BROWN
THE PALACE OF THE GOVERNORS, CA. 1881

next door to the Santa Fe Hotel. The Browns' studio contained cameras they had carried to New Mexico over the arduous Santa Fe Trail. After a few years, they moved on to Chihuahua. Around 1880, the younger Brown returned to Santa Fe, where he opened a studio on the west side of the Plaza, eventually partnering with George C. Bennett. Together Bennett and Brown produced a set of fifty-five stereographic images of Santa Fe that was widely distributed by hotels and railroads. Importantly, Bennett was also associated with Adolph Bandelier, one of the most significant anthropologists and historians in New Mexico.

The railroad, which arrived in the area in 1880, brought many new photographers to New Mexico and allowed their images a much wider distribution. Photographers who worked in Santa Fe during this era include George Ben Wittick, T. Harmon Parkhurst, and Jesse L. Nusbaum. The Photo Archives holds

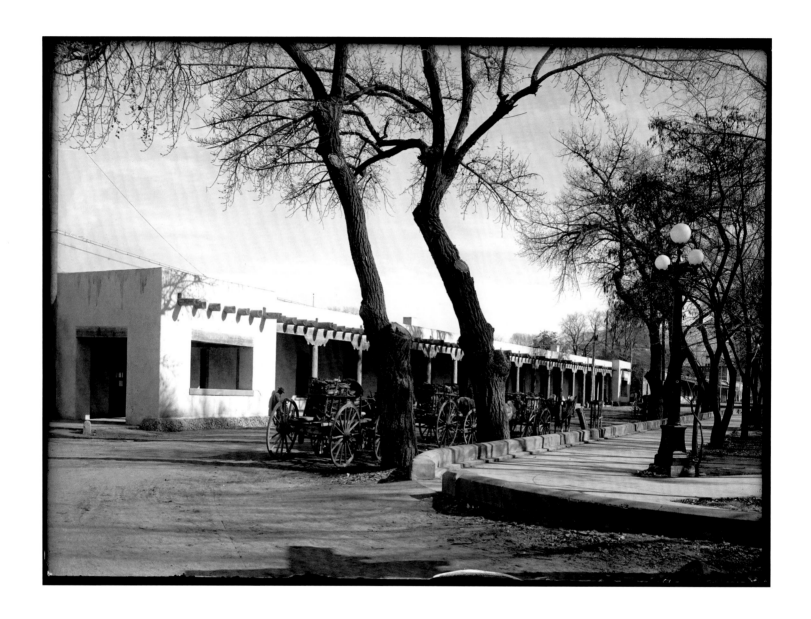

JESSE L. NUSBAUM

WOOD-LOADED WAGON ON PALACE AVENUE

IN FRONT OF THE PALACE OF THE GOVERNORS,

CA. 1915

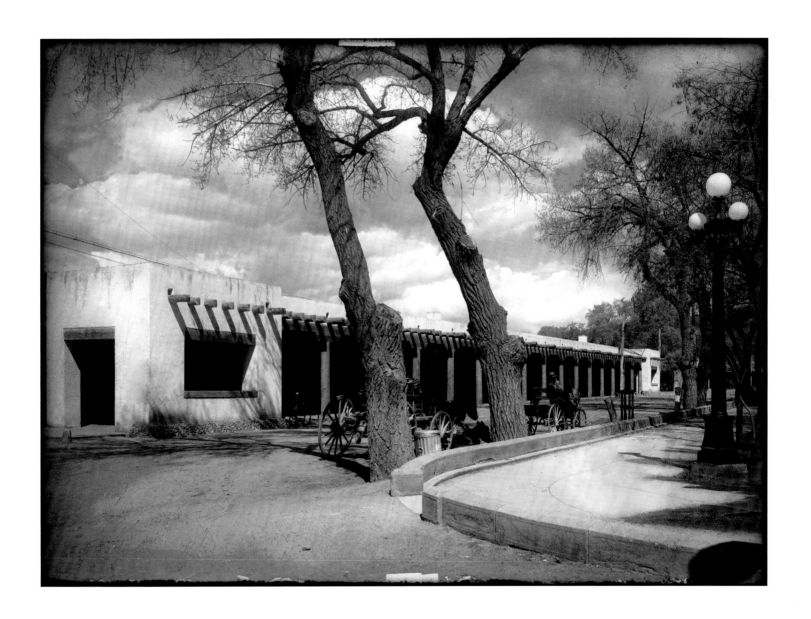

T. HARMON PARKHURST
PALACE OF THE GOVERNORS, CA. 1915

more than twenty-one hundred of Wittick's glass-plate negatives, which show his studio and field images of Pueblo, Apache, and Navajo people. Parkhurst was the most prolific of the railroad-era photographers; the Photo Archives holds more than twenty-five thousand images he made between 1910 and 1951. Parkhurst, along with Museum of New Mexico photographer and restorer Jesse Nusbaum, captured images of Santa Fe during a crucial period of restoration that helped shape the image of the city.

The Palace of the Governors became the first property held by the Museum of New Mexico after the museum was created by the territorial legislature on February 19, 1909. From the moment of its inception, the Palace of the Governors was a complicated institution created under the auspices of the School of American Archaeology (now the School for Advanced Research), with the school and the New Mexico Historical Society holding joint tenancy. The School of American Archaeology intended to make the Palace of the Governors the premier southwestern institution for the study of ancient cultures and to restore the building to its Spanish architectural origins by striping away the layers of Victorian cope and trim that had been added by territorial-era governors. In the process, Director Edgar Lee Hewett and his protégé Jesse Nusbaum, who directed the project, went beyond restoration to create a new regional style from an amalgam of prehistoric and historic architectural elements. Nusbaum, trained in the manual arts and archaeology, carefully documented architectural details in photographs of adobe houses and Pueblo communities near Santa Fe. Nusbaum's photographic survey, consisting of more than forty-one hundred glass-plate negatives now in the holdings of the Photo Archives, shows not only the Palace of the Governors in transition but also the transformation of the cityscape. Subsequently, his photographs were used by the committee that created the Santa Fe Architectural Plan of 1912, which supports the city's historic styles ordinance.

The Photo Archives was not formally managed as a museum collection until the 1960s. In 1971 Arthur L. Olivas joined the Palace of the Governors staff as the first photo archivist of the emerging archive. In 1974 Dr. Richard Rudisill came to the Palace of the Governors as the first curator of photographic collections. Together with consecutive directors Michael Weber and Thomas Chávez, and the generosity of numerous donors, they spent the next thirty years shaping this outstanding historical and fine art collection. Their dedication has made this publication, and its associated exhibition, possible.

Through the Lens: Creating Santa Fe developed over several years in a series of planning sessions and discussions among curators, authors, sponsors,

and students in Santa Fe Community College classes, who provided background research for many of the photographers included in the show. In 2000 Frances Levine, Krista Elrick, and Siegfried Halus began to train students at the community college to record their own communities in preparation for the city's four hundredth anniversary. Ed Ranney of the New Mexico Council on Photography urged this group to broaden its thinking to include the wealth of historic images of the city contained in the Photo Archives. Additionally, several earlier photographic surveys of Santa Fe, particularly *Point of Balance: A Portrait of Santa Fe 1983–84,* gave the original team a body of contemporary work from which to draw. When Mary Anne Redding joined the Palace of the Governors staff as curator of historic photographic collections in 2007, the project got underway in earnest. Redding and Elrick mined the depths of the Photo Archives and searched for images of Santa Fe in archives across the country. They visited the studios of more than one hundred contemporary photographers now working in Santa Fe and throughout New Mexico. Together, they expertly selected and edited the images included in this exhibition and publication to express the breadth and depth of visual material about Santa Fe. The result is a broader community project than what we envisioned in 2000, but it is a project that more appropriately marks the four centuries of Santa Fe and honors the processes that shaped this uniquely creative city. We are fortunate to have the work of so many photographers included in this exhibition and publication. As importantly, we are fortunate to have such a vivid subject to illustrate. Santa Fe is a city that continues to honor its past and its many cultural traditions. It retains, although now quite fragilely, its hold on the land, light, and sky that have brought photographers here for more than a century.

PLACE

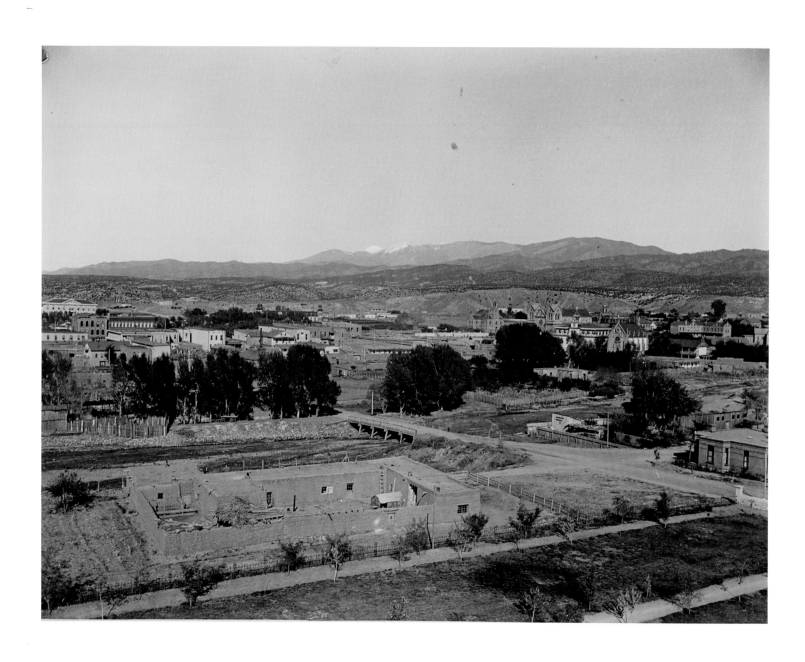

THOMAS J. CURRAN

BIRD'S-EYE VIEW OF SANTA FE, NEW MEXICO,
FROM ST. CATHERINE'S INDUSTRIAL INDIAN
SCHOOL, LOOKING EAST, 1891

LOOKING DOWN: SENSES OF PLACE IN SANTA FE

LUCY R. LIPPARD

"For Americans, the place where we see most clearly the impact of time on a landscape is New Mexico."
—J. B. Jackson, 1985

I was looking for an emblematic landscape to spark this essay—not a picture, but an image expressing a cluster of visual and shared social experiences harbored in the curious city of Santa Fe. As I perused the hundreds of photographs gathered for this book, it didn't turn up. No single image could speak for the multiple senses of place evoked by one picture after another. What did appear was the overview, heir to earlier bird's-eye views of the city. In the course of some 160 years, overviews were first drawn, then photographed from hills (especially Fort Marcy), and finally from aircraft. These pictures suggest the ways that Santa Fe, as a living organism, has grown and changed, has moved out from its unassuming center into a welter of ill-defined neighborhoods—the antithesis of the ordered city required by the Laws of the Indies when it was founded around 1607. Looking down, the human footprint is a mere patch of hubris. Today, Santa Fe seen from above resembles a flower, or a wound.

Bird's-eye views disrupt our sense of balance and place. They exist somewhere between the abstraction of maps and the

WILLIAM HENRY JACKSON
SANTA FE, FROM FORT MARCY HILL, 1881

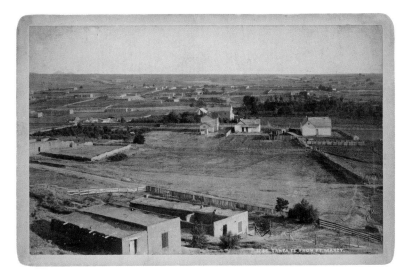

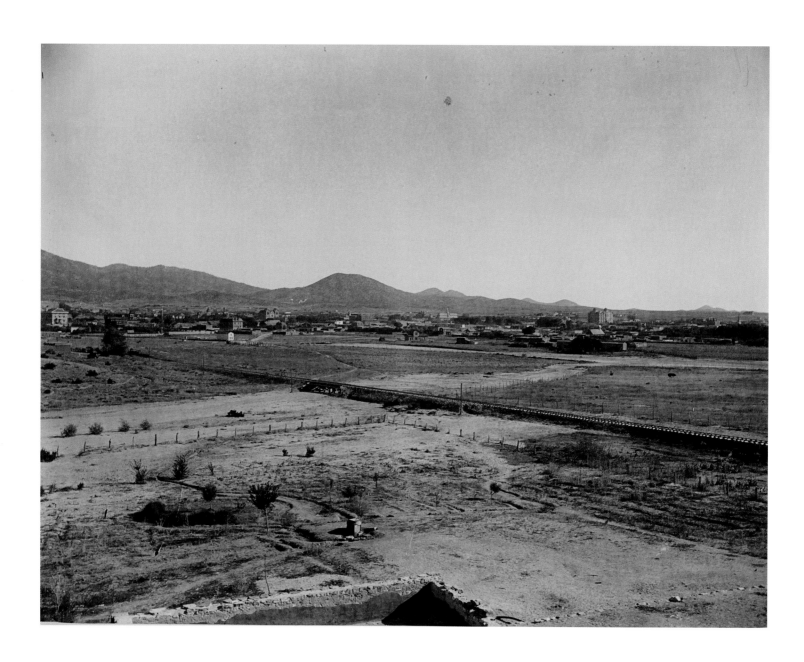

THOMAS J. CURRAN

BIRD'S-EYE VIEW OF SANTA FE, NEW MEXICO,
FROM THE CAPITOL, LOOKING NORTH, 1891

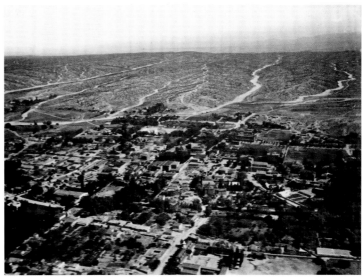
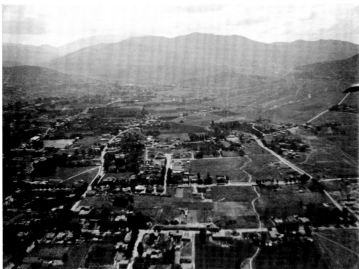
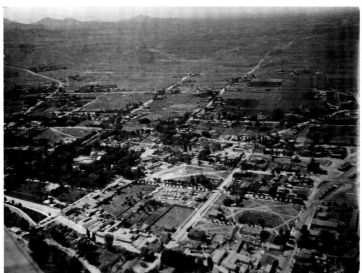

CARLOS VIERRA
AERIAL VIEWS OF SANTA FE, CA. 1921

tangibility of ground-level imagery. More than any detail, they display the psycho-geography of this complex city. Large and small lots, high and low buildings, straight and winding streets, courtyards and plazas—each feature has a specific message to convey. With the miniaturization imposed by distance, overviews render the familiar unfamiliar and teach us where we live.

"The City Different" (aka Fanta Se or Santa Fake) has indeed flourished, wounding many of its original inhabitants as it has grown. Place, or homeland, is paramount to the land-based people who settled it, and the experience of the Indo-Hispano populations has been one of displacement, cultural dispossession, and loss of the land itself—paralleled by a legacy of pride and perseverance. Some fifteen to twenty years ago, Santa Fe lost its Hispanic majority, exacerbating interethnic animosity. Those who are land rich and cash poor find mounting property taxes and the temptation of astronomical sales an insurmountable burden. New Mexico is one of the poorest states in the Union; to many, it seems that Santa Fe has been colonized by the rich. As former mayor Debbie Jaramillo famously said in a speech in Taos in 1991, "We've painted our downtown brown and moved the brown people out." She was also less than complimentary about the arriving hordes who "just got off the bus." While she was accused of polarizing, I see her comments as truth telling. We were lucky to have a mayor who told it like it was, giving us a chance to explore ways to heal the rifts.

"Senses of places" is a more democratic way to look at a location than a homogenized "sense of place." Everyone's Santa Fe is different, and the city has changed so drastically in the last twenty-five years that its tourism moniker—"The City Different"—has come to have layered nuances, depending on whether one knows the town from the cradle, from near the grave, or from anywhere in between. Santa Feans who knew the city in the 1950s, '60s, or '70s (and those survivors who knew it in the '20s, '30s, or '40s) mourn and even deplore the social and visual changes that have occurred. The transience of buildings and businesses is reflected in Kingsley Hammett's *Santa Fe: A Walk Through Time,* which illustrates the incredibly rapid and frequent replacement of downtown buildings since photography became widespread. Even after a mere fifteen years of actual residency, I can play the popular game of recalling the various establishments that have occupied a specific site. ("It's where the Electric Laundry used to be," say the old-timers. "It's where the downtown Kaune's used to be," say later comers.)

Memories make a site into a cultural landscape, and nothing sparks the buried, hidden memories better than photographs. Santa Fe is a city that

lives *on* its history, *in* its past—sometimes superficially, sometimes profoundly, sometimes ponderously, always with a certain poignancy. The place that we love and hate is integrally merged with (or confused with) the historical city, the Villa Réal de Santa Fe that was born around 1607. Thus old photographs evoke a palpable nostalgia even in those who recognize nothing in them except that sense of longing. At the same time, old photographs of Santa Fe can only dispel the illusion of authenticity offered by today's well-meaning but frequently inaccurate imitations of the original city.

Most of what I have written about place and photography has assumed the viewpoint of a walker, a participant in local affairs. The place itself comes up from the ground, into the walker's head and heart. Santa Fe is a great walking city, even though its scenic main arteries are choked with traffic. As we pursue ever busier lives, we lose track of the neighborhood subtleties of adobe detail, coyote fences, high and low walls, yard decoration, pets, paint jobs, new cars, new shrines, new residents, and other changes that are erased by overviews. I live twenty-five miles from Santa Fe, and after even fifteen years of "going to town" a few times a week, I often experience the cityscape in a carbon-fuel–guzzling vehicle. Except for one neighborhood, I see "views" more often than the intimate richness of a lived-in place. And Santa Fe's views can be sublime. Even when trapped in traffic on Cerrillos Road, one can take a deep breath and look out at snowcapped mountains, a magnificent sunset, the shifting light on the plain. The Jemez, Sangre de Cristos, Cerrillos Hills, Sandias, and my local landmark— Cerro Pelon, which marks the Galisteo Basin from the city thirty miles away— are daily fare. Views of rain in the distance, or frustrating virga overhead, or the overwhelming, ever-changing cloud forms, are gifts to the ubiquitous amateur and professional photographers attracted to the area, grist for a plethora of highly filtered photographs. Although I'm as much of a sucker as the next person for those cloud shows when experienced firsthand, I dislike the generalization and exaggeration imposed by cliché-ridden landscape photography, which lifts off from place as though above it all—a lesser kind of overview.

How well does photography convey this place? Santa Fe's picturesque powers pose a major challenge. Contemporary photographs of street-level Santa Fe by a slick postcard photographer and an analytically skilled artist/photographer can look very much the same. The place is calmly dominant, hard to manipulate, immediately readable, and at the same time quite opaque. Once past the ubiquitous quaintness of adobes and flowers, blue doorways and chamisa, the

omnipresent charm spreads out into broader vistas. Take the Plaza, once the heart of the city, now merely its center. It is small and old, laid out for a different life, a different culture. In early overviews it is nearly invisible, overshadowed by a larger military field to the west. The iconic Palace of the Governors is long and low, deflecting visual attention. One of earliest known photos of Santa Fe (1856) shows men standing around on the southeastern corner of the Plaza in front of the Exchange Hotel (later known as the United States Hotel and the La Fonda). In those days, people still lived on the Plaza. Over the photographic years, it has gotten several facelifts. A Nicolas Brown photograph of 1866 shows a plaza divided into what looks like an aerial view or a surveyor's diagram of agricultural *suertes,* or garden strips, perhaps in imitation of or homage to the precious parcels of land that made settlement possible. (The new Railyard Park in the Guadalupe District, which aspires to replace the old Plaza as a populist gathering place, includes a similar if more self-conscious homage.) For decades in the late nineteenth century, the Plaza sported a picket fence, evoking an "American" domesticity. In the early twentieth century, as part of the transformation of Santa Fe into what the colonizers thought it should be, the Plaza was literally taken down a peg toward a purportedly humbler Pueblo Revival, as the Victorian pitched roofs were flattened by a cultural tornado. In 1967 *portales* (covered walkways) were reinstalled all around the Plaza, commemorating traditional shelters from the sun. Within living memory, the Plaza was the local shopping center as well as the place to see and be seen. Today, popular malls on the city's peripheries have left the Plaza unavoidably upscale and alien. Makeovers have continued to follow, one upon another, as the city's image of itself continues to transform (see Wilson 1997).

The bird's-eye overviews eschew these details. They flatten into two dimensions a shared space seen from a distance and through a lens. Aerial views of places where we've often walked the ground can be totally unfamiliar. We are not birds. We are not intimately acquainted with our neighbors' roofs or the shapes of hills from above. Landmarks morph into dots as horizons disappear. If the Santa Fe experience is about rough edges and intimacy, these views offer the opposite. But they allow us to see ourselves in an unaccustomed mirror.

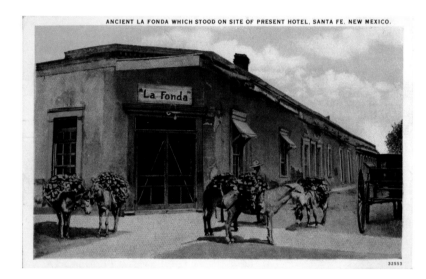

UNKNOWN PHOTOGRAPHER

ANCIENT LA FONDA WHICH STOOD ON SITE OF PRESENT HOTEL, SANTA FE, NEW MEXICO, N.D.

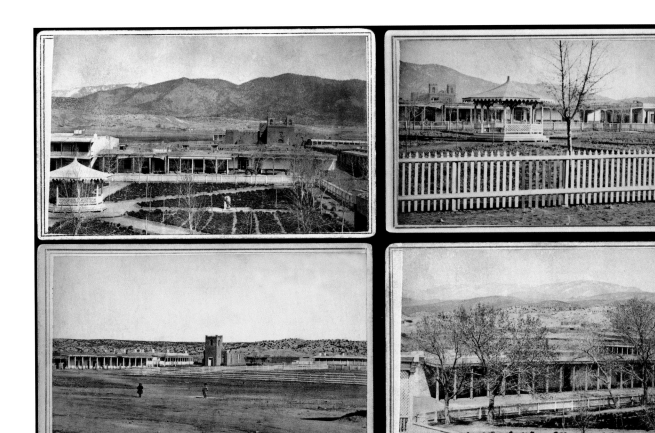

NICHOLAS BROWN

SANTA FE VIEWS: PLAZA, PALACE OF THE GOV-
ERNORS, AND PRESBYTERIAN CHURCH, CA. 1868

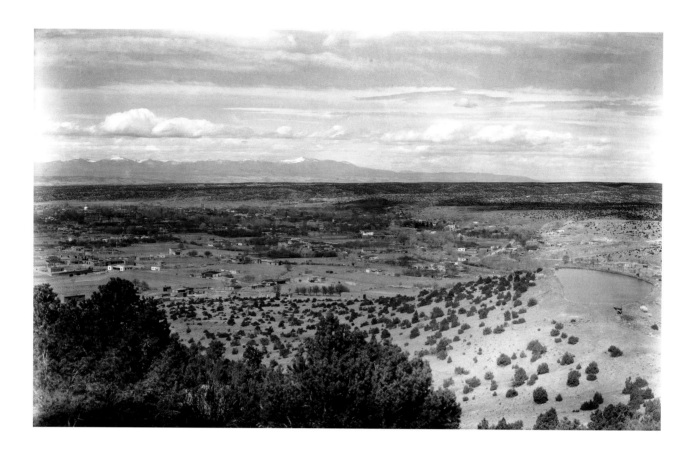

T. HARMON PARKHURST
VIEW OF SANTA FE, N.D.

WILLIAM HENRY JACKSON
SANTA FE. FROM THE COLLEGE,
CA. 1881

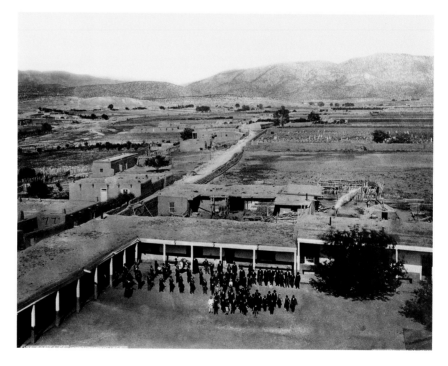

They display that which we—the citizens, the voters, passive and active residents—have wrought. Views from above, over time, illustrate the process by which a rural landscape has become an urban landscape, though Santa Fe is still atypical of American cities. (Visitors are always saying, "I didn't realize it was so small," or "*This* is downtown?")

Early travelers from outside spoke disparagingly of the "miserable" cluster of "mud huts" that met the eye as they looked down at Santa Fe from the descending Santa Fe Trail. Dirt roofs predominated. Agricultural fields lay in the midst of what we now consider downtown. In the 1870s, wooden-wheeled carts were still in evidence; the firewood-bearing donkeys of Burro Alley didn't disappear until the 1920s. An 1882 overview of the city shows a relatively compact town flanked by mountains and fields. In other photographs from the 1880s, the Palace Hotel with its notable tower, an imposing but short-lived capitol, the federal courthouse, and Saint Francis Cathedral stand out like sore thumbs in the barren landscape. In the early 1900s, Santa Fe still crouched on the bare ground from which it seems to have emerged, except for a surprising number of tall buildings—a few old houses, agricultural fields, and those objects dropped in from another world—the skyscrapers of the period, lacking any transition with their surroundings. Today the tall buildings would be banned by the Historic Design Review Board's height ordinances. The acequias, the veins of water that allow life in this arid climate, are invisible.

In comparing photographs of Santa Fe from the 1860s to the present, the most striking feature is the lack of trees (except in the Plaza and along the ditches) until roughly sometime in the 1960s. There is no sign of vegetation anywhere in a photo of Aqua Fria Street in 1900. The apparent bleakness is startling to current residents. In this arid landscape, reservoirs are prominent. In more recent aerial views, the Roundhouse, Santa Fe's fifth capitol, suggests a mother ship landed in an anachronism. Since the mid-twentieth century, the built environment in that area morphed, especially where the new Paseo de Peralta and St. Francis Drive barged through neighborhoods in the name of traffic relief and urban renewal in the late 1960s and early '70s, disrupting the sense of place. Infill and added stories on previously low buildings have replaced the homely disjunction of downtown alleys with straighter streets and sharper corners.

But, of course, the stark black-and-white photographs of Santa Fe's ancient tangle of roads and apparently monochrome dwellings never conveyed the warmth of all that red, yellow, and brown mud set in a drought-prone land-

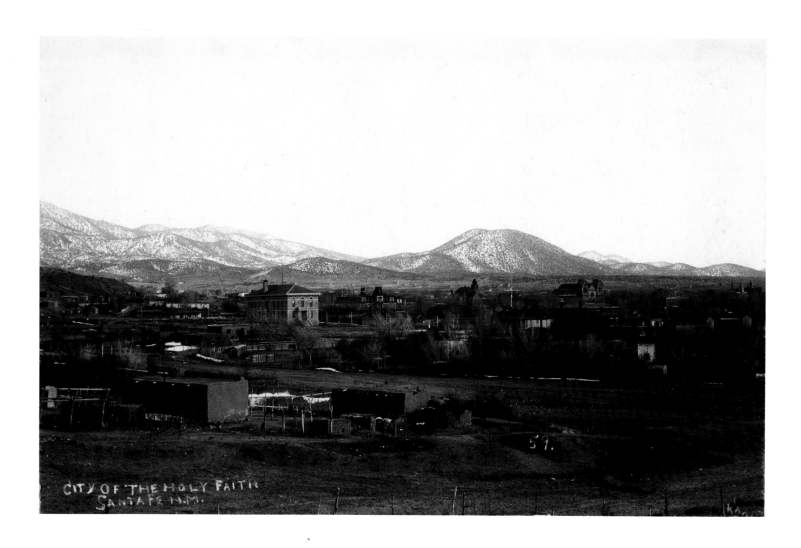

CHRISTIAN G. KAADT

CITY OF THE HOLY FAITH, SANTA FE, NEW MEXICO, CA. 1895

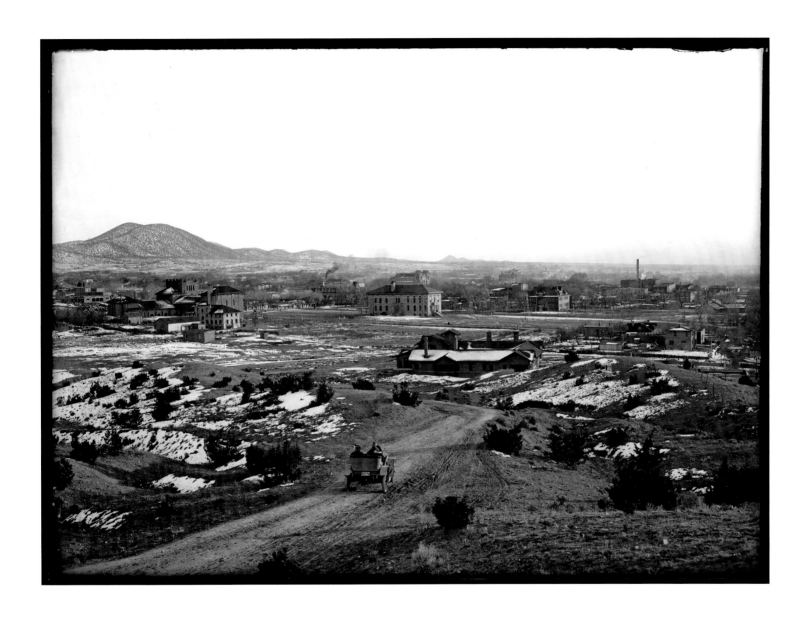

JESSE L. NUSBAUM

PANORAMIC VIEW OF SANTA FE SHOWING

CLARK HOME, FEDERAL COURTHOUSE, AND

CATHEDRAL, CA. 1912

scape of tan and green or wintry white. The drab, stark place they depict was undoubtedly far warmer and livelier than it appeared. Similarly, today's luridly colored publicity shots of the East Side ignore the real life and very different architectural tastes that blanket other neighborhoods.

The intersection of photography and lifestyle is particularly resonant in Santa Fe, where real estate is a major industry, with photography too often its handmaiden. The town's forte is intimacy, but a new population, across classes, has chosen to alter that legacy. Within living memory, there remained some agricultural use within the central urban boundaries. Beyond downtown, and into Santa Fe County, the city is a curious mélange of old houses, abandoned vehicles, an occasional vacant field, glimpses of an acequia, and patches of new condos, wide roads, strip malls (some paying overgrown homage to the Pueblo Revival), and, significantly, a lot of car dealerships on the South Side.

The role of the roads, the entry points, is exaggerated in views from above. They describe lines in a sea of form. The modern landscape is defined by its sprawling highways and by the ephemeral traces of past journeys. Every center is delineated by its peripheries and passages to other centers, whether they lead to shrines in the mountains, pilgrimage routes, or the cheapest place to shop. We continue to migrate. Roads, coming and going, dominate our lives. As J. B. Jackson put it, "Roads no longer merely lead to places; they *are* places" (Jackson 1994). This is especially true for commuters, who are myriad since Santa Fe became prohibitively expensive for many working people. When I first saw the city in 1972, many inner-city roads were still unpaved. Fewer each year remain dirt, sometimes for the peculiar reason that an unpaved road is perceived as a mark of status, while those more concerned with getting to work faster prefer their roads paved.

It was not always so easy to reach the capital. Even after 1821, when Spanish defensive secrecy gave way to Mexican openness to commerce along the Santa Fe Trail, travel was dangerous and time-consuming. When the railroad arrived in 1880 and knocked the old trail off the map, the capital city was bypassed by the main line because of its altitude. The first automotive traffic also had a hard time. A photograph of La Bajada in the early twentieth century shows the road straining up the cliff in vertiginous switchbacks. Technology finally conquered the recalcitrant topography; Interstate 25 was built in the 1970s. Ed Ranney's 1979 *La Bajada Drainage* shows a ranch road (more or less

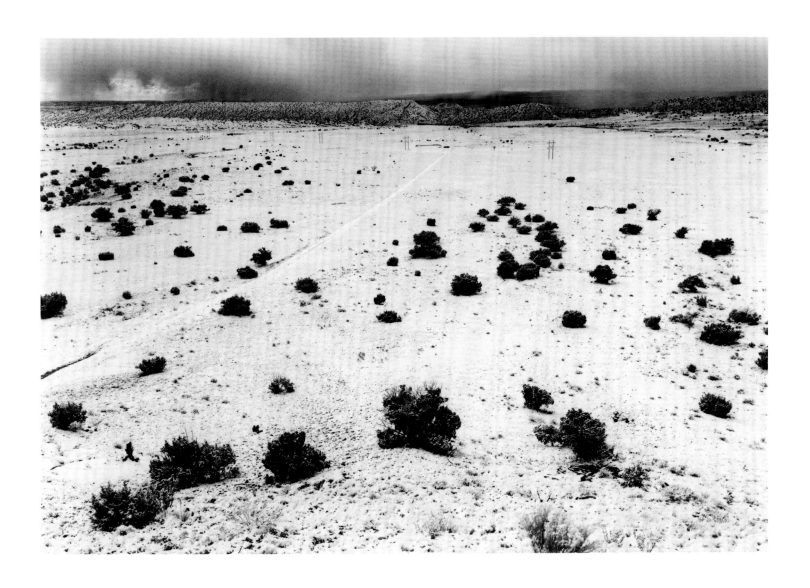

EDWARD RANNEY
LA BAJADA DRAINAGE, NEAR WALDO, 1979

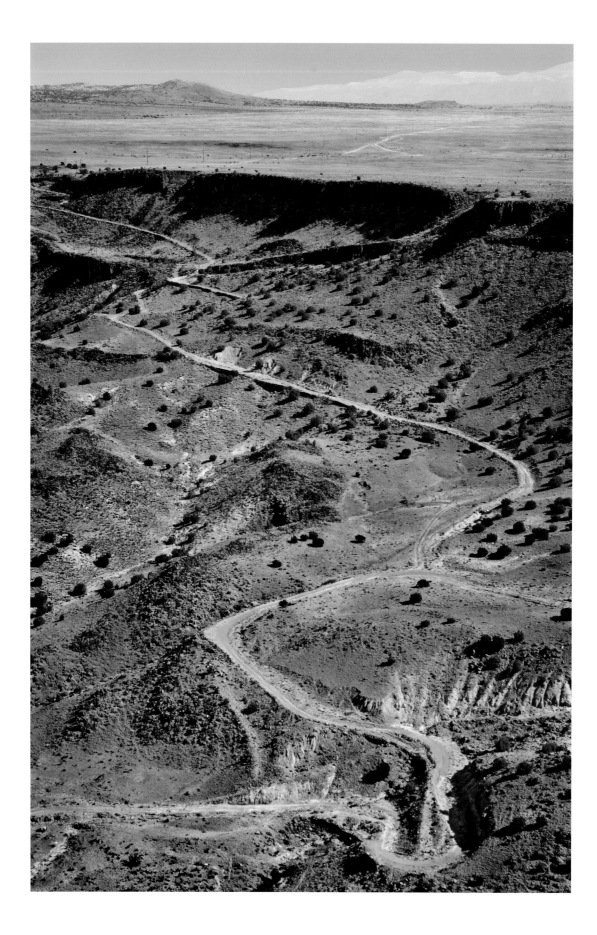

JOAN MYERS
LA BAJADA ROAD (AERIAL), 2004

ALAN PEARLMAN
HIGHWAY CONSTRUCTION, SANTA FE, 2004

following the original road from Mexico, El Camino Real) curving through a classic desert plain, almost timeless except for the utility poles crossing its path near the invisible superhighway.

Joan Myers's 2007 helicopter views illuminate the extent to which highways—I-25, U.S. 285, and the new "relief route" (built to keep nuclear waste on its way to the Waste Intensive Pilot Plant in Carlsbad out of the city and beyond the reach of protesters, although locals insist it was intended to give us some relief from tourists)—define Santa Fe.

The city's changing layout illustrates the gradual invasion (infiltration) of other values and other lifestyles into the picture Santa Feans hold dear. All change is not progress; in Santa Fe, all change is scrutinized with suspicious ambivalence. As small scale gives way to expanding commerce, the profits are not equally shared. As the interstates fatten and bigger jet planes hover, the slow motion for which Santa Fe once was famous is speeding up.

In a curious way, the old overviews of the city are more moving and telling than the recent ones. Exposing a naked city, the structural armatures of scattered buildings and byways, they reflect the notoriously stubborn independence of the earlier settlers. The city and the land once looked almost inseparable. Today, the startling bareness that distinguishes the earlier photographs has been fleshed out by an incongruously lush cityscape that guzzles our precious water supply, even as it shelters the parched earth and protects us from warming. Visually, new condo clusters and McMansions are often disjunctive, dropped onto sites where only wildlife should feel at home. Incredibly steep driveways lead to trophy houses on the ridgetops (despite a city ordinance written to fend off this phenomenon); those quaint drives are impassably icy in the winter and glassy slick after the diminishing rains. The city has spread like a gigantic spider over the landscape. (I'm avoiding the metastasis metaphor, but it is not inappropriate.) The task of managing growth is on top of the list for city and county planners, while sprawl constantly seeps into unmonitored pockets.

Those enormous houses creeping up our sheltering hills remind me of an artwork by Helen and Newton Harrison, who collaborated with a scientist to show how warming temperatures are chasing wildflowers up a mountain. When they reach the top, they will have nowhere to go. I think too of Paul Logsdon's and Adriel Heisey's aerial photographs of local archaeological sites, the native pueblos that did not survive drought and/or invasion, the bones of former cen-

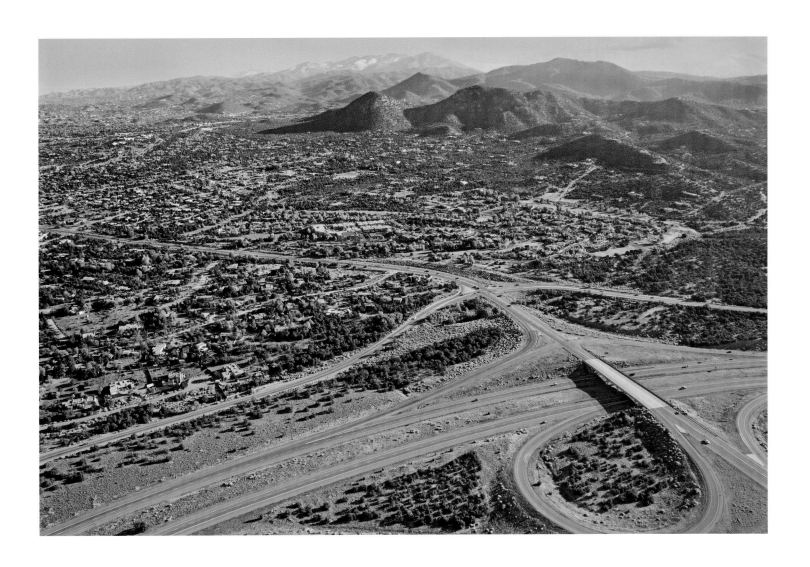

JOAN MYERS
OLD PECOS TRAIL, SANTA FE (AERIAL), 2007

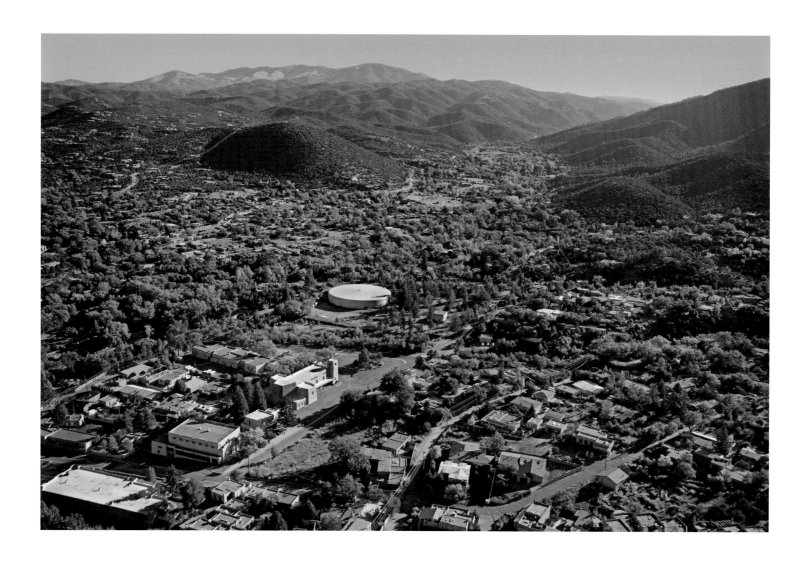

JOAN MYERS

WATER TANK, SANTA FE (AERIAL), 2007

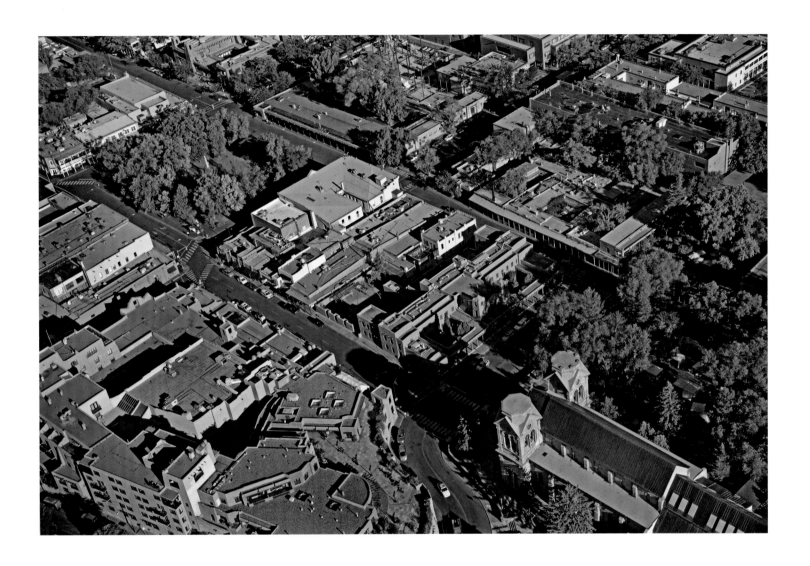

JOAN MYERS
PLAZA, SANTA FE (AERIAL), 2007

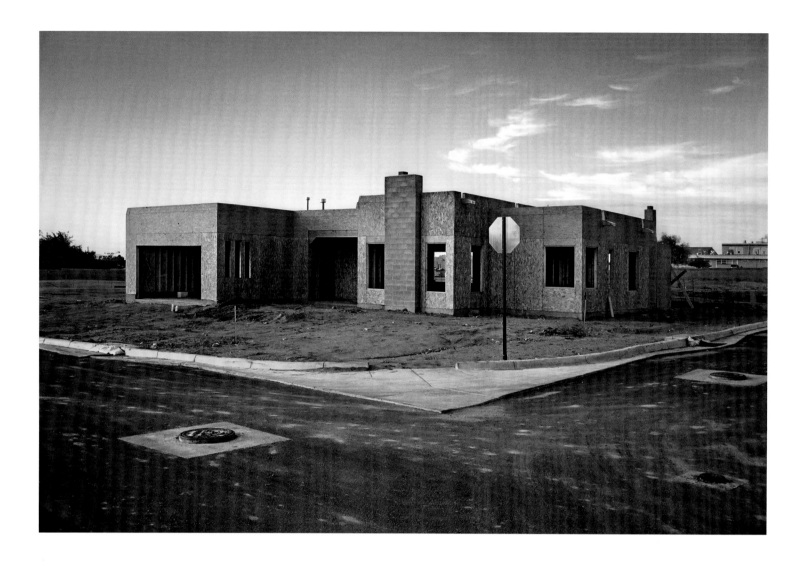

HOWARD KORDER

NEW SUBDIVISION, SANTA FE,
NEW MEXICO, 2007

ters. And I wonder: When Santa Fe runs out of land and water, where will it go? Overviews offer a grasp of the place, an image of the problems. A whole history is spread out before us in these photographs. It would take a book of oral histories to delve beneath their surfaces. Yet even at face value, they clue us in to the present where we live, offering views from mountaintops we rarely climb, conclusions we might otherwise avoid.

HOWARD KORDER
ARROYO MASCARAS, SANTA FE, NEW MEXICO, 2006

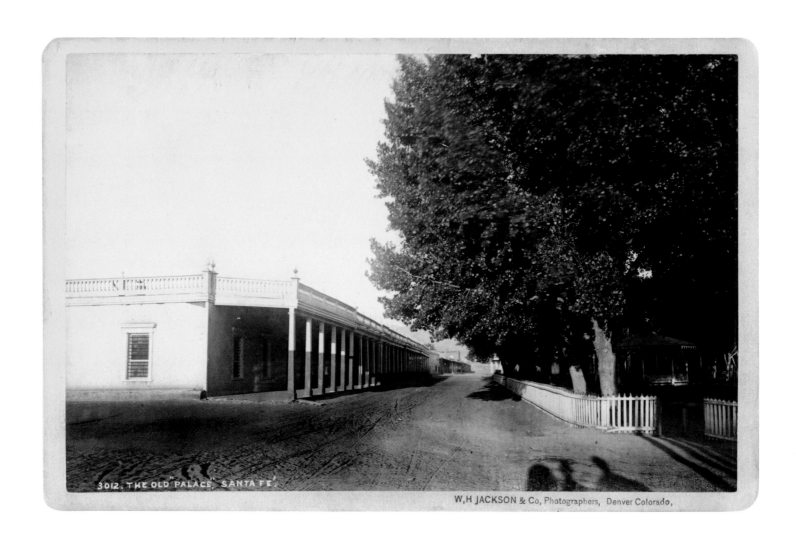

Text in image: 3012. THE OLD "PALACE", SANTA FE.

W,H JACKSON & Co, Photographers, Denver Colorado,

WILLIAM HENRY JACKSON

THE OLD "PALACE," SANTA FE, CA. 1881

IMAGING PLACE

MARY ANNE REDDING

> If they [photographs] can't always convey the complexities of their construction, they can nevertheless exert an almost magnetic sort of pull between our present and the past they depict. They elicit empathy and imagination, create bonds of imaginative understanding between us and people we will never know, places we will never see. For all the differences they mark between our world and an earlier moment of our nation's history—in their monochromatic rendering of a world filled with little details that can shock us with their strangeness as easily as with their familiarity—they still underscore the common ground we share with our ancestors. In showing us what that physical landscape used to look like, they give us a way to measure change and the impact of our own actions. In making visible human passions and emotions that we ourselves seem to recognize, they allow us to create sympathetic links, across the divide of time, to those who lived and worked in this landscape before us.
>
> —MARTHA SANDWEISS, 2002

Most of the time, we experience place unself-consciously. Existing in time and space as part of our everyday world, we pay scant attention to the tangible manifestations of place that surround us. Viewing photographs asks us to do otherwise—to focus our attention, for a moment, on what is physically manifest in the image and to consider what the scene might mean for ourselves, our cultural identities, our relationships with others, and the places we co-inhabit. This is particularly true in Santa Fe, which has historically cultivated a sense of con-

sciously being a very special place—the City Different, if you will. Photography, perhaps more than any other medium, offers us a captured (or created) view of the multiple meanings of Santa Fe. Representation is an interactive process. Memory and imagination are both important components in developing a sense of place, and photography, related as a palimpsest to both, perpetuates and disseminates the meaning of place in a particular cultural landscape.

Initially, beginning in the 1840s, it was artists and photographers who traveled to the Southwest who helped define Santa Fe's image. These artists are sometimes described as antimodernists (Neff 2007, xii), whose restless wanderings represent an escape from the pressures of modern life. Looking for a simpler pace, they chose to escape from the stultifying life of the rapidly urbanizing East, with its pressures to conform to a prescribed definition of success. The artists who came to northern New Mexico, however, were also looking for an authentic and modern American art. Consequently, they investigated the "new" American landscape that they discovered in the Southwest in decidedly different aesthetic terms than those artists who remained in the East. These renegade artists also "discovered" Native American, and to a certain extent Hispanic, cultures, which seemed to represent a romanticized notion of all that America was rapidly losing, most importantly its soul. The ways in which these artists internalized and expressed southwestern topography and different cultural traditions contributed to creating an image of Santa Fe through visual arts and literature that continues to define our understanding of this unique place, both within the confines established for this survey and much farther afield, as Santa Fe has a near magical international reputation.

Much of how the world understands Santa Fe is through visual imagery that provides both historical and contemporary reference. Although there are few known surviving daguerreotypes that can be identified as depicting Santa Fe, itinerant photographers made daguerreotypes here as early as the late 1840s, less than ten years after daguerreotypes were first introduced in Europe. Although it is unfortunate that not more daguerreotypes of the area survive from this time, Santa Fe resident Robert Shlaer is known for having helped revive this nineteenth-century process. He continues to keep the tradition alive by teaching workshops and making contemporary daguerreotypes that confound expectation. His delicately colored nude studies reflect an earlier time in photographic history, when classical male and female nudes—known as *académies*—were initially marketed to aid artists in drawing the human figure but rapidly found other audiences not necessarily interested in making paintings or sculpture.

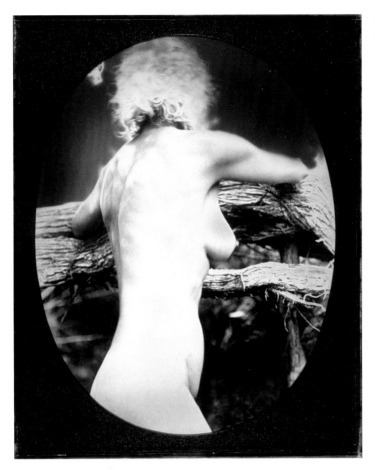

ROBERT SHLAER
NUDE, LAMY, NEW MEXICO, AUGUST 1, 2004

The earliest photographers known to have established businesses in Santa Fe include Siegmund Seligman, William Henry Brown, and George C. Bennett. In 1853 Seligman opened Santa Fe's first portrait studio, specializing in daguerreotypes (Coke 1979, 2). Brown learned photography from his father, Nicholas Brown, before father and son brought their cumbersome studio equipment from St. Louis across the Santa Fe Trail and opened a studio in Santa Fe in 1866. Later, the younger Brown traveled extensively with his cameras before returning to Santa Fe to open a studio with Bennett. Brown and Bennett did considerable work for the New Mexico Historical Society, which was founded in 1859 and revived in the early 1880s. The images Bennett and Brown made established the core collections of what is now the Photo Archives at the Palace of the Governors (Rudisill 1973, 17). Likewise, William Henry Jackson, who first visited Santa Fe in 1877 and returned in 1881, presented the Historical Society with a collection of his images and was voted an honorary member (Rudisill 1973, 37). During both of his visits, Jackson made a number of drawings and took photographs documenting Santa Fe, including a number of images of the

266 VS 267 VS 268 VS 269 VS

270 VS 271 VS 272 VS 273 VS

BEN WITTICK

VIEWS OF SANTA FE FROM WITTICK
COLLECTION

Palace of the Governors that were reproduced as stereographs, cabinet cards, and larger albumen photographs. One of these images, *The Old "Palace," Santa Fe,* captures the photographer, his camera, and a companion's shadow on a dirt street at the bottom right edge of the print. The description of Santa Fe on the back of the card is as fascinating as the image on the front.

George Ben Wittick operated studios in Santa Fe from roughly 1878 until the spring of 1881, when he moved to Albuquerque. Truly an itinerant photographer, Wittick traveled extensively throughout New Mexico and Arizona for the Atlantic and Pacific Railroad. He maintained his own photography business in various locations in northern New Mexico before settling his studio perma-

250VS

251 VS

252VS

253 VS # 15848

254 VS

255 VS

256 VS

257VS

nently at Fort Wingate. He remained there until his death in 1903 from a snakebite received while collecting rattlesnakes for a Hopi Snake Dance, an occurrence that, according to legend, had been predicted years earlier by a Hopi snake priest. In addition to hundreds of glass-plate negatives in various sizes, seven of Wittick's original viewing albums are housed at the Photo Archives. They show numerous images of life in Santa Fe, including portraits, architectural studies, and street scenes, that could have been purchased from his studio.

Other early portrait studios in Santa Fe were the Plaza Art Studio and the Anderson and Kaadt studios, which operated in several different locations around the Plaza. In addition to portraits, Christian G. Kaadt produced images,

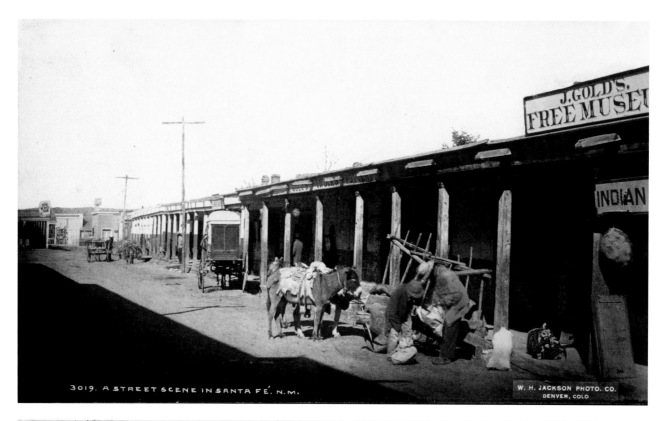

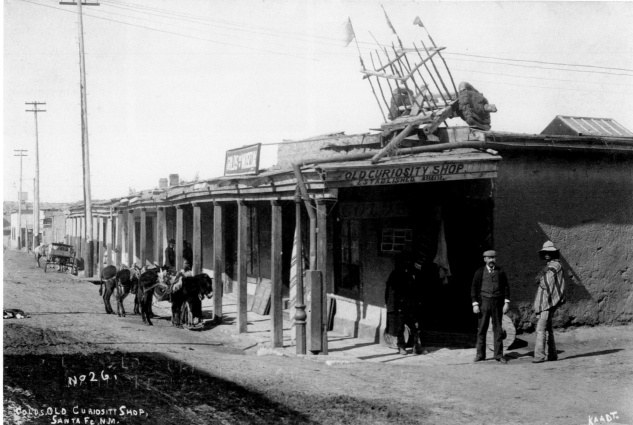

WILLIAM HENRY JACKSON

A STREET SCENE IN SANTA FE, NEW MEXICO, 1881

CHRISTIAN G. KAADT

GOLD'S OLD CURIOSITY SHOP, SANTA FE, NEW MEXICO, CA. 1896

often pirated from other photographers, for Gold's Old Curiosity Shop as well as his own Curio Emporium. Jake Gold's Free Museum and Curio Shop, which opened in the early 1880s, was one of the first enterprises in Santa Fe to sell native arts and crafts, as well as photographs. Although Gold's eventually changed ownership, becoming the Original Old Curio Store, which was later owned by the Candelario family, the storefront on West San Francisco Street has been preserved and can still be photographed today.

The photographic history of Santa Fe began in earnest with the arrival of photographers hired by the U.S. government to accompany the four major geological and topographical survey teams that went west between 1867 and 1879. When the survey photographers came to Santa Fe, they found a thriving

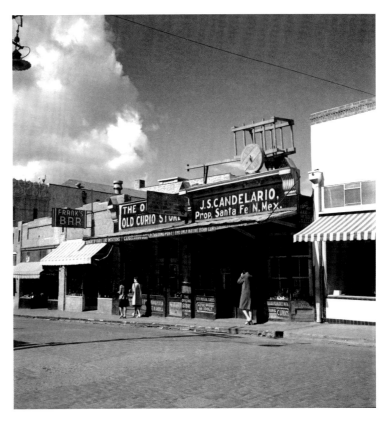

JOHN CANDELARIO
CANDELARIO'S ORIGINAL OLD CURIO STORE, CA. 1955

community unlike any of the cities on the East Coast, with a diverse population of Pueblo and other native peoples, Hispanics, Asians, Africans, and assorted European Americans. One of the most prominent survey photographers was John K. Hillers, a member of John Wesley Powell's survey expeditions from 1872 to 1878. Originally the boatman for Powell's second trip to the Grand Canyon on the Colorado River, Hillers learned photography through self-confident curiosity and practical necessity. After his work with the surveys, he continued his career in photography by making images for the Bureau of American Ethnology at the Smithsonian Institution. As in the image *Pueblo Tesuque, New Mexico,* circa 1890, Hillers usually chose a vantage point that maximized pertinent information about the anthropology and geology of the area, at the same time juxtaposing foreground information with the endless expanse of the desert, tapping into a quality of intense loneliness and desolation (Neff 2007, 37). Although Tesuque Pueblo appears desolate in the photograph, it was and remains an active community, as evidenced by the numerous images documenting Pueblo life there over the years. A curious aspect of early photographs of native peoples of the region was the staging of scenes and the use of often inappropriate props. Many early photographers, including Hillers, Wittick, and

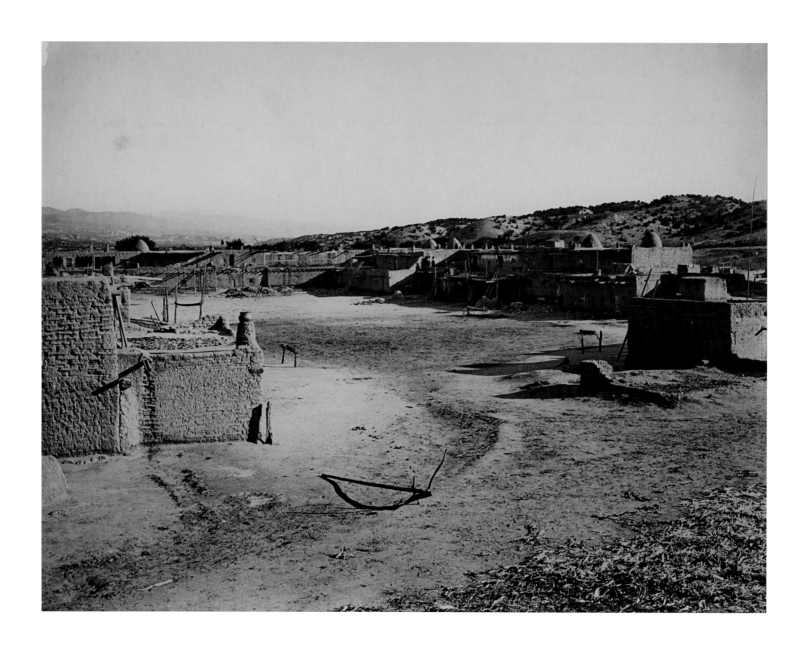

JOHN K. HILLERS
PUEBLO TESUQUE, NEW MEXICO, CA. 1890

most famously Edward S. Curtis (who borrowed costumes from the Smithsonian), posed their subjects with props and backdrops regardless of their authenticity or appropriateness. This practice often resulted in an odd blending of cultures that created an overly romanticized and often false view of what traditional native life looked like in the last half of the nineteenth century.

The early photographers documenting Santa Fe acted almost as if they had a guidebook to follow, placing their tripods in nearly identical locations that afforded the most picturesque views. When photographing Santa Fe, they often focused either on recognizable architectural highlights or overviews showing the city from a distance. Among the most frequently photographed buildings were the Palace of the Governors, then the seat of the territorial government, now a museum; the Loretto Chapel, originally built as Our Lady of Light Chapel for the Sisters of Loretto, now the Inn and Spa at Loretto; San Miguel Chapel and Nuestra Señora de Guadalupe, both of which still operate as Catholic churches; and the old Perroquia, now the Cathedral Basilica of Saint Francis of Assisi. Early photographers of Santa Fe often took panoramic images overlooking the growing city, especially from Fort Marcy, an army outpost built to protect the city. Some of the earliest images of the city included in the Photo Archives are stereographs taken from Fort Marcy from the late 1870s to the early 1880s. These include *View of Santa Fe from Fort Marcy looking northeast* by Bennett; *The Mountains south-east from old Fort Marcy* by Bennett and Brown; and two stereographs by Wittick, *View from Old Fort Marcy* and *Santa Fe Looking West from Old Fort Marcy*. Five to ten years later, Dana B. Chase made a two-part albumen panorama from the same vantage point that shows the rapid growth of the city. Adam Clark Vroman also made a two-part platinum panorama taken from Fort Marcy, probably in 1900 during a visit to Santa Fe. Jesse L. Nusbaum's four-part panorama, *Santa Fe from Fort Marcy,* made with four glass-plate negatives, was probably taken in 1911, just before New Mexico became the forty-seventh state of the Union. Joan Myers continues this tradition today with panoramas made in 1982 and 2007.

When the Denver and Rio Grande and the Atchison, Topeka and Santa Fe railroads reached the area in 1880, the railroad hired painters and photographers to ride the rails and make images that were then distributed nationally to attract tourists to the Southwest. The early proponents of cultural tourism promoted visual artists whose paintings and photographs reflected the long history, multiple cultures, and adobe architecture of Santa Fe, as well as the glowing light of the exotic desert landscapes. Once increased numbers of tourists began

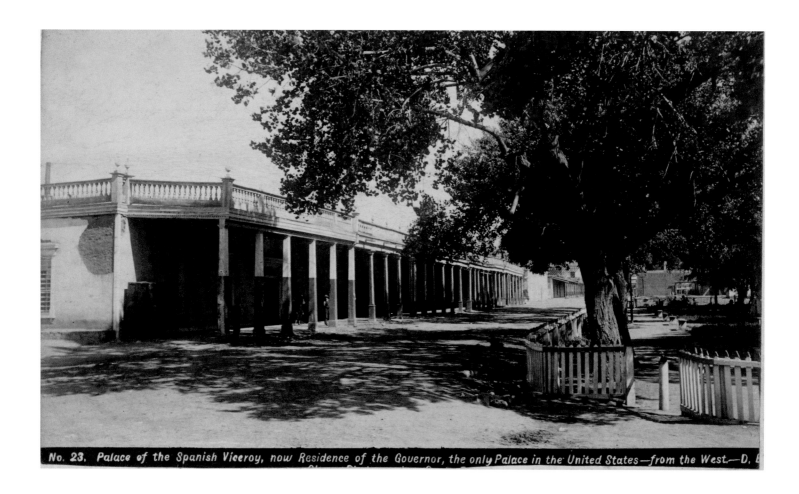

No. 23. Palace of the Spanish Viceroy, now Residence of the Governor, the only Palace in the United States—from the West.—D. B.

DANA B. CHASE

PALACE OF THE SPANISH VICEROY, NOW RESIDENCE OF THE
GOVERNOR, THE ONLY PALACE IN THE UNITED STATES, FROM
THE WEST, CA. 1888

BEN WITTICK
LORETTO CHAPEL, SANTA FE, NEW MEXICO,
APRIL, 1881

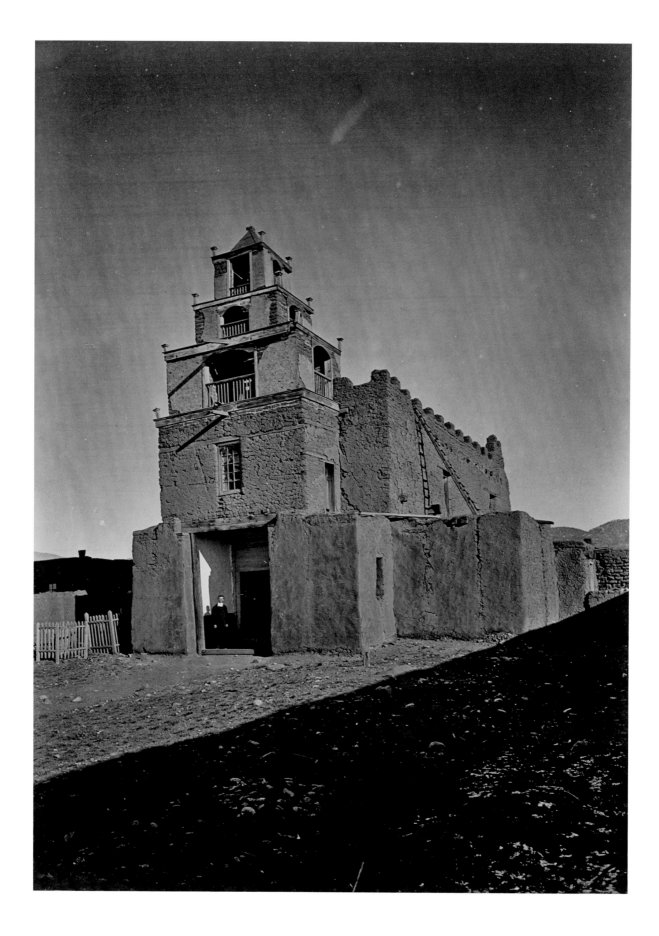

TIMOTHY O'SULLIVAN
SAN MIGUEL CHURCH, CA. 1871–74

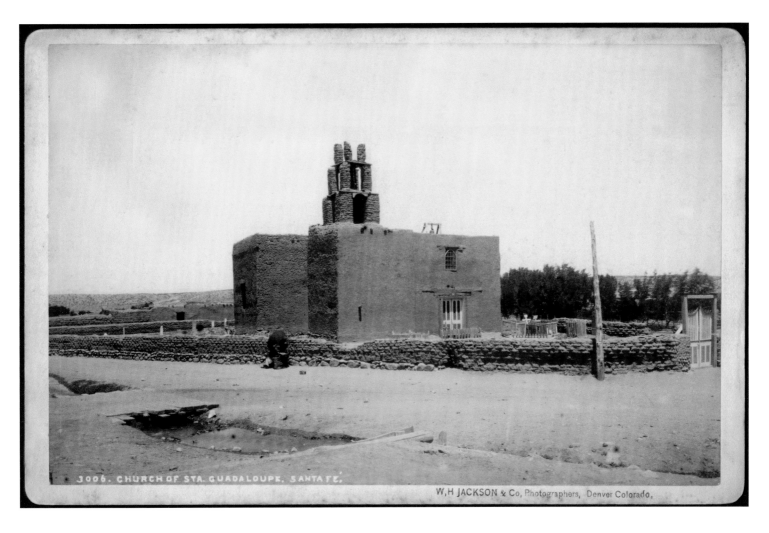

3006. CHURCH OF STA. GUADALOUPE, SANTA FE.

W.H JACKSON & Co, Photographers, Denver Colorado,

to make the journey, rest stops along the train tracks provided opportunities for tourists to interact with native artisans selling traditional weavings and pottery and to purchase mementos of their travels to take back home. The railroads and entrepreneurs such as Fred Harvey, with his wildly famous Indian Detours, encouraged native crafts and trade to make sure tourists' expectations were met and they returned to the quotidian East with objects that further promoted the exotic West (not to mention with lighter wallets). Edward A. Kemp's *Lamy Depot and Harvey Indian Detour Cars Waiting Arrival of Train,* circa 1930, shows the Harvey cars waiting at the Lamy station to take passengers into Santa Fe or out to Tesuque Pueblo.

Early photographs were also used to advertise and promote Santa Fe through picture postcards. Black-and-white and albumen photographs were reproduced as hand-colored postcards, which were popular with travelers throughout the Southwest during the golden age of the postcard, 1900 to 1915.

WILLIAM HENRY JACKSON
CHURCH OF STA. GUADALUPE SANTA FE, 1881

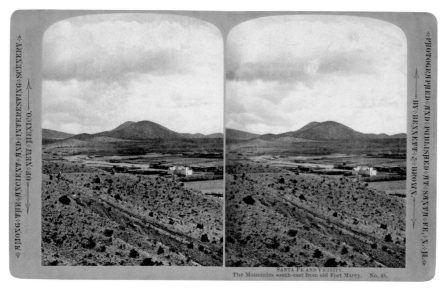

GEORGE C. BENNETT

VIEW OF SANTA FE FROM FORT MARCY
LOOKING NORTHEAST, CA. 1879

GEORGE C. BENNETT AND
WILLIAM HENRY BROWN

*THE MOUNTAINS SOUTH-EAST FROM OLD
FORT MARCY,* CA. 1882

Beginning about 1905, many of Santa Fe's photographers who had earlier made stereographs of the city adopted the postcard format. Tom Phillips, author of *The Postcard Century,* writes, "Postcards provide the world's most complete visual inventory." In her essay "The History of Postcards" in the *Encyclopedia of Antique Postcards,* Susan Brown Nicholson reports, "Picture postcards were so popular that in June 1908, the United States Post Office estimated that 677,777,798 postcards were mailed in the U.S." To put that number into perspective, in 1908 the entire U.S. population was slightly over 88,000,000, which comes out to seven postcards per person. Among the photographic postcards made of Santa Fe, images of the Plaza and the Palace of the Governors, as well as various street scenes, remain among the most popular.

Many photographs of Santa Fe, including the early postcards, are valuable documentation of the city's transformation over time. The vibrancy of the Plaza as a public center is evident in early pictures that show the Plaza planted in corn and other crops necessary for a growing population and a large military presence. An untitled image by J. R. Riddle, circa 1888, provides a glimpse of an early farmer's market with produce being sold from the bandstand. More typically, the bandstand was used for public concerts, as seen in Ben Wittick's image *Ninth Cavalry Band, Santa Fe Plaza, July 1880.* While still the focal point of the town, the Plaza has been transformed over time from the heart of the community into what many perceive as a location that mainly caters to the needs of tourists and art collectors (Lovato 2004, 102). Norman Mauskopf's image *Indian Market, Santa Fe, New Mexico* (2002) pokes fun at this change in an all-too-typical scene.

Photographs documenting public events in Santa Fe also record changes in the city. All aspects of the Santa Fe Fiesta have been thoroughly photographed over the years. T. Harmon Parkhurst made a wonderfully descriptive

image of Santa Fe's promotion of itself as the Indian, Mexican, and Spanish trading capital of the Southwest, complete with billboards, during a Fiesta parade in the late 1920s. James Hart's *La Tercera Entrada: "The Third Conquest,"* circa 1983, is but one example of images made of the Hysterical/Historical Parade, a Fiesta event that satirizes economic, political, and social situations with which Santa Fe struggles to this day. Contemporary images of the Pet Parade by Wendy Young and Sam Adams show a Fiesta event from a more modern perspective.

Photographs record changes in the facade of the Palace of the Governors over the years prior to its renovation in 1912–13, indicating how the city's architecture was viewed at various times in the past. One of the earliest photographs in the Photo Archives, by an unknown photographer working for the U.S. Army Signal Corps circa 1865–70, shows the Palace of the Governors with a simple portal of rough-hewn posts and a slightly sloped, plain flat roof that provided a modest Territorial-style porch. When the portal was remodeled between

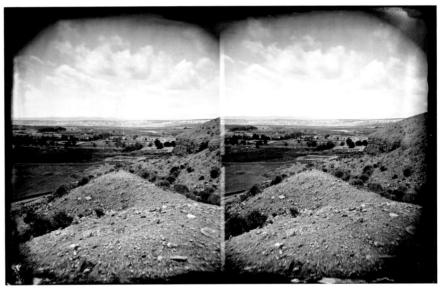

1877 and 1878, the posts were wrapped in molding topped with a cornice, and the roof was extended upward with an elaborate balustrade. Further images by Ben Wittick, Dana Chase, William Henry Jackson, George Bennett, Nicholas Brown, William Henry Brown, and other photographers from this time show varying changes made to the columns on the portal. Adam Clark Vroman's *Governor's Palace, Santa Fe, New Mexico, March 8, 1900* shows the deteriorating condition of the outside walls. The building's facade remains largely unchanged today. Greg MacGregor's *Palace of the Governors Construction Site,* from 2007, shows the most recent addition to the Palace of the Governors with the construction of the new New Mexico History Museum.

BEN WITTICK

VIEW FROM OLD FORT MARCY, MAY 1880

BEN WITTICK

SANTA FE LOOKING WEST FROM OLD FORT MARCY, CA. 1880

(text continues on page 73.)

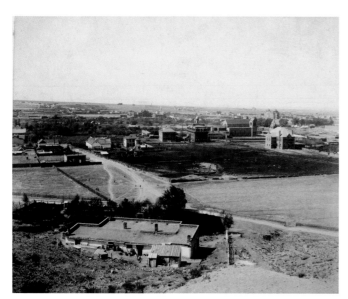
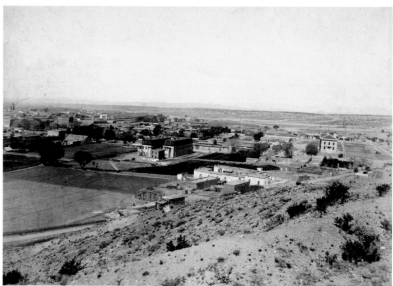

DANA B. CHASE

SANTA FE FROM OLD FORT MARCY, CA. 1888

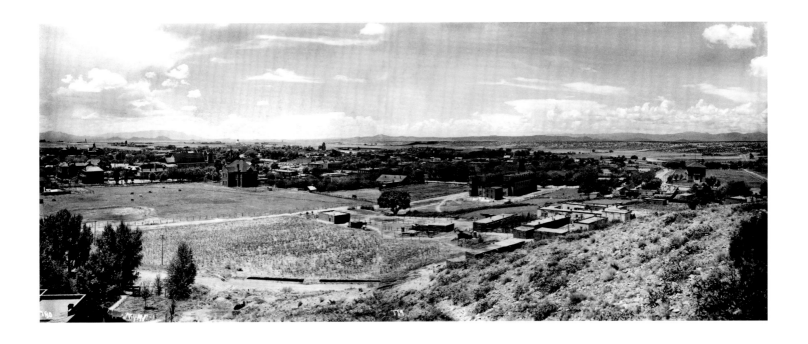

ADAM CLARK VROMAN
OVER SANTA FE FROM FORT MARCY, CA. 1900

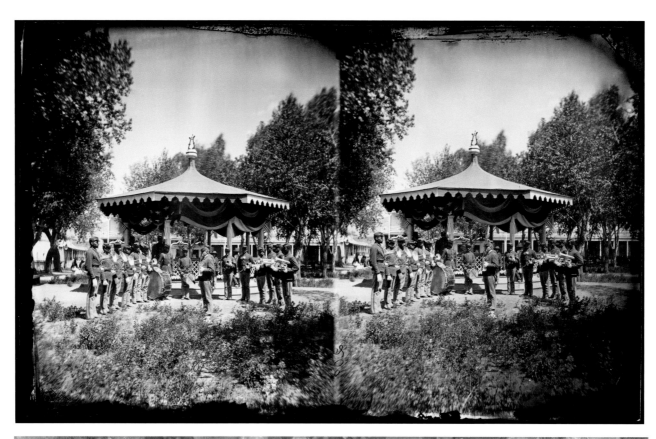

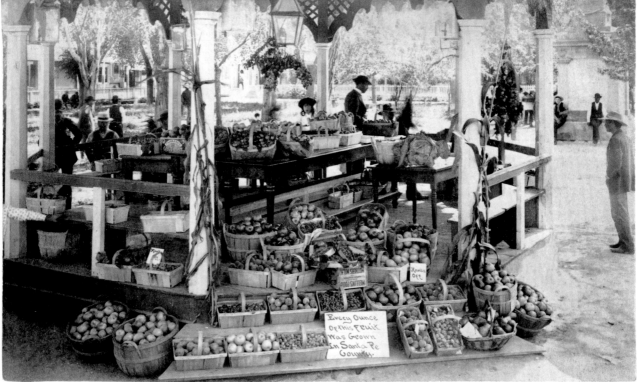

BEN WITTICK

NINTH CAVALRY BAND, SANTA FE PLAZA, JULY 1880

J. R. RIDDLE

BANDSTAND, PLAZA, SANTA FE, CA. 1888

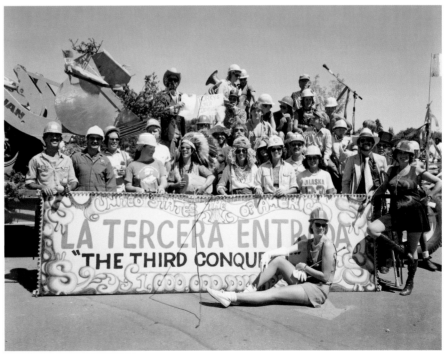

NORMAN MAUSKOPF

INDIAN MARKET, SANTA FE, NEW MEXICO, 1992

JAMES HART

LA TERCERA ENTRADA: "THE THIRD CONQUEST," CA. 1983

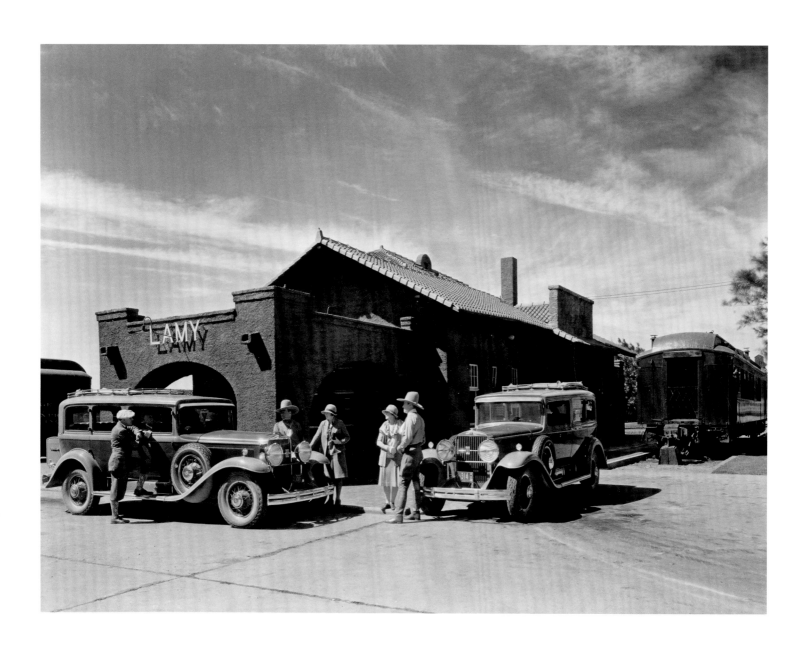

EDWARD A. KEMP

LAMY DEPOT AND HARVEY INDIAN DETOUR CARS

WAITING ARRIVAL OF TRAIN, CA. 1930

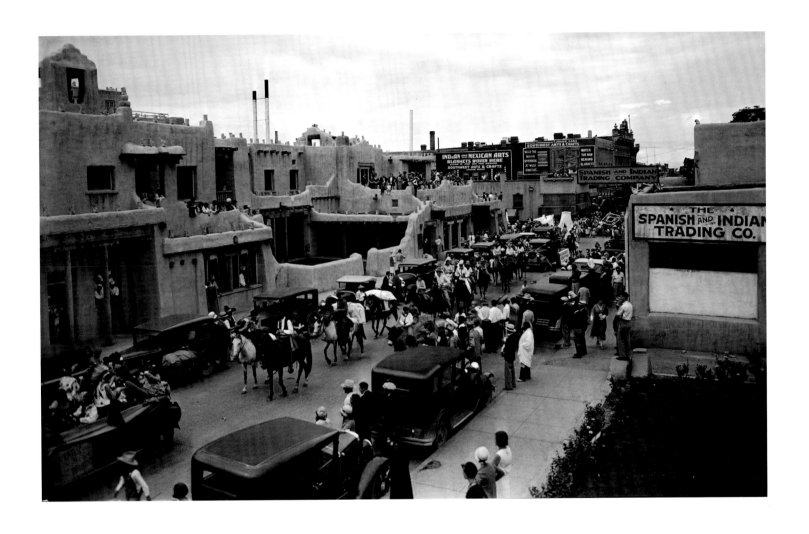

T. HARMON PARKHURST

FIESTA PARADE, EAST SAN FRANCISCO STREET,

CA. 1925

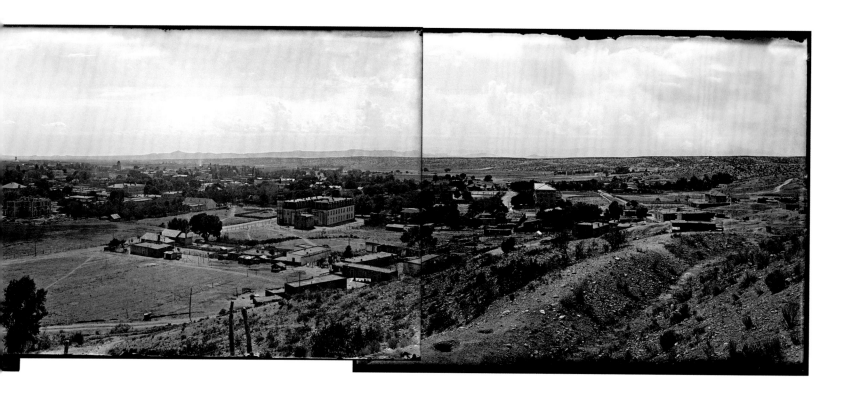

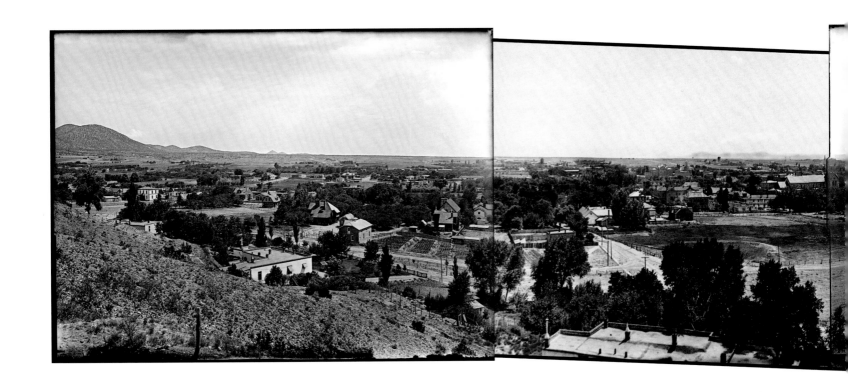

JESSE L. NUSBAUM

SANTA FE FROM FORT MARCY, CA. 1911

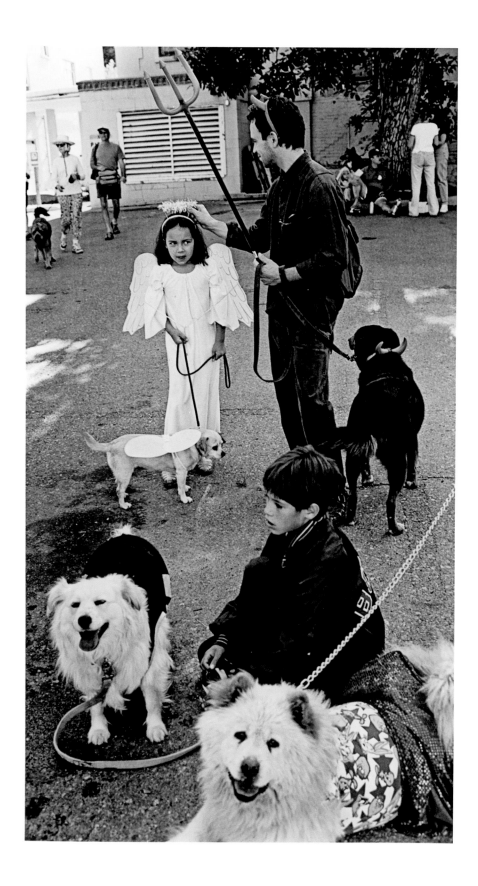

SAM ADAMS

PET PARADE, FIESTA, SANTA FE, 1999

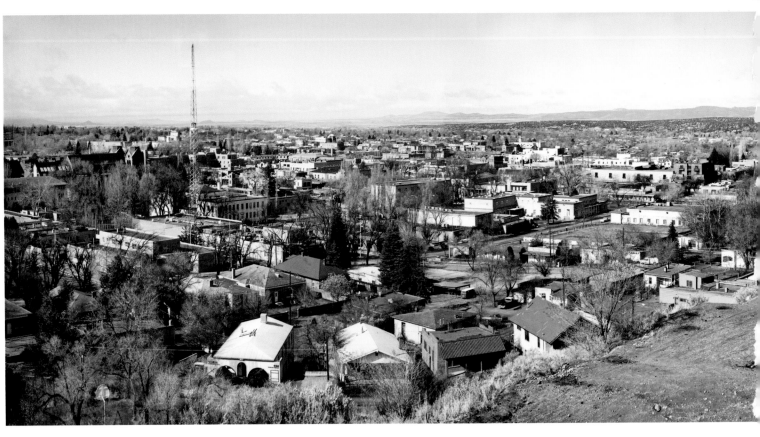

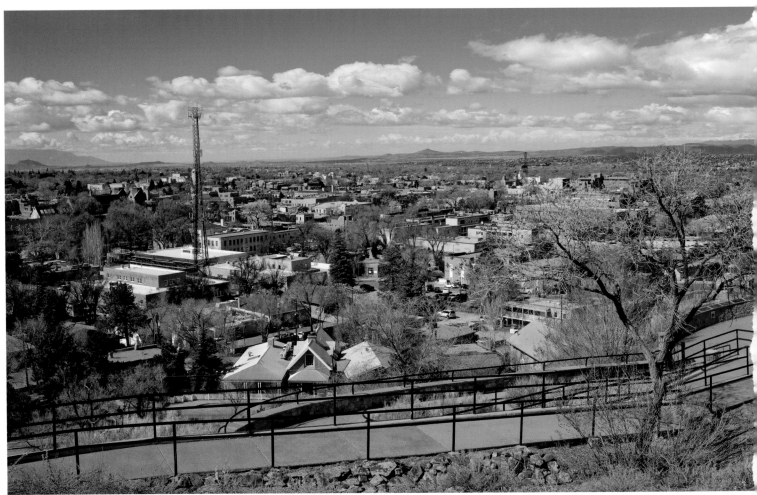

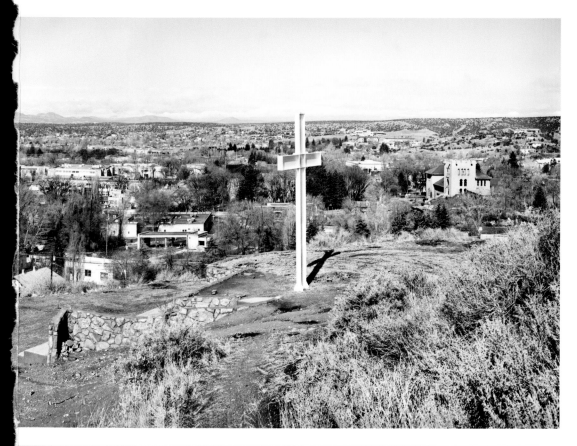

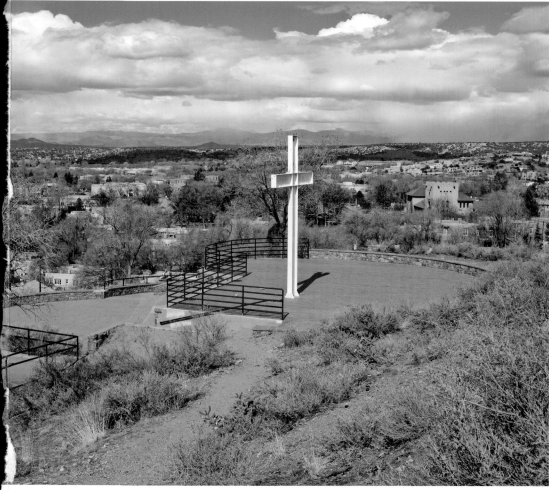

JOAN MYERS

SANTA FE PANORAMA, 1982

JOAN MYERS

SANTA FE PANORAMA, 2007

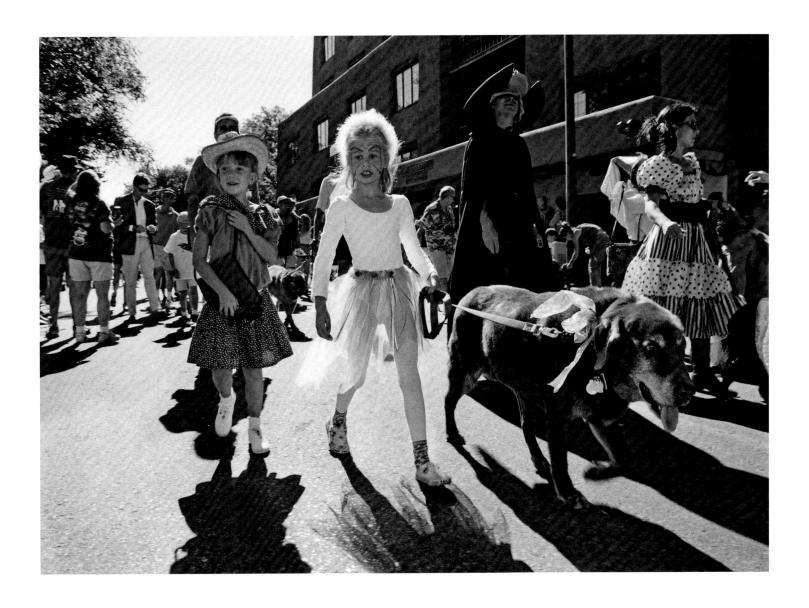

WENDY YOUNG

PET PARADE, 1998

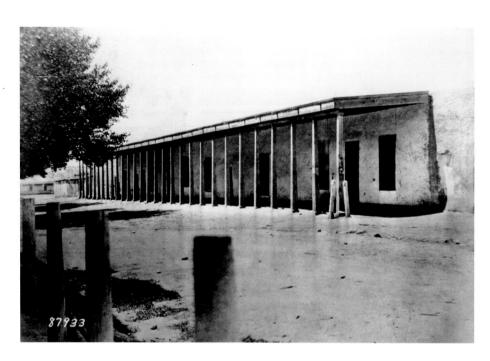

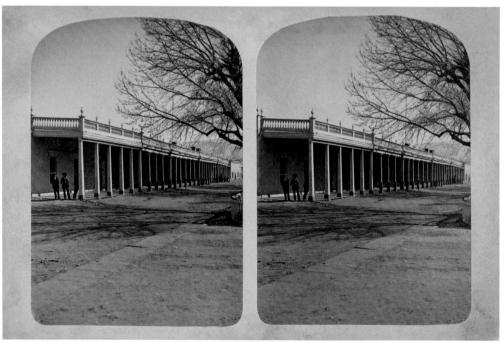

U. S. ARMY SIGNAL CORPS

PALACE OF THE GOVERNORS, CA. 1865–70

GEORGE C. BENNETT

THE PALACE OF THE GOVERNORS, CA. 1879

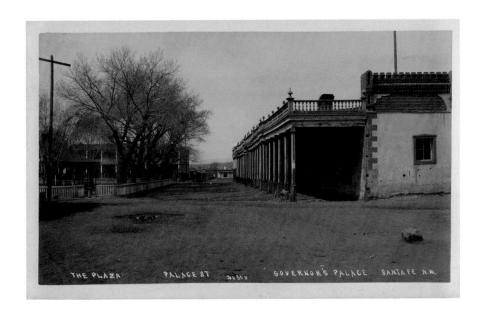

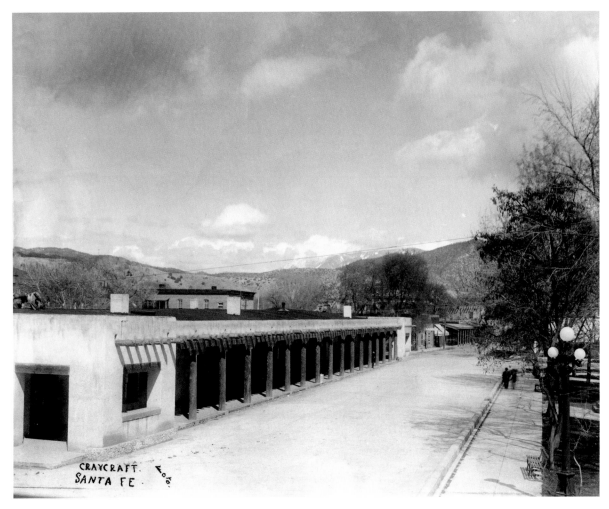

UNKNOWN PHOTOGRAPHER
THE PLAZA, PALACE ST., GOVERNOR'S PALACE,
SANTA FE, NEW MEXICO, CA. 1885

AARON B. CRAYCRAFT
PALACE OF THE GOVERNORS, CA. 1914

GREG MACGREGOR

PALACE OF THE GOVERNORS CONSTRUCTION SITE, 2007

Over the years, specific aspects of Santa Fe's transformation have been recorded by photographers involved with a number of restoration projects. Interestingly, when the Palace of the Governors was refurbished to promote the Santa Fe plan of 1912, which defined Santa Fe style as a regional blend of Pueblo and Hispanic architecture, some of the men most closely involved with its restoration were photographers. In 1909 Dr. Edger Lee Hewett, founder of the School of American Archaeology and the newly formed Museum of New Mexico, hired twenty-one-year old Jesse Nusbaum to oversee photography and the architectural reconstruction of the building, which was completed in 1913. To understand and promote the envisioned Santa Fe style, Nusbaum conducted an extensive photographic survey of Santa Fe, concentrating on the unimproved Spanish sections of the city and rephotographing many of the same scenes that Bennett and Brown had promoted in their 1880 stereograph catalog (Wilson 1997, 123). In keeping with his architectural observations, Nusbaum's many images of the Palace of the Governors following his renovation show thicker posts and huge Zapata capitals with a high parapet wall on top of the portal (Wilson 1997, 27). Nusbaum's successful restoration of the Palace of the Governors and museum exhibits helped sway public opinion toward adopting an architectural style based on a return to the Pueblo–Spanish heritage of Santa Fe (Lewis and Hagan 2007, 22).

So successful was Nusbaum's 1912–13 renovation, that in 1960 a commemorative stamp celebrating Santa Fe's 350th anniversary as the oldest capital city in North America showed the Palace of the Governors as seen in a 1959 image made by Tyler Dingee. Presumably that 1¼-cent stamp went around the world, drawing attention to Santa Fe and promoting its unique historic architecture.

As Nusbaum's photographs appeared in local and national magazines, world's fair publications, railroad publicity, and postcards, the image of Santa Fe created for tourists increasingly became its official image (Wilson 1997, 94). From its earliest years, *El Palacio,* the journal of the School for American Archaeology and the Museum of New Mexico, helped create and promote Santa Fe's identity as a location with a high desert landscape, dazzling light, diverse cultures, Native American and Hispanic arts and crafts, and a vibrant fine arts community. New Mexico had just attained statehood, Santa Fe was the capital, and the emphasis in national publicity was on northern New Mexico. The southern part of the state was largely considered "uncultured"—that is, too close to Mexico to be given serious attention at the time.

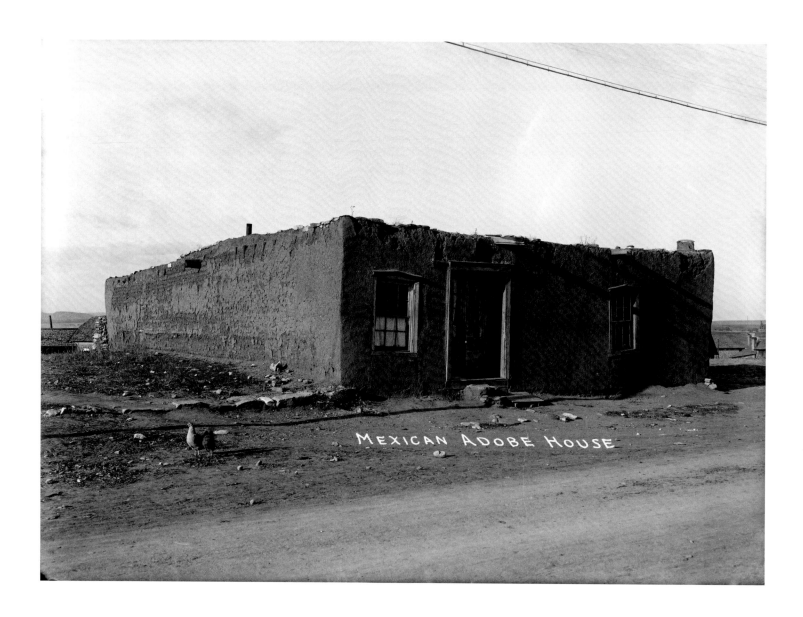

JESSE L. NUSBAUM

HOUSE BEHIND THE JAIL—ON OR NEAR
GUADALUPE STREET, 1912

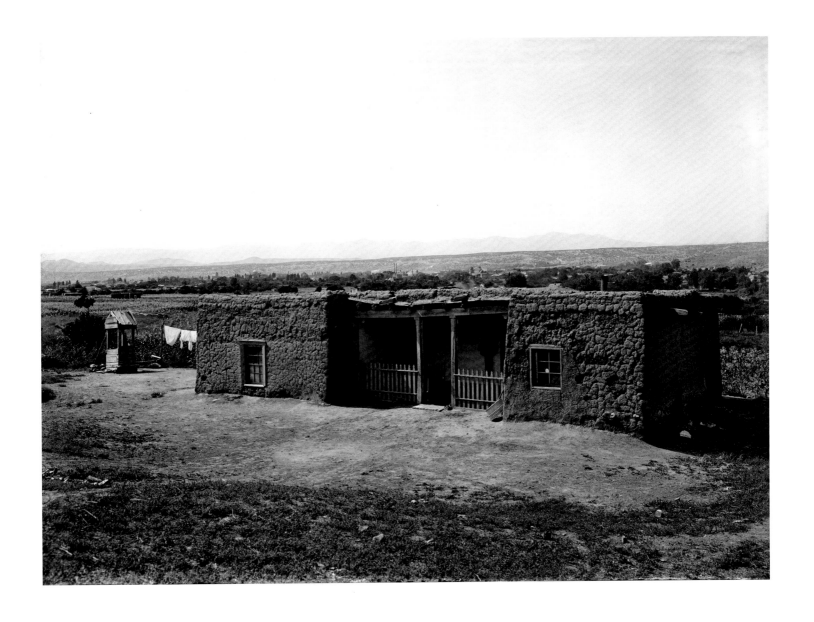

JESSE L. NUSBAUM

OLD HOUSE WITH PORTAL, MEXICAN SETTLEMENT
BELOW SUNMOUNT, NEW MEXICO, 1912

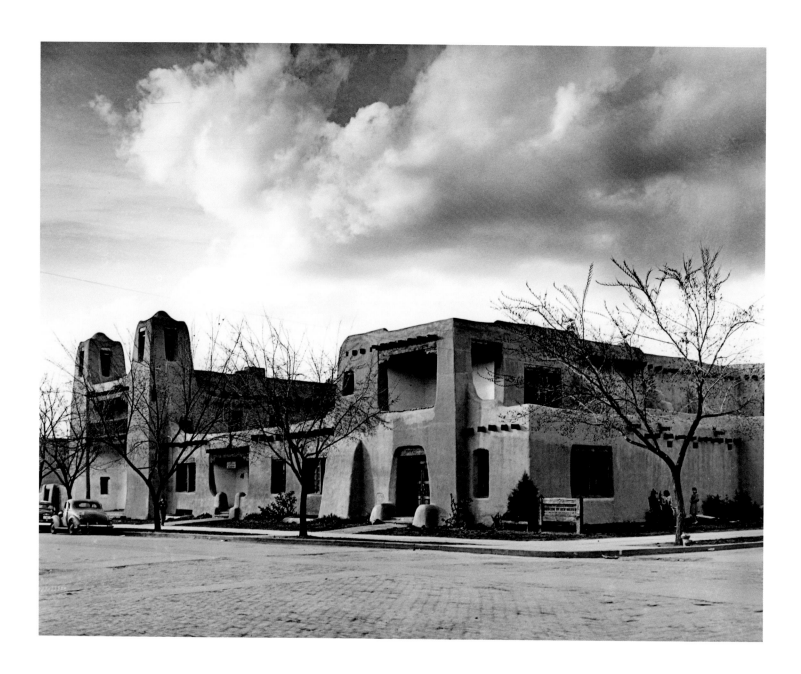

JOHN C. COLLIER JR.

SANTA FE, NEW MEXICO, 1943

Another artist/photographer who recorded and championed regional Spanish–Pueblo architectural style, thus influencing local renovation, was Carlos Vierra. Because of poor health, Vierra initially sought respite at the Sunmount Sanitarium, well known among national intelligentsia for providing an inspirational healing environment. An advocate for the preservation of traditional Pueblo and Hispanic architecture and crafts, Vierra was commissioned to photograph the mission churches and convents in the northern New Mexico pueblos and then to make paintings of them. Best known as a painter and architect, Vierra also was an accomplished photographer with a studio on the Plaza. He made the first aerial views of Santa Fe. He was also a writer who published articles on traditional cultures in *El Palacio.* Vierra's photographs and paintings of mission churches formed the basis of the design for Hewett's new art museum. Built across the street from the Palace of the Governors and the Plaza, the museum was modeled after a blend of six of New Mexico's early Franciscan missions: Acoma, San Felipe, Laguna, Cochiti, Santa Ana, and Pecos. Both the design of the new Museum of Fine Arts and renovation of the Palace of the Governors, however, represented a modern interpretation of the past rather than a return to a specific architectural style. The Pueblo and Spanish Revival architectural forms that became predominant in Santa Fe "smoothly integrated documentation and nostalgia with the revival of historic forms" (Traugott 2007, 10).

Perhaps T. Harmon Parkhurst best succeeded in documenting the passage of time in Santa Fe. Actively making pictures for more than forty years, Parkhurst created a body of work that reveals numerous aspects of Santa Fe's evolution. Like so many other artists who came to Santa Fe from the East Coast, Parkhurst was largely self-taught. He probably arrived in Santa Fe in 1910, several years before the territory achieved statehood, and he documented his adopted city until 1951. Parkhurst, assistant to Jesse Nusbaum at the Museum of New Mexico between 1910 and 1915, worked closely (although perhaps somewhat contentiously) with him, as evidenced by the strikingly similar images they made of Santa Fe. The majority of Parkhurst's negatives and photographs are housed in the Photo Archives at the Palace of the Governors, and his collection is one of the largest in the museum. Many of Parkhurst's early

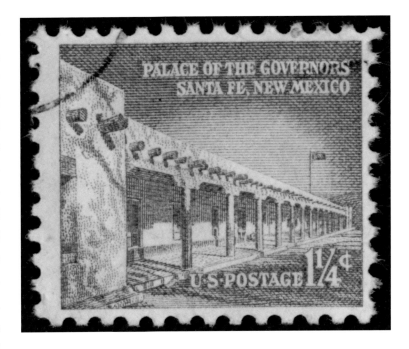

TYLER DINGEE
PALACE OF THE GOVERNORS COMMEMORATIVE STAMP, ISSUED JUNE 1960

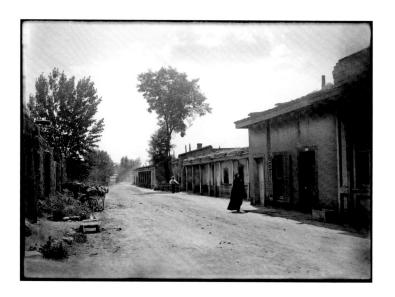

images were made on nitrate negatives; the Photo Archives is in the process of producing archival digital scans and freezing the negatives, both to retain their important visual information and to preserve them for future research. A wonderful series of three images that Parkhurst made on Ortiz Street about 1915 reflects his dedication and patience in creating images. Using a 5 x 7 view camera and glass-plate negatives, he recorded the slow passage of time along the dusty street, revealing the ebb and flow of life in the city. Pack burros graze lazily on the shrubbery poking out between the adobe structures that rise out of the brown dirt street. A hooded woman in a long black veil glides silently past abode houses as a horse-drawn wagon trots from house to house, perhaps transporting wares for sale. From the sequence, it appears that the woman in black was a model, but the horse-drawn wagon coming and going on the street would have been more difficult to stage. In this series of images, Parkhurst succeeded in showing Santa Fe at a crucial juncture of transition from territory to state.

Parkhurst probably knew and certainly admired Laura Gilpin, who began photographing in Santa Fe in 1923. Their mutual influence on each other's work is evident when reviewing their images. In addition to documenting scenes of Santa Fe's transformation, Parkhurst, along with Gilpin, Ansel Adams, Ernest Knee, and Tyler Dingee, was hired by Santa Fe architect John Gaw Meem to photograph his buildings, thus contributing to the dissemination of the Santa Fe style of architecture that Meem promoted. In 1920, attracted by railroad photographs advertising the desert landscape and adobe architecture, Meem, like Vierra, first came to Santa Fe seeking a cure for tuberculosis. Meem's early

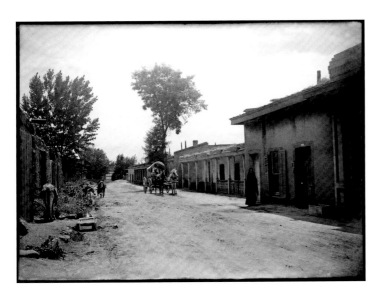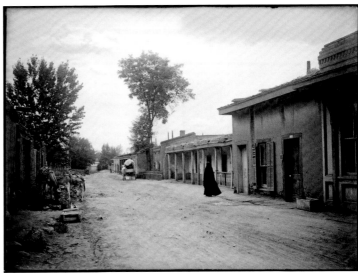

work was clearly influenced by Vierra's aesthetic. The two men were friends, but Meem went on to evolve his own style, adding a more modernist aesthetic to the traditional Santa Fe Pueblo Revival style (Wilson 1997, 274).

T. HARMON PARKHURST
ORTIZ STREET, CA. 1915

Several albums in the Photo Archives document Meem's ongoing influence on Santa Fe's architecture. The La Fonda Hotel, although originally designed by the same architectural firm that built the Museum of Fine Arts, was renovated by Meem and is one of his signature buildings. A beautiful leather-bound photo album documents the Meem renovation, with interior and exterior views of the hotel by many photographers. Although Ansel Adams is certainly not well known for commercial work documenting the buildings of Santa Fe, his images of the Hollenback and M. V. Conkey residences show the emergence of his later monumental style. More recent images of the Hollenback home taken by Kirk Gittings clearly reveal how it retains Meem's innovative architectural style to this day.

In addition to documenting the architectural work of Meem, Adams was sometimes able to capture the more intimate details of 1940s life in Santa Fe. Often a chair becomes a substitute portrait for the person who sits there. An image Adams made of the Conkey residence, ostensibly to show the architectural detail of the Meem doorway, also lovingly caught a small wooden chair under a mirrored shrine with candles, perhaps a place to drop a hat or schoolbooks, or to place a handbag before carefully applying lipstick in the mirror. In 1961 Eliot Porter made a similar image, *Chair and Window, Tesuque, New Mexico,* of his home, which had been built by Ernest Knee. Likewise, Janet Russek,

Eliot Porter's longtime assistant and the executor of his estate, made *Eliot Porter's Chair with Light and Bird's Nest, Tesuque, New Mexico,* in 1987. In all three images, constructed with modernist formality, the sturdy, unadorned chairs reveal something about their owners. In the photographs, the intimate surroundings of classic adobe walls with simple accessories—the Mexican tin-work mirror, the ornate Spanish-style light sconce, the simple Territorial wooden window frame that becomes a Cornell box—infuse the images with meaning. These images, and the 1983 portrait that David Scheinbaum made of Eliot Porter sitting on a worn wooden bench against an adobe wall in his home, provide a glimpse into the private Santa Fe. They reveal the close connections between the photographers who live in and visit Santa Fe, drawn both by the magical light and the sense of community they find. They also contribute to the romantic view of the charms of living in Santa Fe. When published and exhibited, such photographs become part of the photographic history of Santa Fe—part art-world commodity, part visual legacy.

Santa Fe's current photographic community is integrated into the larger Santa Fe community, as were the early Santa Fe art circles, and its involvement with social issues is equally committed. Today, photographers are grappling with issues of urban sprawl, water contamination and shortages, the threat of increased oil drilling in the Galisteo Basin, and overcommercialization. Howard Korder's *New Subdivision, Santa Fe, New Mexico* (2007) raises the issue of whether Santa Fe style will continue to run amok in the subdivisions and planned communities springing up like wildfire throughout the region. Alan Pearlman's *Land for Sale, Santa Fe* (2004) hints at an answer. If the proposed 12,800-acre Galisteo Basin Preserve evolves as anticipated, William Clift's exquisite photograph of the pristine Galisteo Basin, *La Mesita from Cerro Seguro, New Mexico* (1978), may be one of the last views of this landscape without development. Further threatening the basin are proposals to drill through private and public property on environmentally sensitive land to reach the oil and natural gas resources below. Will it be possible to undo the damage the state land office and the Bureau of Land Management have done through deliberate governmental insensitivity and Bush-era greed for oil at any cost?

Perhaps the biggest issue determining the future of Santa Fe is water contamination and shortage. Increased drilling threatens to contaminate the water, while the growing population threatens the availability of what little water remains after years of drought. Images of the Santa Fe River drastically illustrate the changes in availability of water over the years. Early photographs indicate

KIRK GITTINGS
THE HOLLENBACK HOUSE BY JOHN GAW MEEM,
SANTA FE, NEW MEXICO, 1989

ANSEL ADAMS

M. V. CONKEY RESIDENCE,
SANTA FE, NEW MEXICO, 1929

ANSEL ADAMS
M. V. CONKEY RESIDENCE,
SANTA FE, NEW MEXICO, 1929

ELIOT PORTER

CHAIR AND WINDOW, TESUQUE, NEW MEXICO, 1961

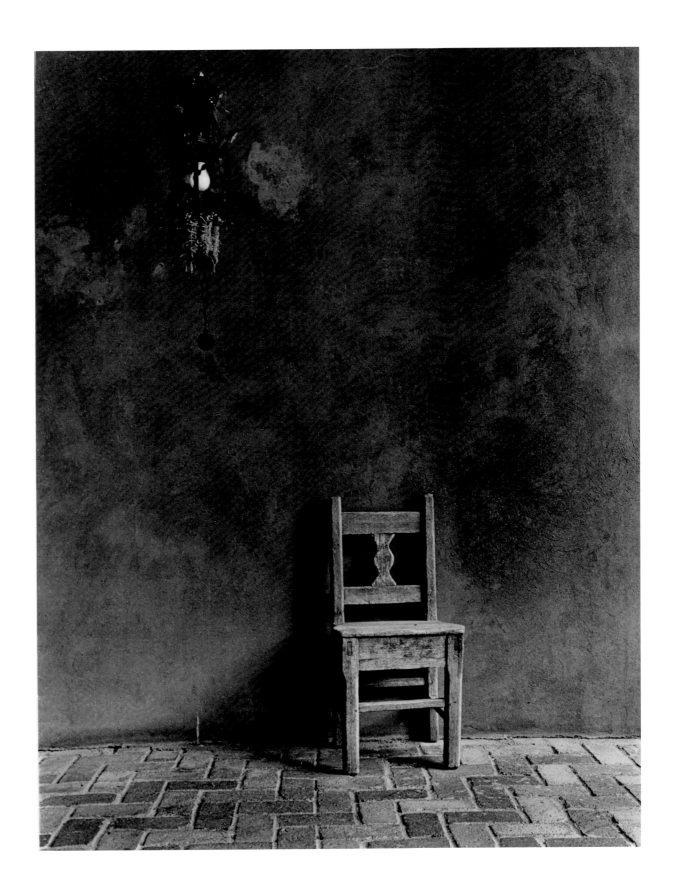

JANET RUSSEK
ELIOT PORTER'S CHAIR WITH LIGHT AND
BIRD'S NEST, TESUQUE, NEW MEXICO, 1987

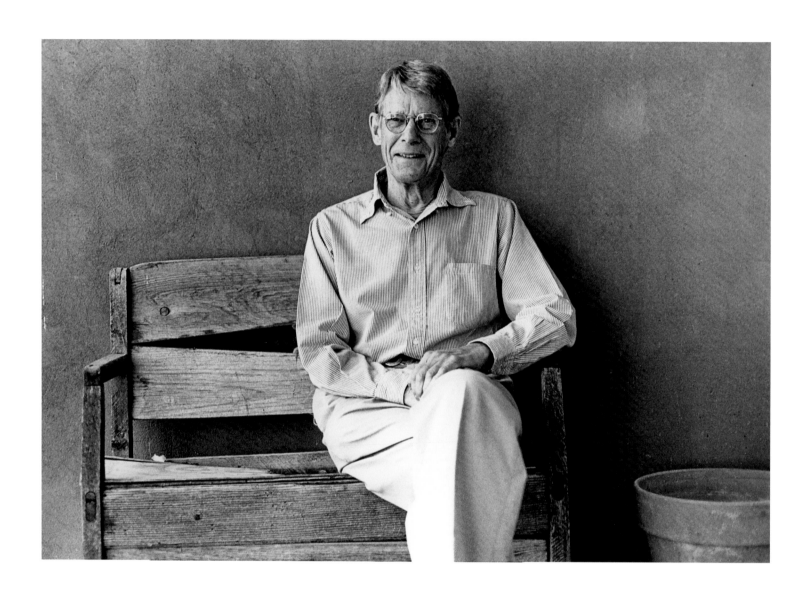

DAVID SCHEINBAUM
ELIOT PORTER, TESUQUE, NEW MEXICO, 1983

that the river once ran sweet and wet year-round. By contrast, in 2007 American Rivers, a Washington, D.C.–based river advocacy group, declared the Santa Fe River to be the most endangered river in America, putting it first on the "10 Most Endangered Rivers" list. While the Santa Fe Watershed Association is working hard to restore the river, it remains an uphill battle. Edward Ranney's 1974 image *Water Storage Tank, Looking North to the Sangre de Cristo Mountains, Chaquaco, New Mexico,* with its yawning steel water tank, expresses more clearly than words what it takes to sustain life in the Santa Fe area.

Yet this semiarid landscape with its spectacular vistas has always been an important photographic subject. Laura Gilpin's *Storm over La Bajada Hill, New Mexico,* 1946, combines pictorialist vision with the sweeping landscape of the Southwest. In photographing the land and sky as a late-afternoon monsoon thunderstorm rolled across the desert, Gilpin captured both the grandeur and the fury of the monsoons that can cause torrential flash floods without warning. She has pictured the spirits that the Indians call the male rains. It is perhaps a stretch to include Paul Strand's *Badlands, Near Santa Fe, New Mexico,* 1930, since it was taken miles outside the boundaries set for this study. But Strand's own title for this photograph indicates that the landscape in it resonated with him more as Santa Fe than as Española, the town closer to where it was taken. Like Gilpin's *Storm over La Bajada Hill, New Mexico,* Strand's small platinum print captures a moment when the spirits of both the earth and sky are in harmony, as evidenced in the formal qualities of the undulating hills stretching up lazily to meet the storm clouds floating heavily down to kiss the land.

In showing us what Santa Fe has looked like at different moments over the past 160 years, the images in this exhibition and publication provide a way to measure the circular rather than linear nature of time here in the City Different. They remind us that the architectural struggles taking place today are really not so different from those of fifty years ago, when the Historic Styles Ordinance of 1957 (updated in 1983 and in the news again in 2007) was enacted after heated debate. The photographs also allow us to measure change and assess the visual impact of our own mark on the places we live. Photography and Santa Fe tourism are inextricably linked, perhaps now more so than in the past, as the photography industry actively draws people to Santa Fe for workshops of all kinds. Further, there are more excellent photography galleries in Santa Fe than in any other city of its size — several world renowned for their commitment to photographic excellence and longtime support of the photographic community. Moreover, three colleges — the College of Santa Fe, the

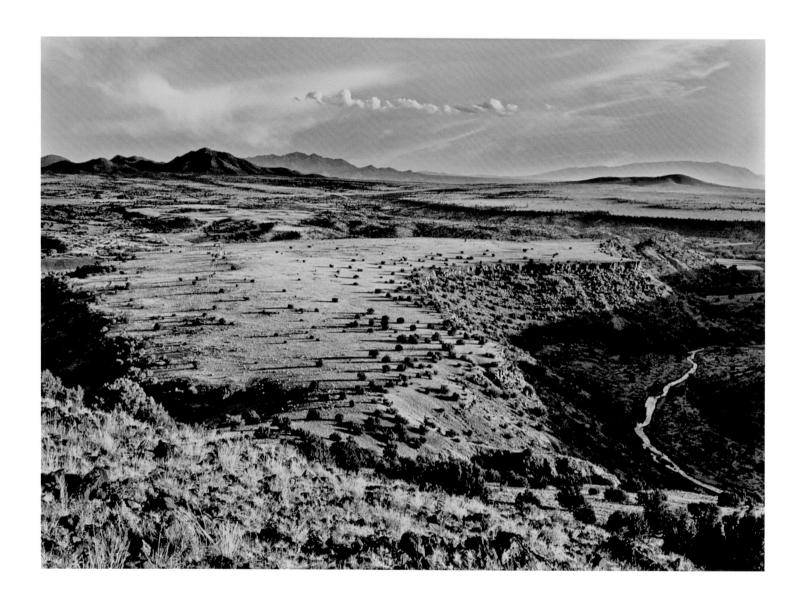

WILLIAM CLIFT
LA MESITA FROM CERRO SEGURO, NEW MEXICO, 1978

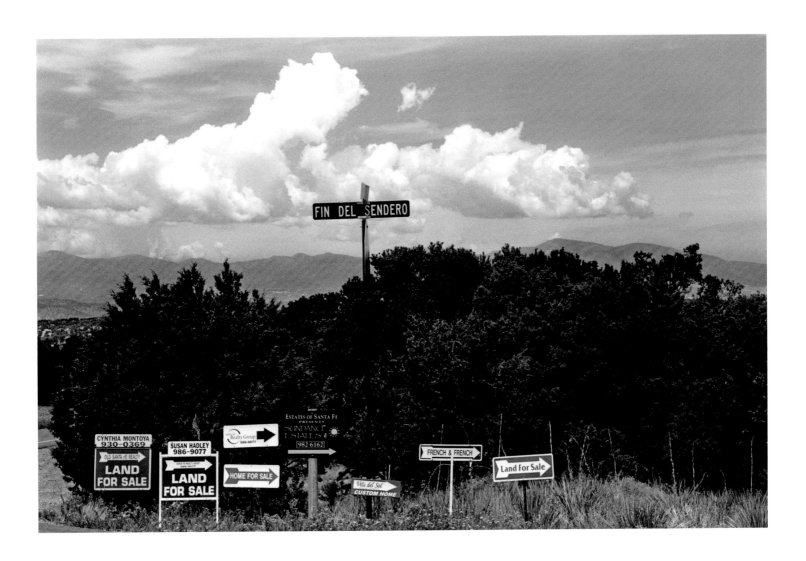

ALAN PEARLMAN
LAND FOR SALE, SANTA FE, 2004

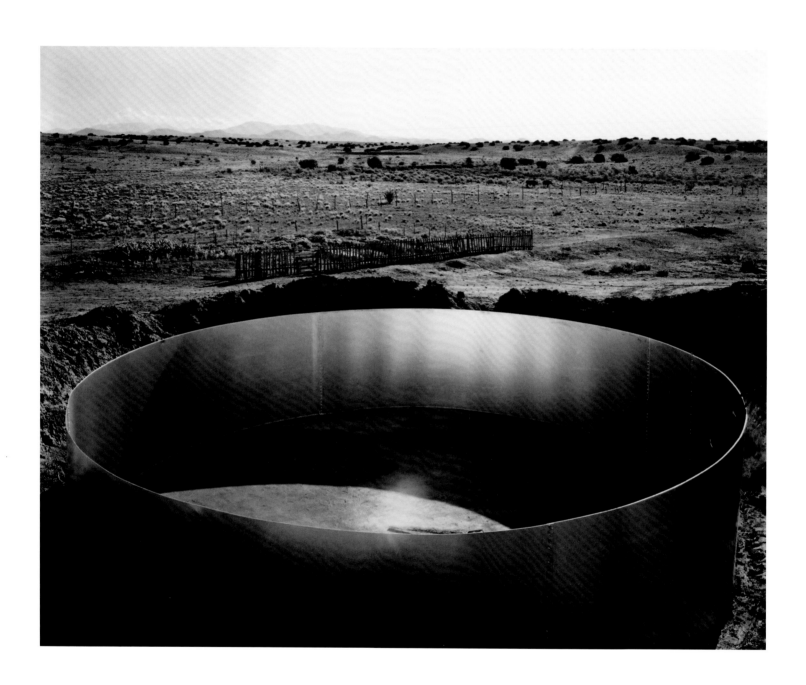

EDWARD RANNEY

WATER STORAGE TANK, LOOKING NORTHEAST
TO THE SANGRE DE CRISTO MOUNTAINS,
CHAQUACO, NEW MEXICO, 1974

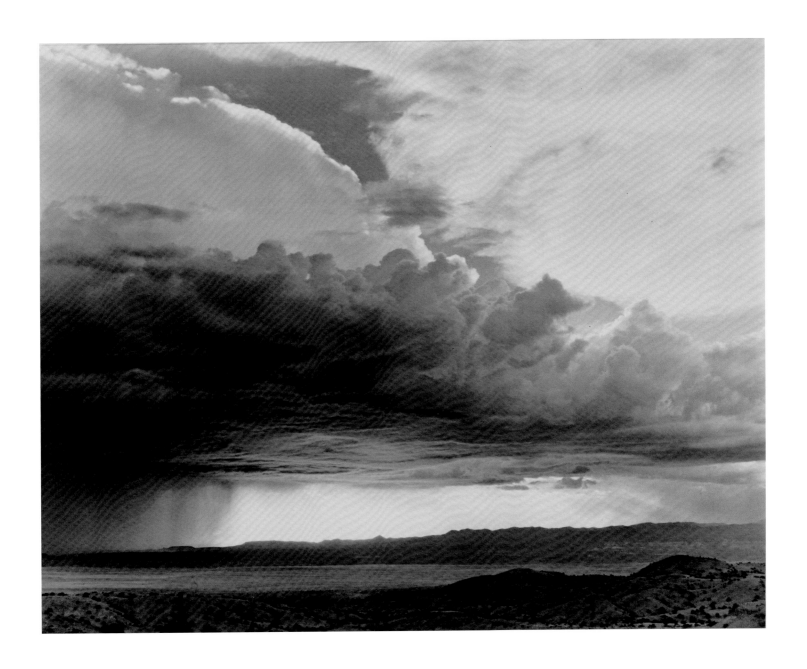

LAURA GILPIN
STORM OVER LA BAJADA HILL,
NEW MEXICO, 1946

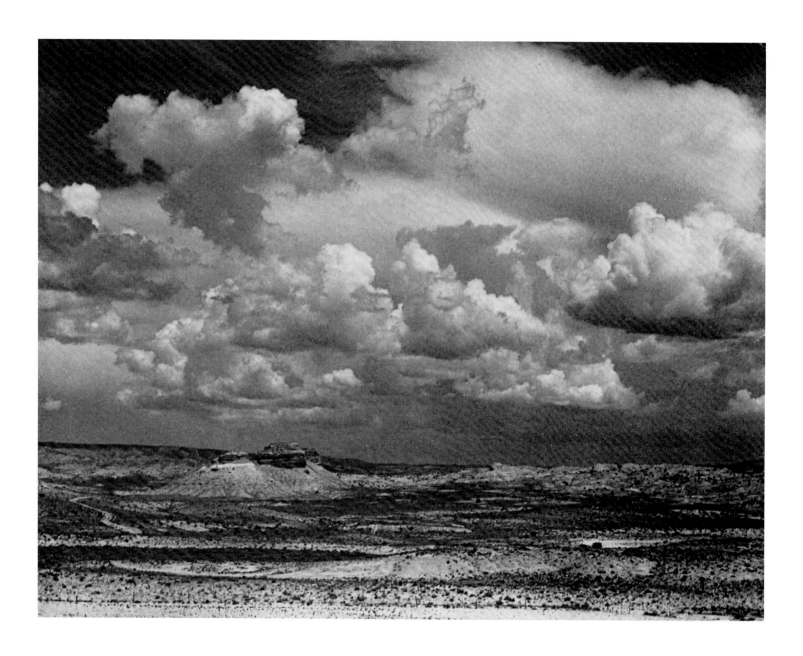

PAUL STRAND

BADLANDS, NEAR SANTA FE, NEW MEXICO, 1930

Santa Fe Community College, and the Institute of American Indian Arts—offer photographic instruction. Each of these institutions, and the people involved, whether simply passing through or having settled in to call Santa Fe home, share responsibility for how the city's image continues to be projected to the larger world. Being a part of any place, no matter for how long, makes us all, in some measure, responsible to it. Santa Fe and the surrounding regions will continue to be photographed no matter what their future. The city's future, however, is in our hands.

EDWARD RANNEY
SAN CRISTOBAL PUEBLO, GALISTEO BASIN, 2007

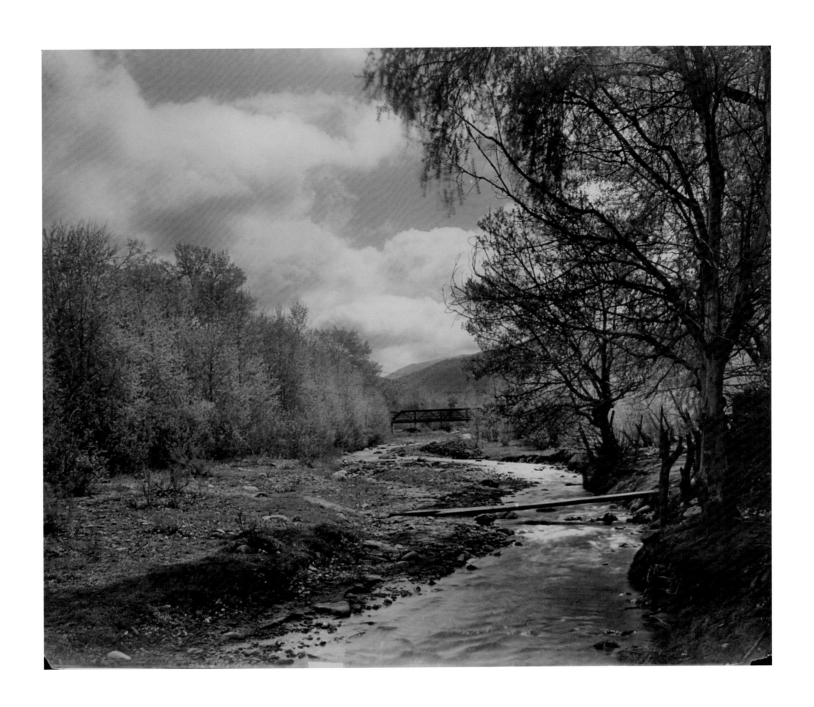

T. HARMON PARKHURST
*SANTA FE RIVER, CANYON ROAD—CASTILLO
STREET BRIDGE,* CA. 1912

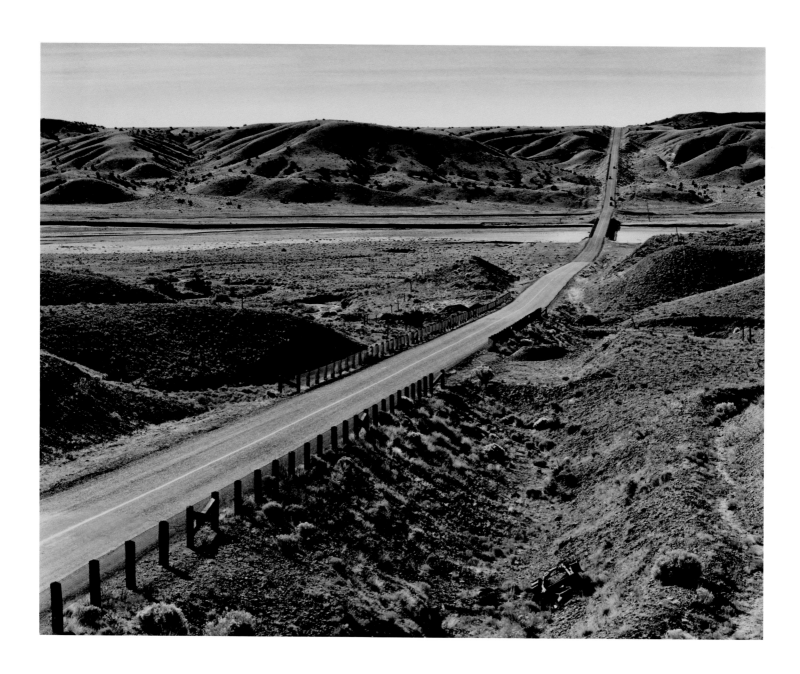

EDWARD WESTON

SANTA FE–ALBUQUERQUE HIGHWAY, 1937

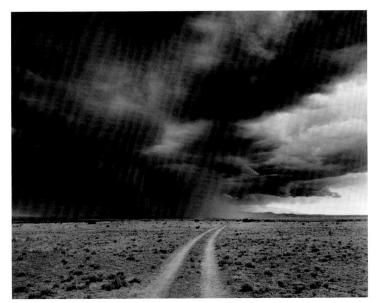
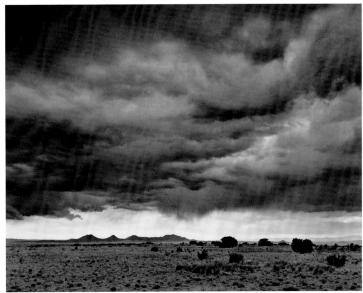

ALAN ROSS

ROAD & PLAINS/CERRILLOS HILLS,
THUNDERSTORM, SANTA FE, 1995

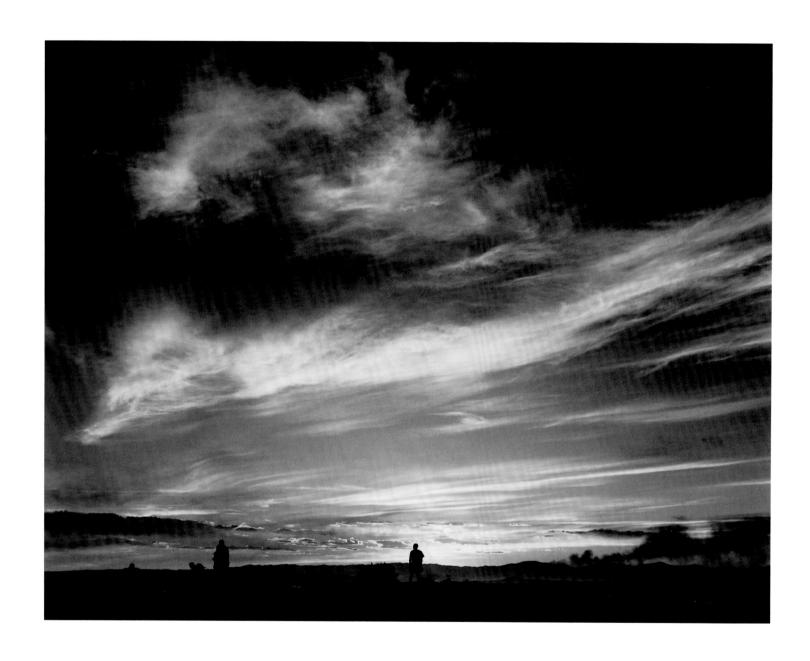

JOHN VAVRUSKA

VIEWING THE LAKES FIRE FROM THE CROSS OF
THE MARTYRS, AUGUST 27, 2002

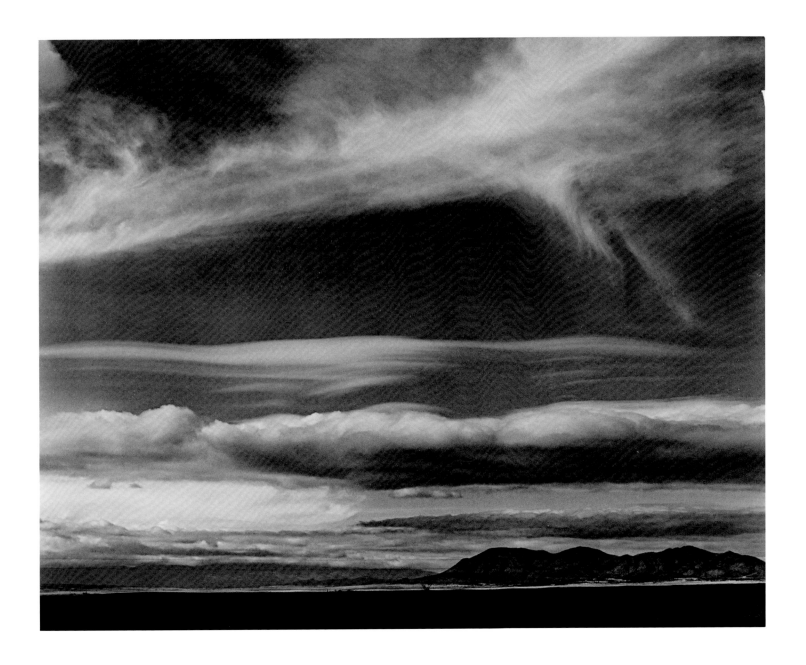

EDWARD WESTON

MORIARTY TO LAMY ROAD, 1937

ANDRE RUESCH
BIG WATER AT 760 FEET, MARCH 2002

CARLAN TAPP
BLACK FERRILL #1, GALISTEO BASIN, 2007

ROLF KOPPEL

VERKLÄRTE NACHT (ACEQUIA & MONTE SOL), 1976

ROLF KOPPEL

VERKLÄRTE NACHT (OFF CANYON ROAD), 1975

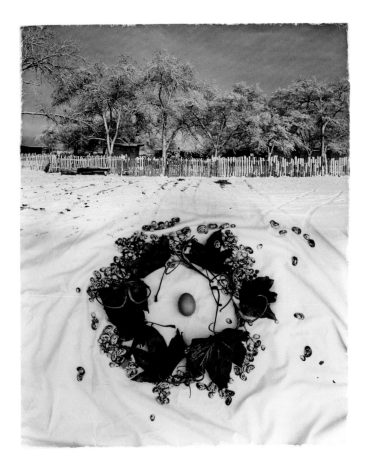

ERIC RENNER
DECEMBER 27, 1979, 11 A.M.

MERIDEL RUBENSTEIN
CELEBRATION NEST, 1978

NANCY SPENCER

DAVE'S NOT HERE, 1995

ROXANNE MALONE

POWER GARDEN GRID, 2000

NANCY SUTOR
COMANCHE GAP 1, 1983

ELIOT PORTER

FROZEN APPLES, TESUQUE, NEW MEXICO, 1966

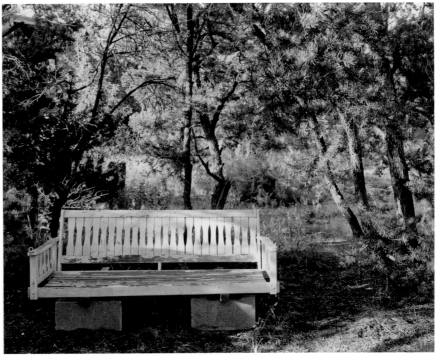

BEAUMONT NEWHALL
FROM THE SERIES THIS IS THE GARDEN, 1985

JANET RUSSEK
BEAUMONT AND CHRISTI NEWHALL'S BENCH,
SANTA FE, 1985

KATE JOYCE, AND **JULIE DEAN**
UNTITLED FROM *SANTA FE NEIGHBORHOODS*, 1996–2007

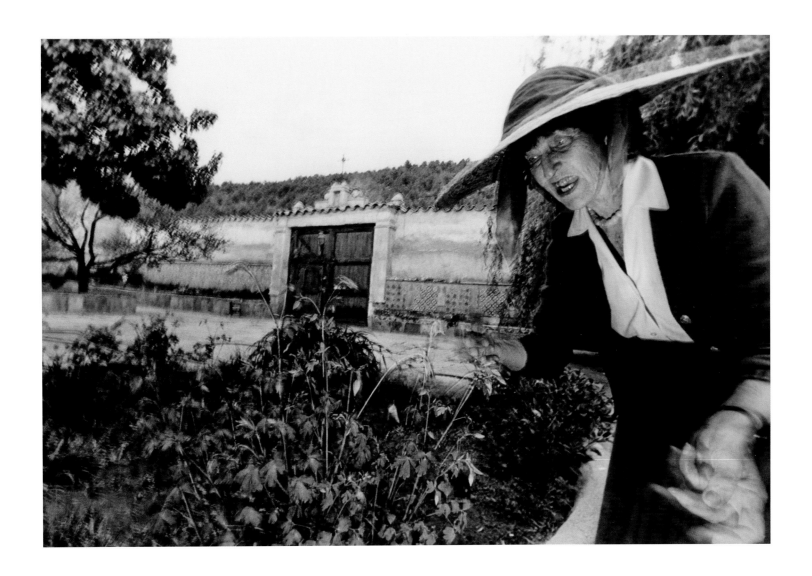

ANNE NOGGLE
SANTA FE SUMMER #1, 1976

GAY BLOCK

LAURA GILPIN'S HOUSE, 1974

LYNN LOWN

LAURA GILPIN, 1976

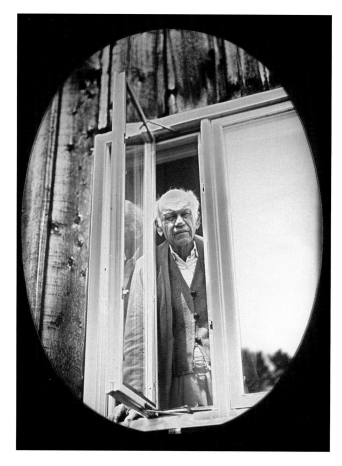

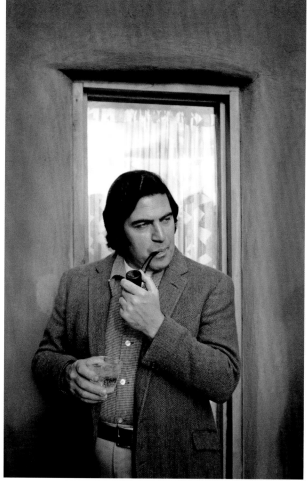

ROBERT SHLAER
BEAUMONT NEWHALL AT HOME, SANTA FE,
NEW MEXICO, 1988

BILL JAY
PAUL CAPONIGRO, CA. 1974

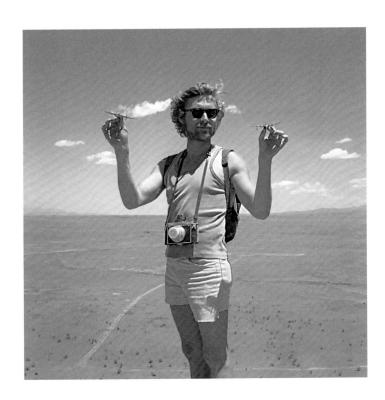

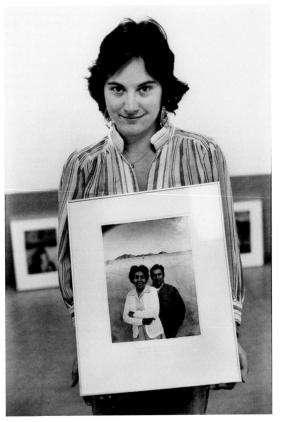

LYNN LOWN
GREG MACGREGOR, 1975

JAMES NACHTWEY
MERIDEL RUBENSTEIN, N.D.

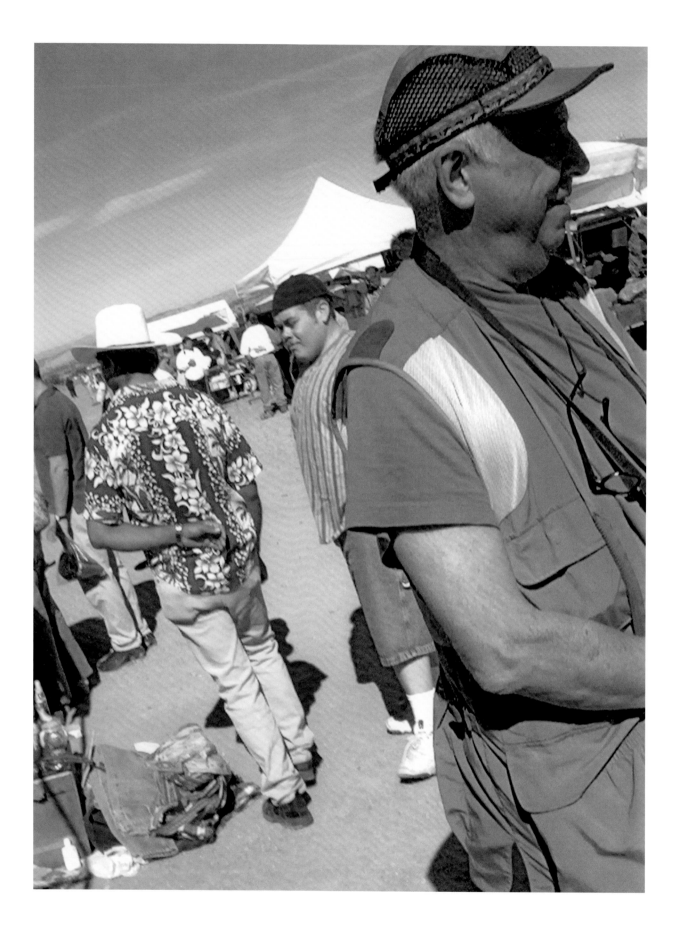

JAMES L. ENYEART
LEE FRIEDLANDER, 2003

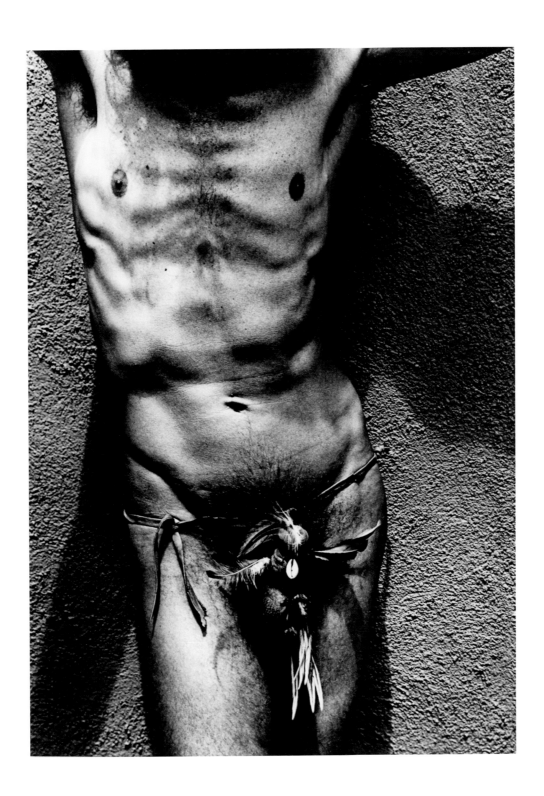

WALTER CHAPPELL
FEATHER TORSO CEREMONIAL, SANTA FE, 1966

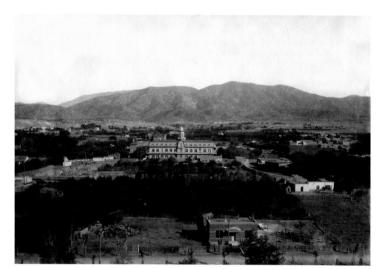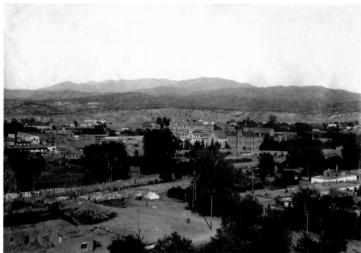

CHRISTIAN G. KAADT

VIEW OF SANTA FE FROM THE CAPITOL,
EAST/NORTHEAST, CA. 1895

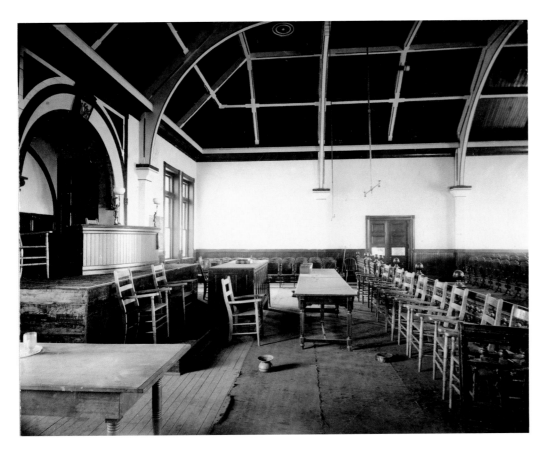

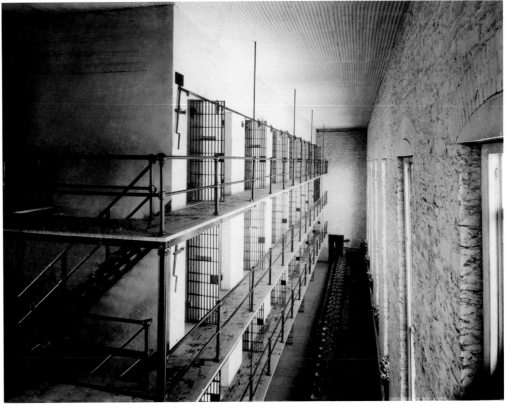

THOMAS J. CURRAN
SANTA FE COUNTY COURT HOUSE, COURT ROOM, 1893

THOMAS J. CURRAN
CELL HOUSE, PENITENTIARY, 1893

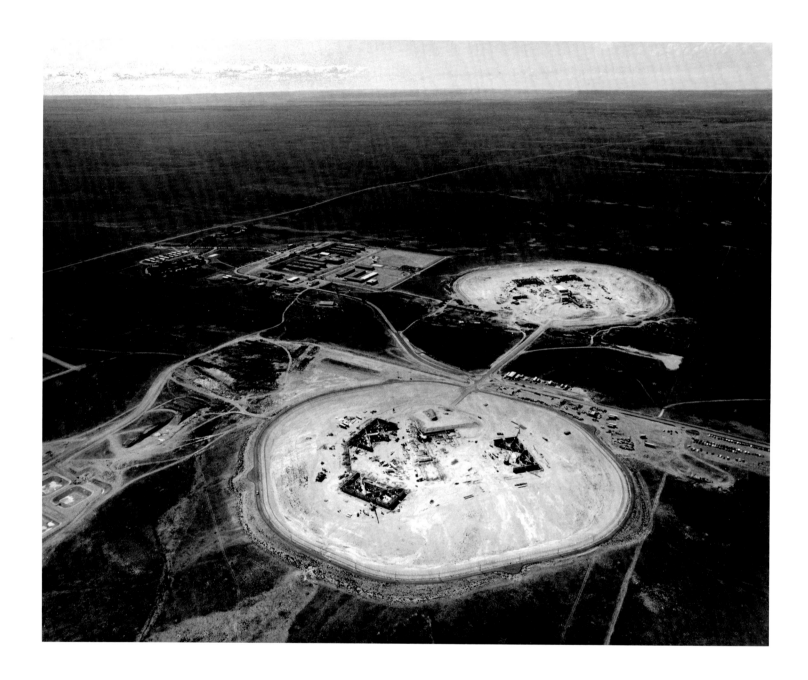

PAUL LOGSDON

NEW MEXICO STATE PENITENTIARY, LOOKING
SOUTHEAST, CA. 1984

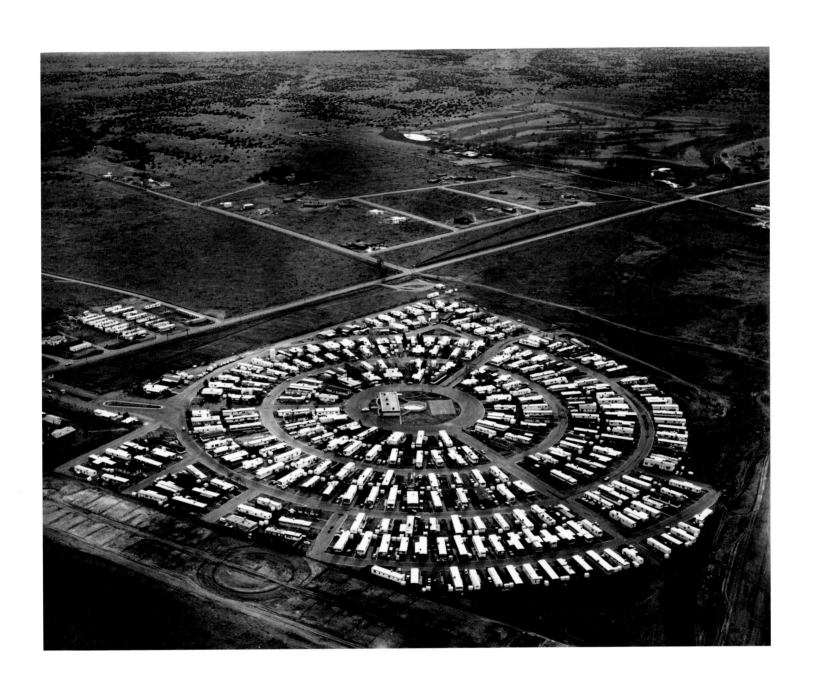

PAUL LOGSDON

COUNTRY CLUB GARDENS MOBILE HOME PARK
ON AIRPORT ROAD, LOOKING SOUTHWEST,
SANTA FE, NEW MEXICO, 1984

GREG MACGREGOR
SWEENEY CENTER CONSTRUCTION SITE, LOOKING EAST, 2007

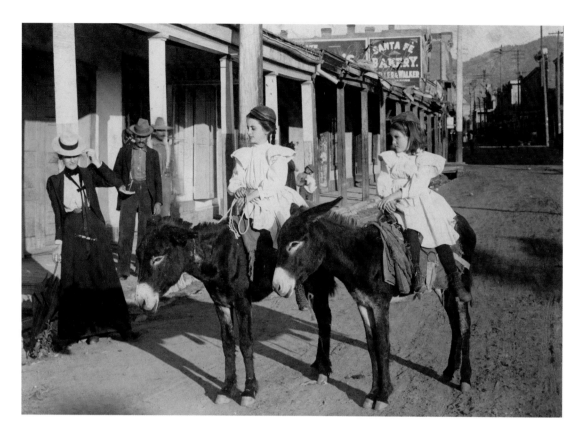

CHRISTIAN G. KAADT

LOWER SAN FRANCISCO STREET, SANTA FE, NEW MEXICO, CA. 1900

JESSE L. NUSBAUM

SOUTHWEST CORNER OF THE PLAZA, CA. 1910

T. HARMON PARKHURST

STAAB AND GALISTEO BUILDINGS, WEST SAN FRANCISCO
STREET AT GALISTEO STREET, CA. 1933–34

LEWIS BALTZ

SANTA FE, 1972

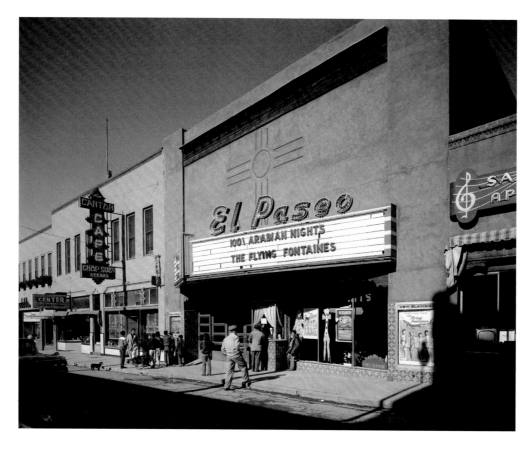

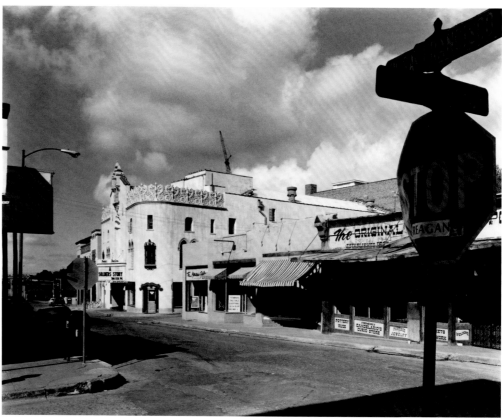

TYLER DINGEE

EL PASEO THEATRE, WEST SAN FRANCISCO STREET, 1959

RICHARD WILDER

WEST SAN FRANCISCO STREET FROM THE CORNER OF GALISTEO STREET, OCTOBER 1984

KENT BOWSER

YUCCA DRIVE-IN, SANTA FE, NEW MEXICO, FALL 1994

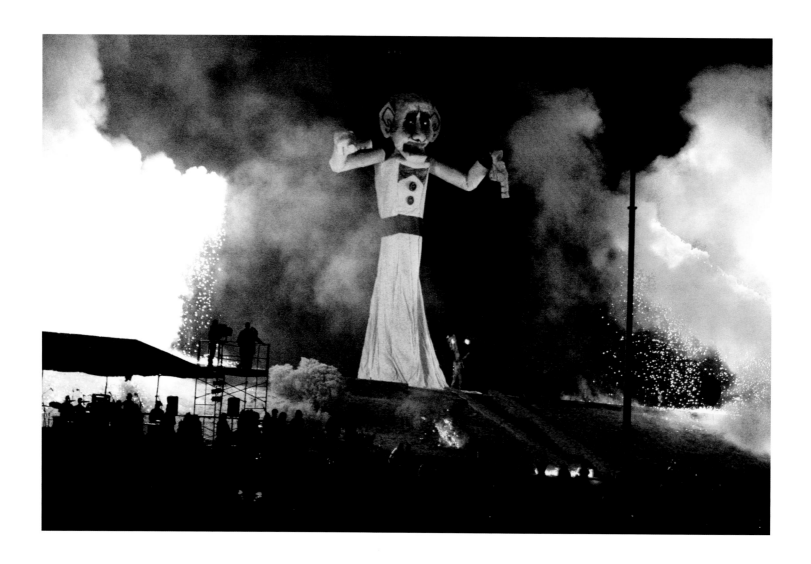

LISA LAW

ZOZOBRA, SANTA FE, NEW MEXICO,
SEPTEMBER 9, 2004

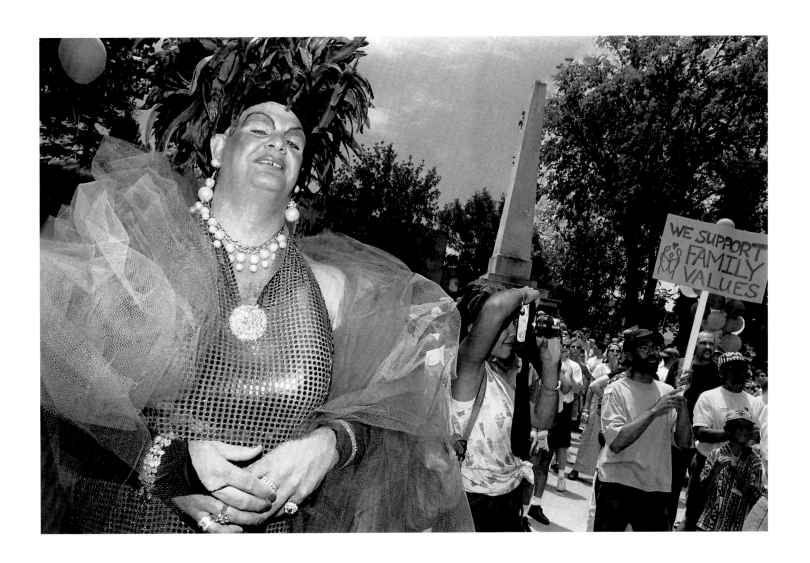

POLLY BROWN

GAY PRIDE ON THE PLAZA, 1996

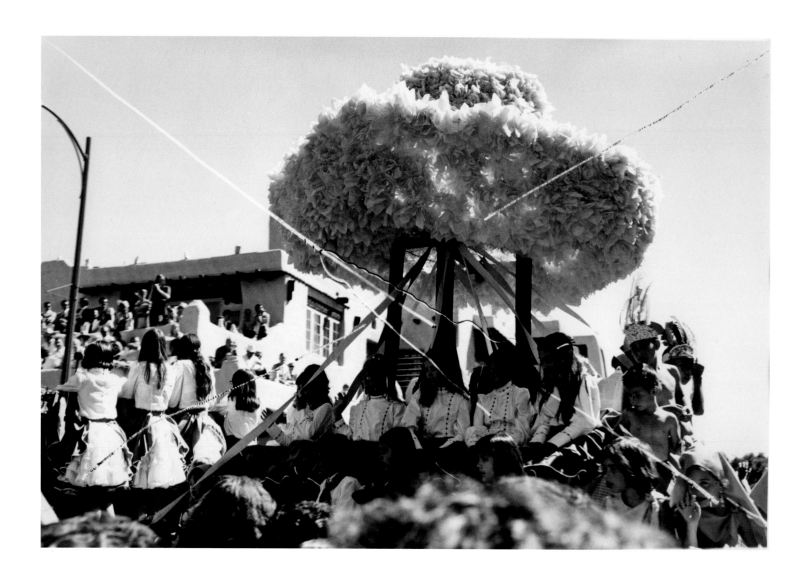

THOMAS BARROW
CANCELLATIONS (BROWN) FESTIVAL, 1973

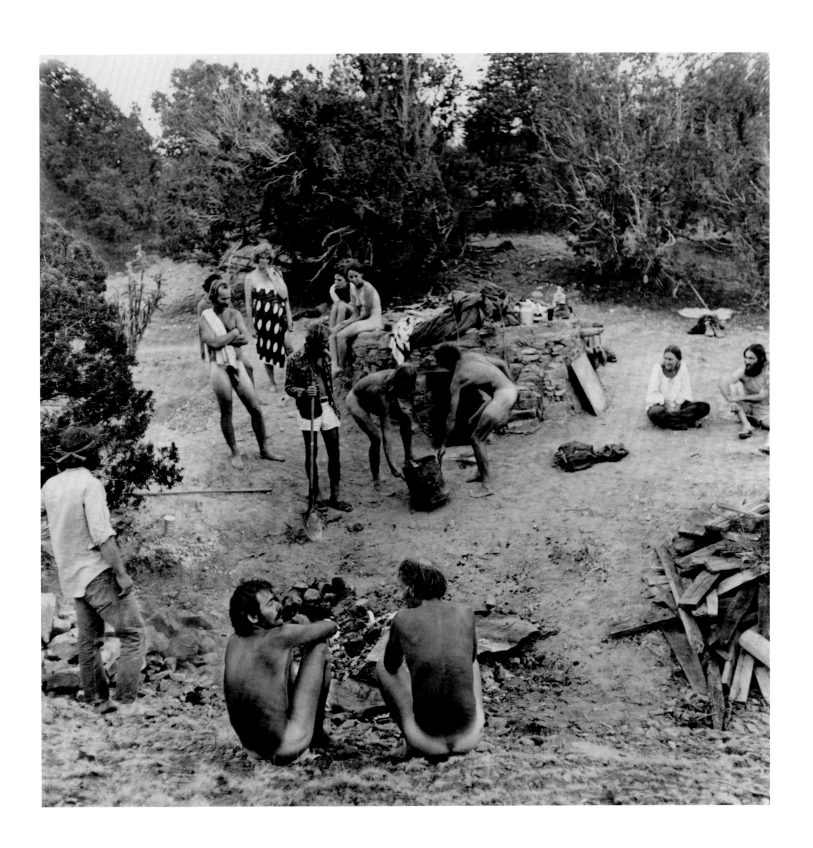

DAVID GRANT NOBLE

PREPARING A SWEAT LODGE, SOUTH OF DOWN-
TOWN SANTA FE, 1973/74

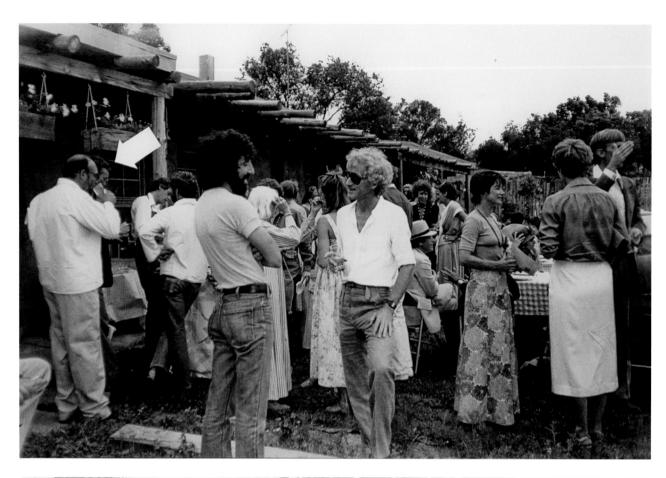

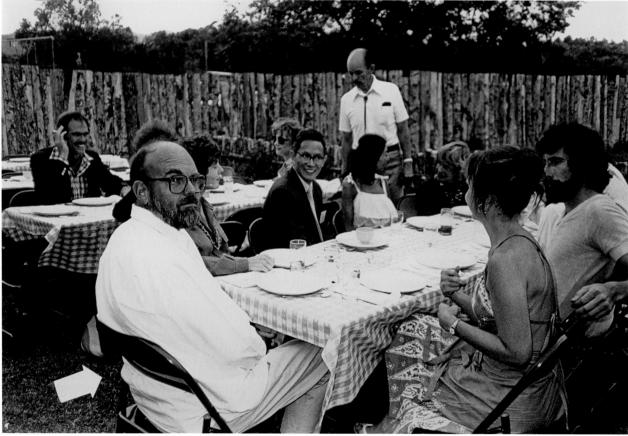

BETTY HAHN
EHRLICHMAN SURVEILLANCE SERIES, SHIDONI SCULPTURE GARDENS AND FOUNDRY,
TESUQUE, NEW MEXICO, EIGHT-PART SERIES, 1982

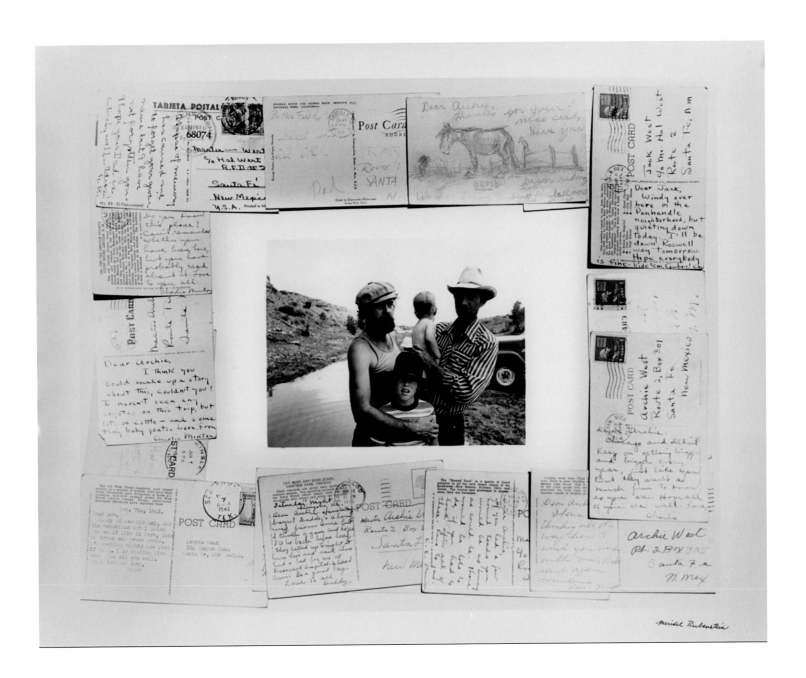

MERIDEL RUBENSTEIN

POSTCARDS, FATHERS AND SONS, CERRILLOS
FLATS, NEW MEXICO, 1978

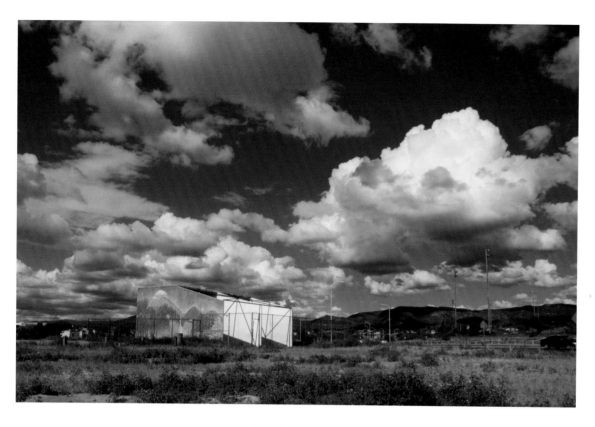

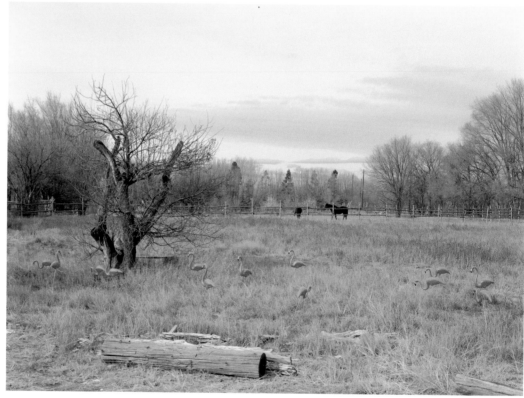

BLAIR CLARK

HANDBALL COURT, 2007

MARGARET MOORE

FLAMINGOS IN TESUQUE, 1995

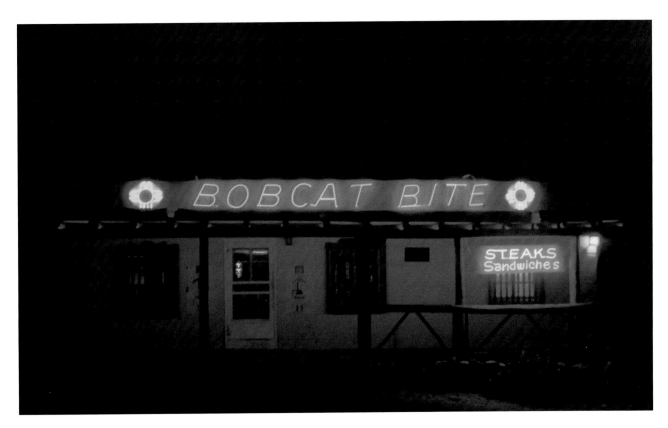

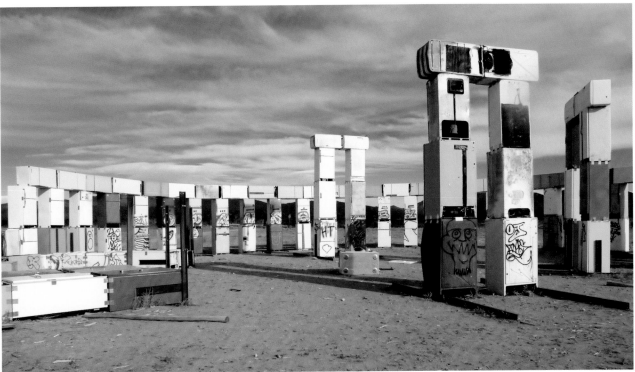

DONALD WOODMAN

BOBCAT BITE, N.D.

BRIAN EDWARDS

STONEFRIDGE, JANUARY 7, 2006

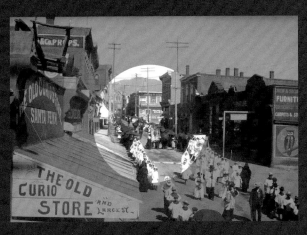

IDENTITY

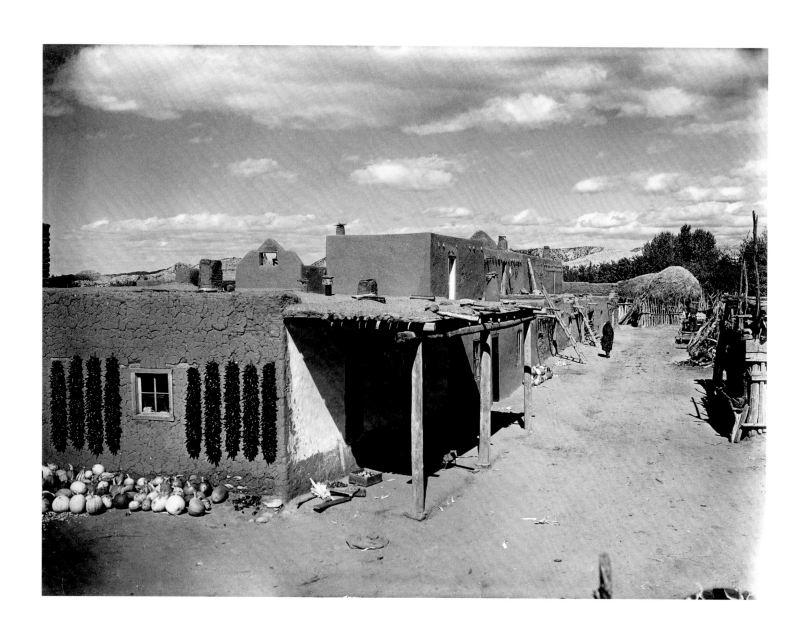

T. HARMON PARKHURST

TESUQUE PUEBLO, CA. 1920

IN AND AROUND SANTA FE:
ANGLO PHOTOGRAPHERS AND TEWA PUEBLO PEOPLE

RINA SWENTZELL

Before the Spanish arrived in the mid-1500s, the Santa Fe area of New Mexico was populated primarily by Tewa Pueblo people, who spoke the Tewa language and had lived in communities in northern New Mexico since prehistoric times. There were many Tewa pueblos in and around present-day Santa Fe and nearby Agua Fria Village, south along the Santa Fe River to La Cienguilla, and east to west from the Galisteo Basin through Santa Fe to the Rio Grande. Often, the Tewa intermingled with the Keres Pueblos. It was in this Tewa country that in 1598 the Spanish established their capital near present-day San Juan Pueblo at San Gabriel del Yunge along the Rio Grande. By 1609, however, the Spanish capital had moved about thirty miles southeast to a new community named Santa Fe. Interaction between the Tewas and Spanish was complex, ranging from the exchange of goods and ideas to intermarriage, slavery, intense conflict, and finally, in 1680, revolt by the Pueblo people against the religious and civil rule of the Spanish. The colonizing mentality of the Spanish was matched some 150 years later by that of Anglos (another European invasion), who arrived in the 1800s with new economics, science, and technology. Santa Fe was transformed from a Spanish province into first a U.S. territory and then, in 1912, the capital of the new state.

In the early years of European contact, most Tewa communities abandoned their pueblos in the Santa Fe region and moved into existing pueblos along the Rio Grande. Tesuque Pueblo was the exception, remaining in its original location nine miles north of Santa Fe and retaining an identity distinct from the surrounding Spanish and Anglo towns. During territorial years, Santa Fe remained, for Tesuque residents and other Pueblo people, a place to gather; to barter and sell wares, produce, and livestock; and to find work. Spanish and American officials who negotiated land and water rights between the Pueblos

and the territorial government were seated at the Palace of the Governors in Santa Fe. After 1890, much of the Pueblo people's travel into Santa Fe was to visit their children at the Santa Fe Indian School, a Bureau of Indian Affairs boarding school located in the fields southwest of the city along the Santa Fe River.

Except for a growing interest in Pueblo culture by Santa Fe artists, photographers, and anthropologists, interaction between Pueblo people and Anglos was minimal from the mid-1800s to the early 1900s. For the most part, Pueblo and Anglo communities remained distinct social and political entities within northern New Mexico. During these years, the relationship between Pueblo people and Anglos was mostly defined by a small number of Anglos who perceived themselves as caretakers of the Pueblo people. By the late nineteenth century, the earlier Spanish dilemma of questioning whether native peoples were humans gave way to the Anglos' strong conviction that Pueblo people had a distinct and valuable culture that needed to be documented and thereby preserved.

By the late nineteenth century, a conjunction of technological innovation and patronage made Santa Fe the center of a relentless promotion to avert the loss of Pueblo culture. Photography, invented in 1839, quickly became an established art medium for recording places, landscapes, and people in the Southwest. It was especially useful for Anglo photographers concerned with documenting the vanishing but still visible culture of the Pueblo peoples and their communities.

Photographers with a passion to help preserve the southwestern landscape, peoples, and cultures moved into the area. Incredible images of native peoples survive from this period. Many of the photographs in the Museum of New Mexico collections were taken by people connected with the developing art communities of Santa Fe and

UNKNOWN PHOTOGRAPHER

SANTO DOMINGO PUEBLO STUDENTS, U.S. INDIAN SCHOOL, SANTA FE, N.D.

PAULINE COMMACK

ART STUDENTS AND TEACHERS ON GRADUATION DAY, SANTA FE INDIAN SCHOOL, 1944

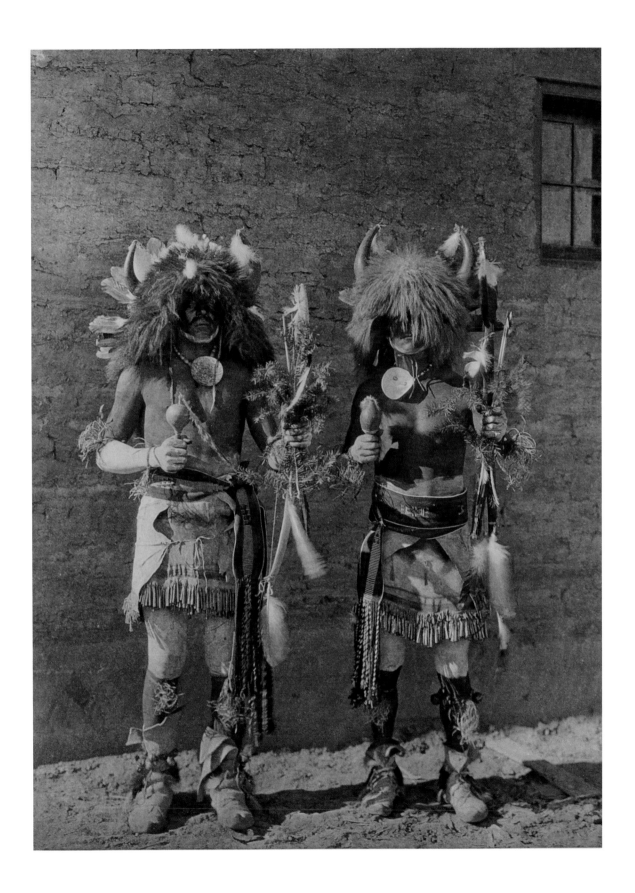

EDWARD S. CURTIS
TESUQUE BUFFALO DANCERS, 1925

Taos. These individuals, many of them Anglo transplants from the eastern United States, saw Native Americans of the Southwest as dignified citizens of the American republic rather than dependent wards of the government. Some of these Anglos were offended by the boarding schools for Native Americans, such as the Santa Fe Indian School, where the philosophy was to extract children from their home communities and "civilize" and refashion them as mainstream American citizens. Despite this evident cultural sensitivity, photographers often photographed children arriving at the Santa Fe Indian School looking unkempt and timid, in contrast to photographs made following graduation showing them as well dressed and confident—adding to the perception of Pueblo culture as "uncivilized."

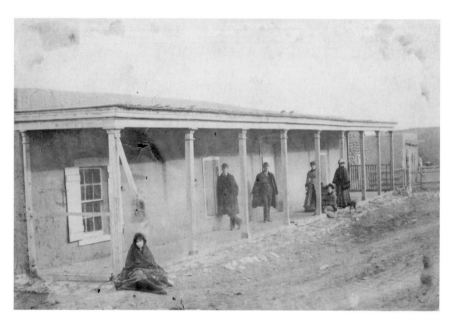

UNKNOWN PHOTOGRAPHER
A MODERN ADOBE IN SANTA FE, CA. 1880–90

Although one of the main goals of late-nineteenth- and early-twentieth-century photographers was to reveal Native Americans' intimate relationship with nature, many of the existing photographs of Pueblo people were taken in and around Santa Fe. Further, in some photographs, Anglo photographers, whether consciously or unconsciously, show native people as alienated from their environment and show the photographers themselves as belonging and having a mission. In one photograph by an unknown photographer, a native woman sits on the edge of a portal in Santa Fe. Her man-made context isolates her, expressing her sense of not belonging, of desolation. Another photograph, of a cameraman and Tesuque Eagle Dancers, taken by T. Harmon Parkhurst in Tesuque Pueblo, shows the photographer with a sense of purpose and control, while the stance and gestures of the Eagle Dancers and drummers give the impression that they are simply present and compliant, ready to take orders with humility, even though the event is taking place in their own environment. The photographer's sense of belonging comes from his mission to document a culture that is on the verge of vanishing. Moreover, his mission dictates that Pueblo people should not be seen in American clothes, which was the norm during those years, but in traditional dress and participating in ceremonial activity. Consequently, the resulting photograph reflects the photographer's agenda and cultural perspective.

Many early photographs of native people taken by Anglo photographers were staged, with artifacts provided by the photographers. Charles Lummis,

Edward S. Curtis, Laura Gilpin, and other photographers posed native peoples with native artifacts, some of which were not culturally appropriate. For example, one photograph by John K. Hillers, *Water Carriers, Tesuque, New Mexico,* circa 1880, shows native women in front of a well-worn adobe wall with pots that are not from their community. The photographer most likely provided the black pots, which are of a style made at Santa Clara Pueblo. Additionally, the activity depicted was also staged in an inauthentic way. The women are stately and stoic, hauling water from the stream to their houses. Although hauling water was a common activity in the pueblos through the 1940s, the static staging of it as portrayed in this image is at odds with the agility required to carry a clay pot full of water on one's head over uneven terrain.

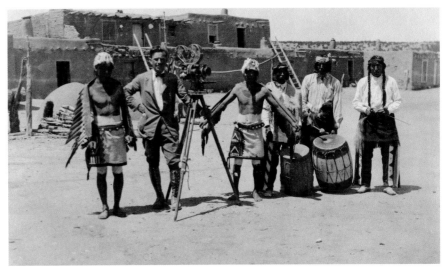

Unnatural staging can dim the beauty of reality and also distort the truth. In Christian Kaadt's photograph of a man drumming, *Juan Pino, Tesuque Pueblo,* circa 1900, there are nice details of the drum that could be used for ethnographic purposes. The stance of the man, however, is very uncharacteristic of

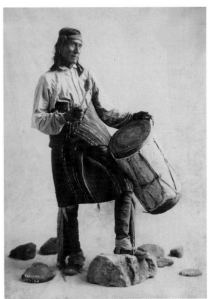

Pueblo people. A Pueblo man would not use deliberately placed rocks to help support his legs and drum, giving the effect of a person in charge of his surroundings. The man's stance is not unlike that of an independent, self-confident person, which seems at odds with his facial expression, which suggests that he would be more comfortable drumming with others and being part of both his human and natural environment. Even more disturbing is the undated T. Harmon Parkhurst photograph *The Smoker, José Angel, Tesuque Pueblo,* which shows a Pueblo man in a self-conscious "thinker" pose smoking a cigarette. He doesn't look dignified and sophisticated; he looks ridiculous, because the background of mud buildings and context of his costume with bells and feathers is about knowing the world through other senses than self-conscious thought and is thus in stark contrast to

T. HARMON PARKHURST
MOTION-PICTURE CAMERAMAN WITH DRUMMER AND EAGLE DANCERS, TESUQUE PUEBLO, CA. 1917

T. HARMON PARKHURST
THE SMOKER, JOSÉ ANGEL, TESUQUE PUEBLO, N.D.

CHRISTIAN G. KAADT
JUAN PINO, TESUQUE PUEBLO, CA. 1900

JOHN K. HILLERS
WATER CARRIERS, TESUQUE, NEW MEXICO, CA. 1880

T. HARMON PARKHURST
JOSÉ LA CRUZ HERRERA, TESUQUE PUEBLO, N.D.

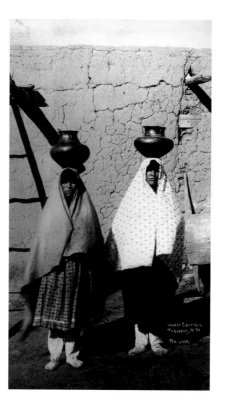

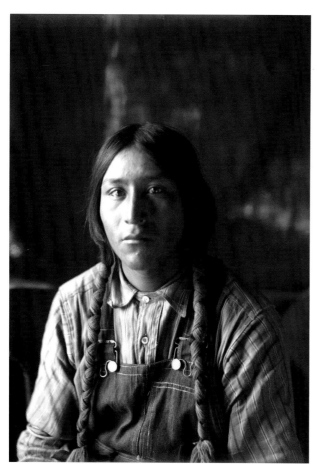

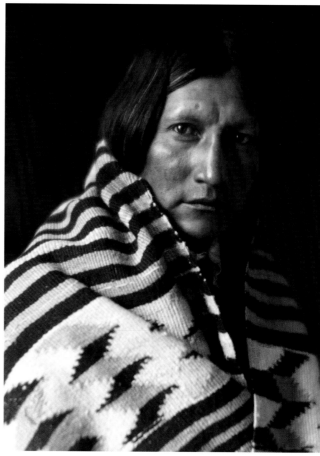

his pose. Manipulation of the subject to match the photographer's concept also occurs. In Parkhurst's sequence of portraits of José La Cruz Herrera from Tesuque Pueblo, La Cruz Herrera appears to be an unassuming, compassionate, and almost effeminate man when not posed wrapped in a blanket. But his personality seems altered when he is photographed with a blanket, a prop that apparently reflects the photographer's expectation of Indian apparel and appearance.

In addition to posing and dressing native subjects, photographers used other ways to make Indians conform to their conceptions. Photographs were sometimes altered in a number of ways to produce postcards for the tourist trade, especially during the days of Fred Harvey's promotion of tourism. For example, a photograph of a staged scene at Tesuque Pueblo, showing people in the plaza supposedly going about everyday life, was later manipulated for use as a postcard. More people were placed on the rooftops, a child was included next to a drum in the plaza, and a donkey was inserted. The gestures and costumes of the two women in the foreground were also drastically changed. In the postcard, the woman on the ladder looks older than she does in the photograph. Her dress and shawl have been whitened for contrast, so that she stands out from her adobe background, as do the other figures on the rooftops. She is perched nonchalantly, rather than holding onto the ladder as she does in the original photograph. The woman standing in the plaza is placed closer to the ladder and to the inserted child. She is looking at the camera rather than away, as in the photograph. Her shawl has been draped closer to her body, her dress darkened, and her moccasin boots straightened, making her look thinner and more statuesque. The decoration of the pot on her head was repainted with baroquelike drapes rather than the less distinctive Pueblo floral design in the photo-

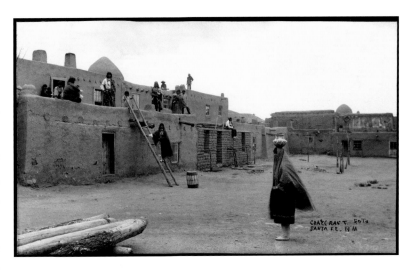

AARON B. CRAYCRAFT
EAST SIDE OF TESUQUE PLAZA, CA. 1900

UNKNOWN PHOTOGRAPHER
TESUQUE INDIAN PUEBLO, N.D.

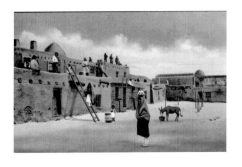

graph. Considering all the changes, the overall effect is of a brighter place that was undoubtedly more visually appealing to nonnative tourists.

As both southwestern romanticists and the American economy pushed Pueblo people into the forefront of the tourist trade, the integrity of Pueblo people and their communities was compromised. By the 1920s, tourist visits to the pueblos were well organized. A circa 1927 photo by Parkhurst shows Indian Detours personnel and equipment ready to leave the

T. HARMON PARKHURST

*INDIAN DETOURS PERSONNEL AND EQUIP-
MENT, PALACE OF THE GOVERNORS*, CA. 1927

Palace of the Governors in Santa Fe. As late as the 1940s, such tours were a daily part of Pueblo life. When I grew up in Santa Clara Pueblo, every house had a basket of pottery sitting by the door to be sold to the people in the tour cars or buses arriving in the village. We would form a semicircle in the plaza, untie cloths from around our baskets, and place our pots on the cloths while shyly looking up at the white people. The immaculately dressed tourists looking back at us and our wares were unsettling. Under their gaze, we felt like oddities in our own world.

As the tourist industry grew, photography was increasingly used to record Pueblo people's appearances at public events in Santa Fe, sometimes revealing stereotypes of native people used to promote the area. For example, a 1919 Parkhurst photograph of the Santa Fe Fiesta parade, celebrating the reentry of the Spaniards after the Pueblo Revolt of 1680, shows a group of Pueblo men wearing war bonnets, artifacts that are worn by Plains tribes. During the same year, some San Ildefonso Eagle Dancers were photographed dancing in the courtyard of the Palace of the Governors, seemingly to promote Santa Fe as

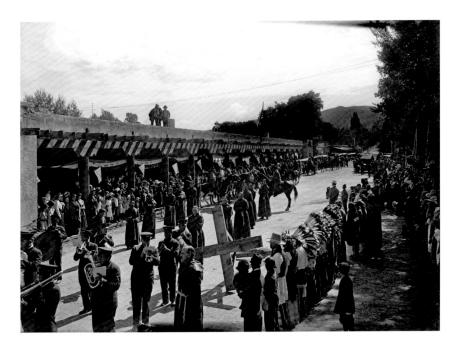

T. HARMON PARKHURST
FIESTA, 1919

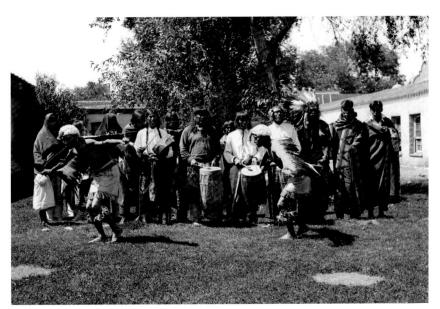

UNKNOWN PHOTOGRAPHER
SAN ILDEFONSO EAGLE DANCE, PALACE OF
THE GOVERNORS COURTYARD, FIESTA, 1919

an exotic destination. Many photographs of Pueblo people provide documenta-
tion of the interaction between Anglo and native people in those years and thus
are valuable documents of our common past in Santa Fe. Other photographs,
taken by early Anglo romantic photographers, are precious reminders of specific
times and places. Examples are Nympha Vigil and her son Marcus photographed
in Tesuque by Carlos Vierra, Parkhurst's images of a woman drying wheat in
Tesuque, the venerable grandfather with a grandchild hanging on his legs, and
the ever-present hungry dog, as well as a Hillers' photograph of two men and
their oxen staring back at the photographer.

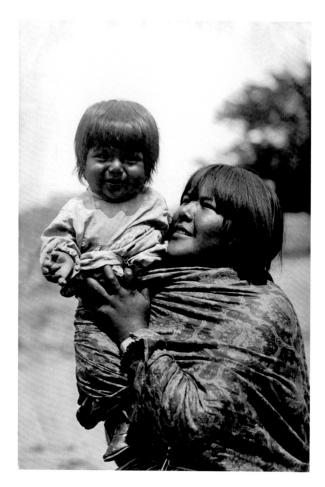

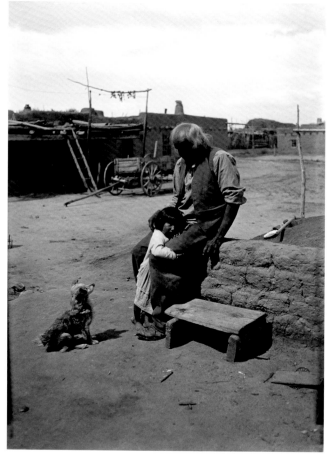

CARLOS VIERRA
NYMPHA VIGIL AND MARCUS VIGIL, TESUQUE PUEBLO, N.D.

T. HARMON PARKHURST
TEOFOLO ORTEGA, TESUQUE PUEBLO, CA. 1919

JOHN K. HILLERS
A TESUQUE OXCART, 1880

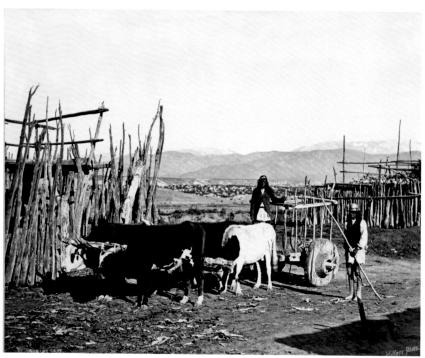

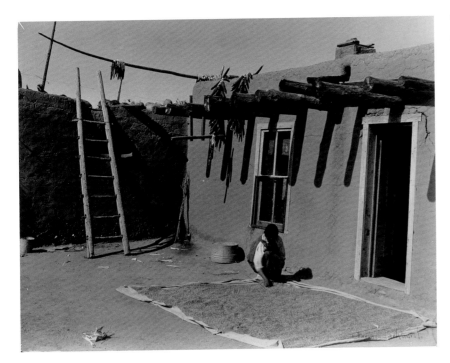

T. HARMON PARKHURST
DRYING WHEAT, PUEBLO OF TESUQUE, N.D.

The solicitous manner of Pueblo people that allows others (such as photographers, artists, and tour guides) to dress us, give us props, and stage settings continues to some extent today. Santa Fe is a tourist town overwhelmed by glitzy magazines featuring Pueblo people and their artworks and crafts to promote tourism. Although Pueblo people are still tourist attractions, we also participate in the American art market economy and are included in photographic magazines that help bestow fame, recognition, and money. We are still propped and photographed, but as individuals who have accomplished what the Anglo world values. Some of us are photographers and artists recording our own perceptions and memories of our culture and past. The Western educational system has succeeded to the point that we are now contributing members of a society that was once antithetical to our way of life. The photographs show a changing Pueblo world being charmed by a very seductive American culture, including its technical capability to visually document our vanishing Pueblo past in undeniably beautiful, although sometimes manipulated and falsified, ways.

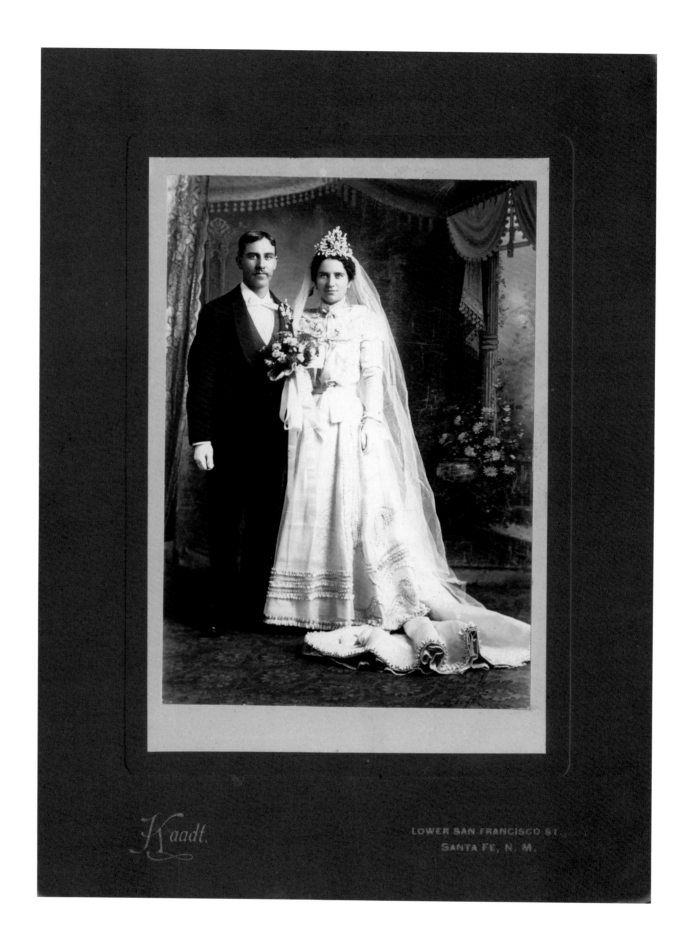

CHRISTIAN G. KAADT

WEDDING PORTRAIT: FELIPE AND MELINDA VALDEZ, CA. 1900

HISPANIC IDENTITY IN A TOURIST TOWN

ANDREW LEO LOVATO

The Santa Fe mystique is a creation that has been supported by many interests over the years. More than one million visitors from across the globe come to "the City Different" annually to experience the landscape, architecture, and cultural flavor that make Santa Fe one of the most successful tourist destinations in the United States. Santa Fe Hispanic cultural identity is therefore unavoidably influenced by the fact that Santa Fe is a tourist town in which local culture and history have been made into commodities for sale by the tourism industry.

The image that Santa Fe has cultivated since the late nineteenth century has not been accidental but rather a conscious effort to portray the city as a "sagebrush Shangri-La" and a "mecca of mesas and margaritas" (Lovato 2004). This romanticization of Santa Fe has impacted Hispanic identity as well. The creation of Santa Fe's romantic image has its roots in the migration of Anglo-American artists and anthropologists from the eastern United States who wished to escape their industrialized lifestyle and discover a pristine, exotic landscape.

As Sylvia Rodriguez stated in her essay "Art, Tourism, and Race Relations in Taos: Toward a Sociology of the Art Colony" (1989), "[New Mexico] promised the quintessential frontier experience, vast desert spaces, wild but noble savages, and unlimited freedom. Fed by a generation of dime-store novels, the painters' imaginations in turn produced the visual component for what would become the Taos-Santa Fe mystique." This vision was shared by artists of various mediums, including painters, writers, and photographers.

After the U.S. occupation of the New Mexico Territory from 1846 to 1848, and especially following the Civil War, Anglo culture became predominant in the Southwest. In the late nineteenth and early twentieth centuries, an increasing number of photographers from the eastern United States traveled to New Mexico to make images of the landscape, people, and architecture of this

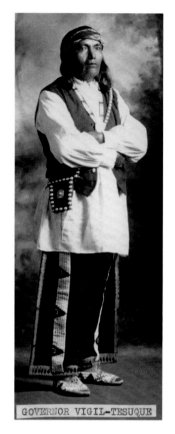

GOVERNOR VIGIL-TESUQUE

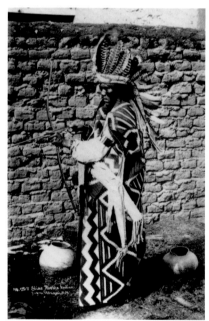

HORACE SWARTLEY POLEY
GOVERNOR VIGIL, TESUQUE, CA. 1910

UNKNOWN PHOTOGRAPHER
*ELIAS, PUEBLO INDIAN FROM TESUQUE,
NEW MEXICO,* N.D.

exotic region. Some of the more notable of these photographers were William Henry Jackson, Timothy O'Sullivan, Charles Lummis, and Ben Wittick.

The Anglo-American infatuation with the "noble savage" caricature of the Pueblo peoples was evident in the art produced and disseminated throughout the rest of the United States. This stereotype of the mythologized American Indian thus prevailed in the minds of many Americans during this period. The portrayal of the dominant Hispanic population, however, was more complex and convoluted. The once socially influential Hispanic culture was relegated to the lowest status among the three groups. This situation, described by Rodriguez as the "tri-ethnic trap," placed Hispanics in the position of being "conquered, dispossessed, dependent, ghettoized, and above all, witness to the Indian's spiritual and moral elevation above themselves (Rodriguez 1989). This attitude was instrumental in the evolution of "Hispanophobia," or anti-Mexicanism, which in turn supported the U.S. doctrine of Manifest Destiny and eventually legitimized the Mexican War. War propaganda painted New Mexicans as an inferior race of mixed ethnicity, incapable of following democratic principles or taking advantage of the territory's resources. The same prejudices that had been projected on blacks and Indians were now extended to those of Mexican ancestry.

Highly stylized photographs of Native Americans in New Mexico in regal poses wearing full costumes were common. Examples include H. S. Poley's portrait of Governor Vigil from the Pueblo of Tesuque taken around 1910, and another portrait of a Native American man in front of an adobe wall, wearing a Navajo blanket and feathered headdress and posing with a bow and arrow and pottery props. During this period, the portrayal of Anglo-American people by Anglo photographers also showed tremendous respect and dignity. For example, Jesse Nusbaum's 1912 photograph of a group of Anglo-Americans taken in front of the Scottish Rite Temple in Santa Fe reflects a dignified cultural identity.

Although there are examples of sensitive and dignified portraits of Hispanics in the region during this period, the 1888 photograph by J. R. Riddle entitled *Street in Santa Fe, New Mexico* reflects a prevalent stereotype of Hispanics. The viewer's eye is drawn to a man in the left-hand bottom corner, who squats in an unflattering prone position next to an aging adobe wall, at eye level with a dog—an image that reinforces the widespread belief that Hispanics were an inferior race of mixed ethnicity. In fact, the single most determining factor in delaying statehood for sixty years was that New Mexico was a Spanish-speaking, Catholic territory that easterners considered foreign.

After the designation of New Mexico as a U.S. territory led to a steady stream of Americans arriving from the East, the image of Santa Fe changed. Ini-

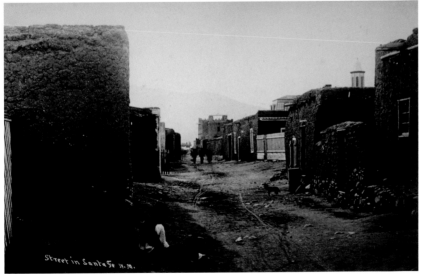

JESSE L. NUSBAUM
MASONIC CONSISTORY CLASS FALL
REUNION, SANTA FE, NEW MEXICO, 1912

ANDERSON STUDIO
MRS. CLEOFAS MARTINEZ JARAMILLO IN
HER WEDDING HAT, 1901

J. R. RIDDLE
(SOMETIMES ATTRIBUTED TO J. L. CLINTON)
STREET IN SANTA FE, NEW MEXICO, 1888

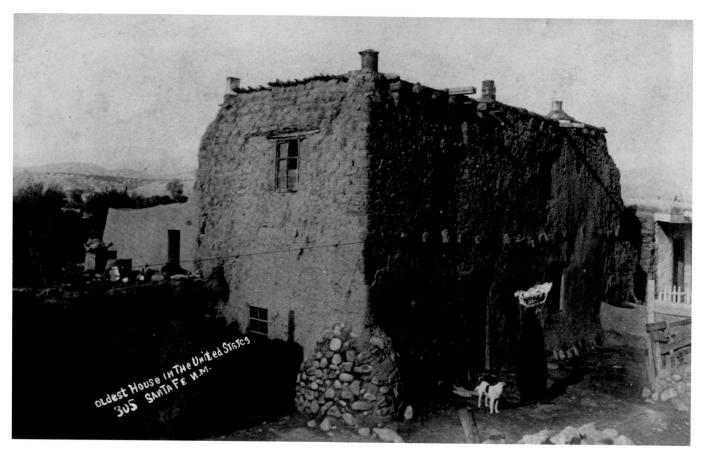

DANA B. CHASE

OLDEST HOUSE IN THE UNITED STATES,
SANTA FE, NEW MEXICO, CA. 1888

tially, many Anglos were disdainful of the city's adobe architecture, which was described by one writer as reminiscent of a "prairie dog town." Dana B. Chase's photograph *Oldest House in the United States, Santa Fe, New Mexico* is perhaps an example of the image Anglos held when they thought about Santa Fe. Anglo attitudes often associated adobe with a lack of morals, hygiene, and civilization. Consequently, toward the latter part of the nineteenth century and the early twentieth century, there was a concerted effort to transform Santa Fe into what writer and anthropologist Oliver LaFarge described as a replica of "a minor Indiana town" (Wilson 1997). Americans brought in milled posts and trim to create the illusion that the adobe buildings did not exist. They were partial to a simplified Greek Revival style that is referred to locally today as Territorial (Wilson 1997). Photographs of the state capitol building and the governor's mansion in Santa Fe taken the year New Mexico was granted statehood reflect an architectural style that could have existed anywhere in the United States, thus reflecting an image of Santa Fe as an Americanized territory that deserved to be admitted to the Union.

During the early twentieth century, however, there was a renewed appreciation for the native style of architecture and lifestyle, reversing the ear-

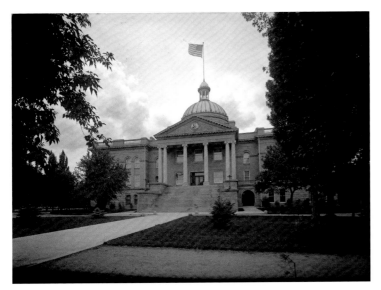

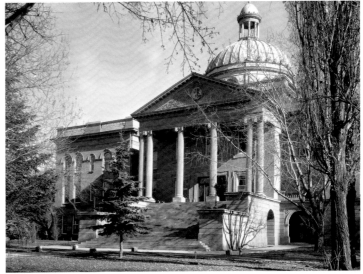

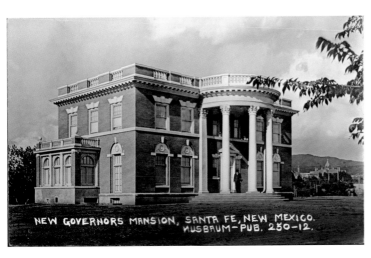

JESSE L. NUSBAUM

STATE CAPITOL BUILDING, 1912

T. HARMON PARKHURST

STATE CAPITOL BUILDING, CA. 1912

JESSE L. NUSBAUM

GOVERNOR'S MANSION, CA. 1912

T. HARMON PARKHURST

GOVERNOR'S MANSION, N.D.

JESSE L. NUSBAUM

NEW GOVERNOR'S MANSION, SANTA FE,
NEW MEXICO, 1913

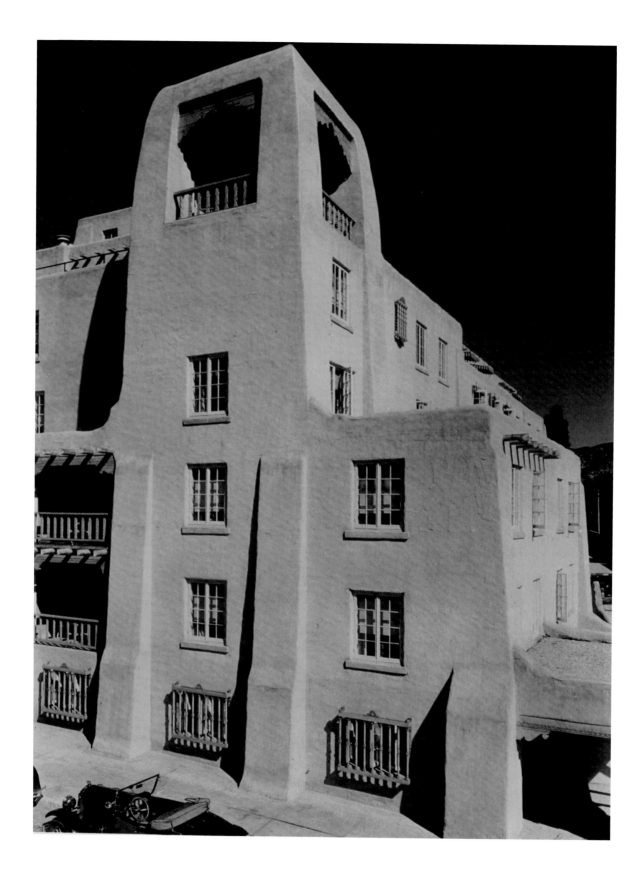

ANSEL ADAMS

LA FONDA HOTEL, SANTA FE, NEW MEXICO, 1928

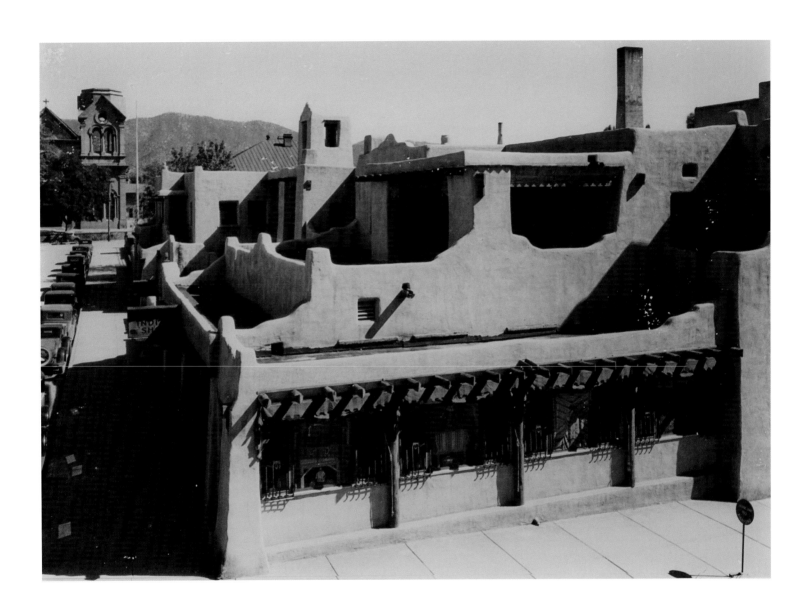

ANSEL ADAMS
LA FONDA HOTEL, SANTA FE, NEW MEXICO, 1928

lier drive to Americanize Santa Fe. Whereas nineteenth-century Anglo-Americans considered Santa Fe backward and its appearance undesirable, newcomers in the early twentieth century, many of whom were artists and anthropologists, saw Santa Fe style as historical, aesthetic, and even virtuous. The Spanish-Pueblo Revival style—later Santa Fe style—was encouraged for new buildings (Sherman 1983). The catalyst for this shift in building preference came from the influence of the Museum of New Mexico/School of American Archaeology, founded in 1909. A plan put forward by the museum called for the city to encourage more homogenous new construction based on the Santa Fe style as a means of making Santa Fe distinct from other cities and promoting tourism that would bring an economic boost to the area. Subsequently, the Chamber of Commerce coined the label "the City Different" to support this vision. A prime example of a Santa Fe–style structure is the historic La Fonda Hotel in downtown Santa Fe. Photographs of this building taken by Ansel Adams capture the soft corners and lines of the adobe look so admired by visitors. Ironically, the city found itself between a rock and a hard place in trying to promote itself as a quaint, rustic village and at the same time the capital of a progressive territory vying for statehood.

Along with the renewed appreciation for Santa Fe architecture came a heightened regard for Hispanic culture. Photographs of the Corpus Christi procession by Aaron B. Craycraft and T. Harmon Parkhurst reflect this new attitude, along with photographs of the Santa Fe Fiesta by Parkhurst and Nusbaum that portray Hispanics in a positive, humanistic light.

The photography produced in Santa Fe during this period in many ways reflects the attitudes of Anglo-Americans toward the Hispanic majority in New Mexico. Since most of the photographers were Anglo-Americans from the East (with a few notable exceptions, such as Carlos Vierra), and their intended audience was other Anglo-Americans, a great deal can be gleaned from the nuances in the work produced.

In examining photographs for the purpose of determining what they say about cultural identity, it is essential, according to photo historian Peter E. Palmquist, to ask the following questions: "What kind of pictures did the photographer make, and why did he or she make them? How did these pictures find an audience? How did people understand them? What ideas did they convey, and what kind of response and actions did they inspire?" (Palmquist 2000). Sylvan Barnet states, "We now no longer accept photographs, even so-called documentary ones as unmanipulated truth. All photographs are representations in that they tell us as much about the photographer, the technology used to pro-

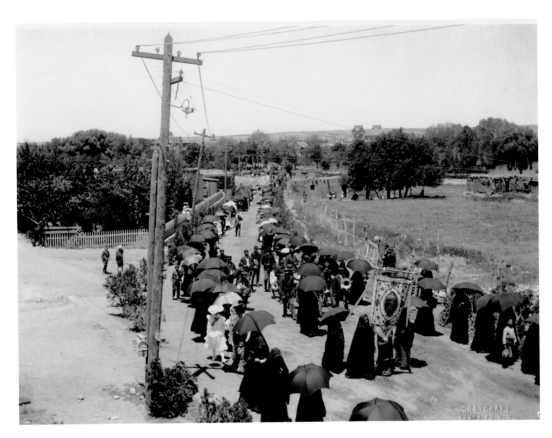

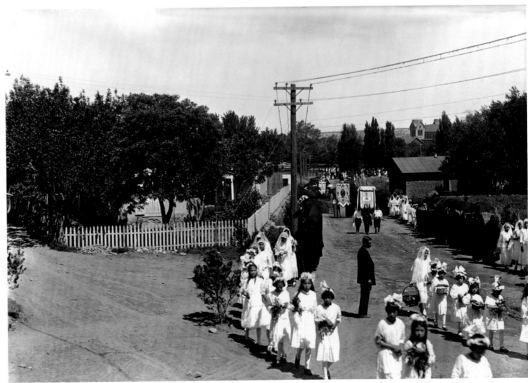

AARON B. CRAYCRAFT
CORPUS CHRISTI PROCESSION ON CANYON ROAD, 1905

T. HARMON PARKHURST
CORPUS CHRISTI PROCESSION, N.D.

T. HARMON PARKHURST

FIESTA, 1921

JAMES HART

MURALISTS FABIAN SALAZAR AND FRANK CORRIZ, 1983

MIGUEL GANDERT
NUESTRA SENORA DE LA PAZ, 2006

duce the image, and their intended uses, as they tell us about the events or things depicted. . . . We should be careful about ever assuming that from photographic evidence we can always draw valid conclusions about the lives of people, the historical meaning of events, and the possible actions that we should take" (Barnet 2008). Museums also play a role in defining cultural identity through the types of photographs they acquire and save for posterity. Ivan Karp wrote that museums are part of a public culture involved in defining the identities of communities or denying them identity.

Museums provide a formal setting for the display of objects that represent the essence and accomplishments of a culture through art or other physical manifestations. The problem with this process is that if museum patrons do not question or contemplate the messages that these exhibits relay, then they are allowing an unknown other to define the essence of their own culture or to define someone else's culture for them. Thus minority groups need to be particularly concerned with this situation, because dominant cultural attitudes are often transmitted unintentionally, even by well-meaning museums (Karp 1992).

Finally, tourism also plays a role in defining cultural identity, since it is a motivating force for emphasizing certain cultural aspects of a place. Places are chosen as tourism destinations based on the uniqueness they offer or the sense of "differentness" they have in relation to the tourist's regular place of residence. Travelers want to have out-of-the-ordinary experiences that take them away from their everyday life experiences. This situation in turn influences tourists' perceptions of Hispanic identity in Santa Fe. As Lucy Lippard writes, by using travel as a means of escape, a tourist tends to view the dissimilarities of other individuals and other places in an exaggerated, exoticized way, while similarities tend to be dismissed or hidden (Lippard 1999). Perhaps this situation helps explain why Santa Fe's cultural landscape has gone through so many perceptual shifts during its history.

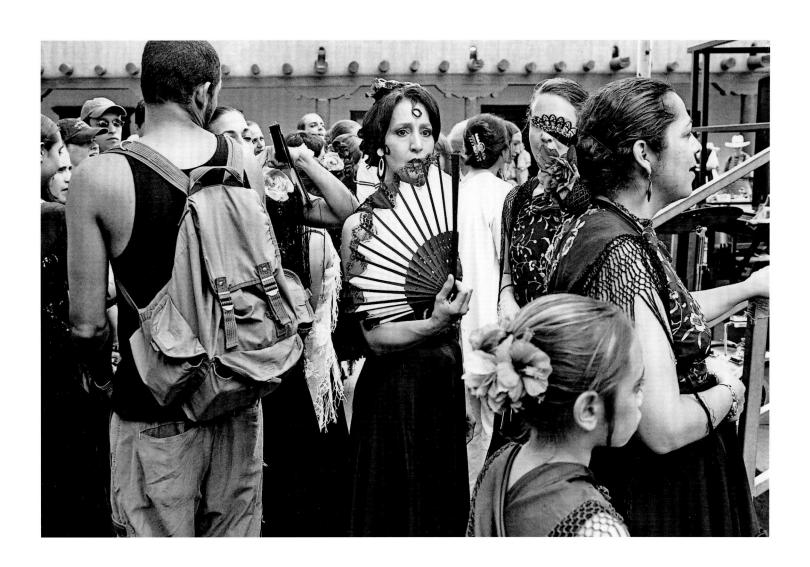

NORMAN MAUSKOPF
FOURTH OF JULY, SANTA FE, NEW MEXICO, 2002

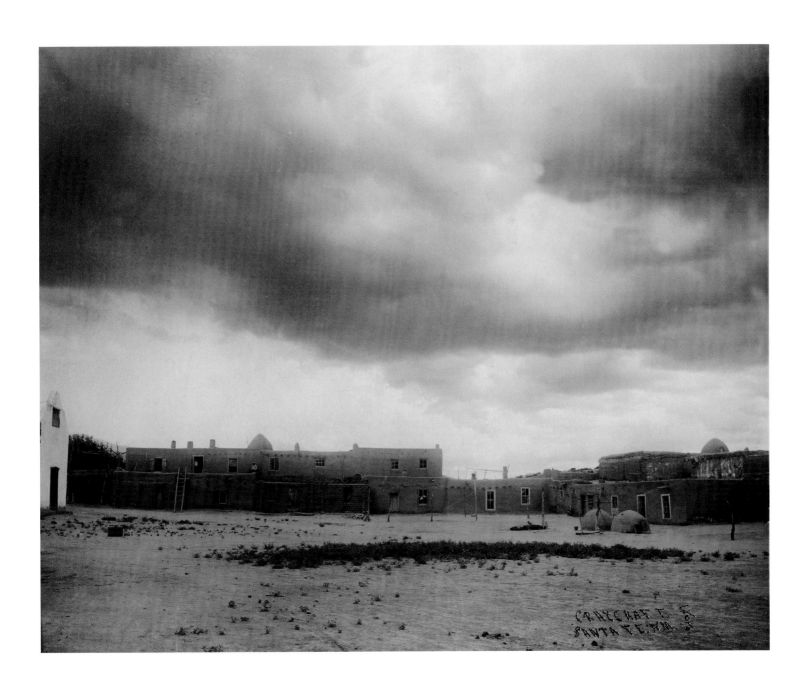

AARON B. CRAYCRAFT
SOUTHEAST VIEW OF TESUQUE PUEBLO, CA. 1900

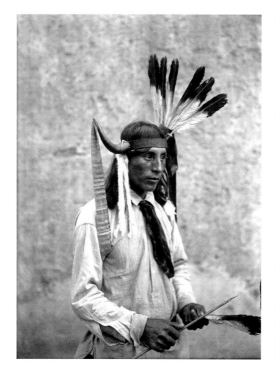 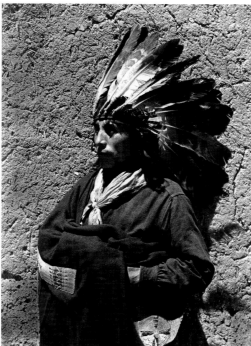 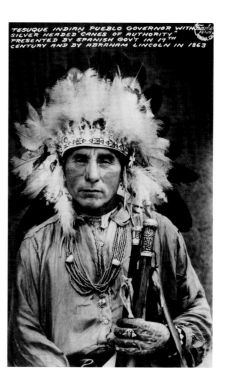

JESSE L. NUSBAUM

CANDIDO HERRERA, TESUQUE PUEBLO, 1912

T. HARMON PARKHURST

CANDIDO HERRERA, TESUQUE PUEBLO, APRIL 27, 1924

FRASHER

CANDIDO HERRERA, TESUQUE INDIAN PUEBLO GOVERNOR WITH
SILVER HEADED CANES OF AUTHORITY, PRESENTED BY SPANISH
GOVERNMENT IN 17TH CENTURY AND BY ABRAHAM LINCOLN IN 1863

TYLER DINGEE

COCHITI PUEBLO STUDENTS AT ST. CATHERINE'S
SCHOOL, CA. 1950

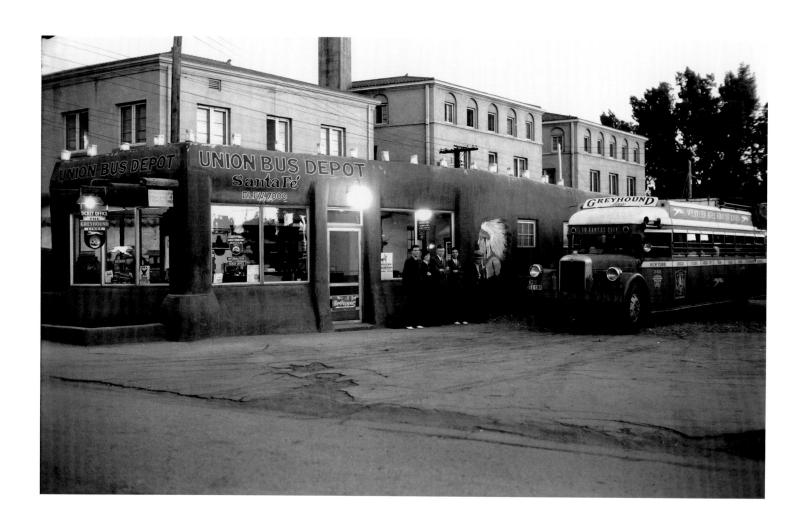

T. HARMON PARKHURST

UNION BUS DEPOT, N.D.

ZIG JACKSON
URBAN OFFERING, SANTA FE, NEW MEXICO, 2001

POLLY BROWN

FARMER'S MARKET, CA. 1998

LEE FRIEDLANDER
SANTA FE, 2005

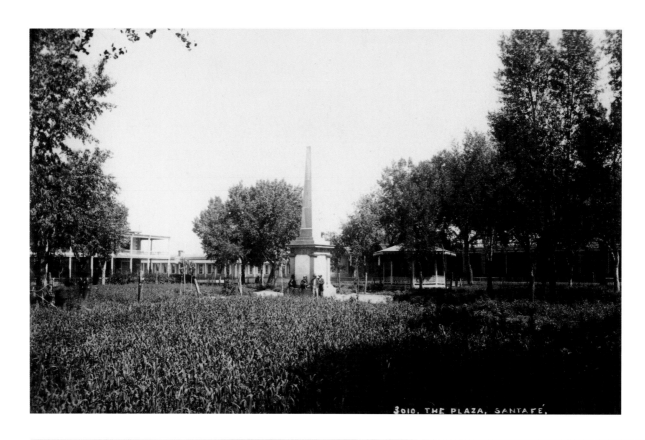

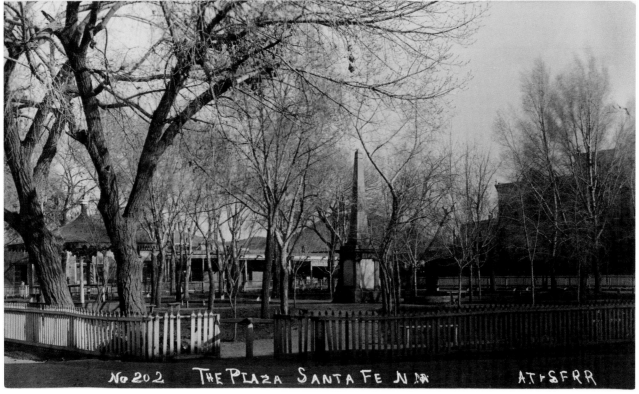

WILLIAM HENRY JACKSON
THE PLAZA, SANTA FE, CA. 1881

UNKNOWN PHOTOGRAPHER FOR THE
ATCHISON, TOPEKA AND SANTA FE RAILWAY
THE PLAZA, SANTA FE, NEW MEXICO, CA. 1885

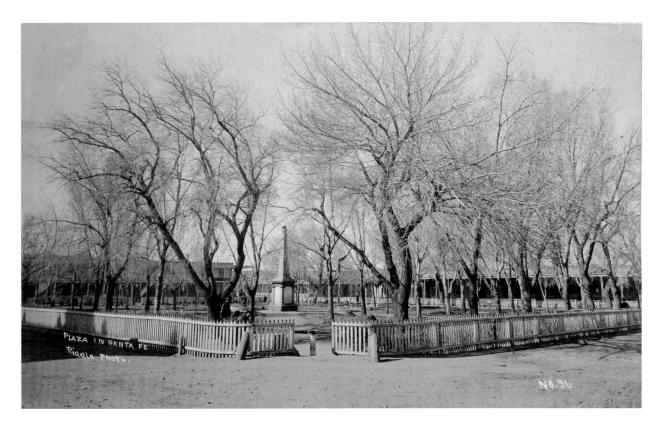

J. R. RIDDLE
(SOMETIMES ATTRIBUTED TO J. L. CLINTON)
PLAZA IN SANTA FE, NEW MEXICO, CA. 1888

JACK PARSONS
CHRISTMAS, SANTA FE PLAZA, 1993

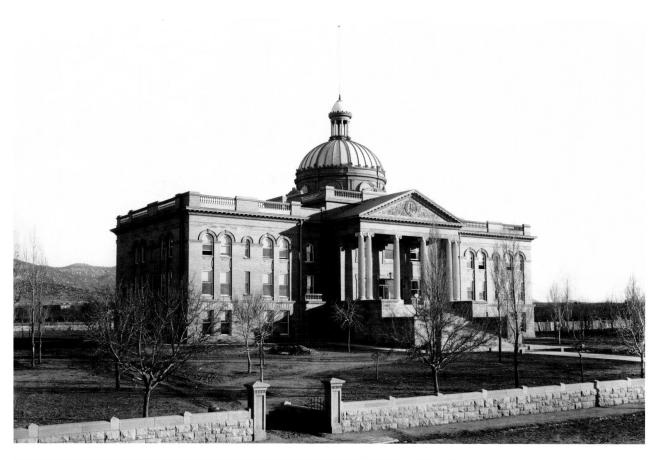

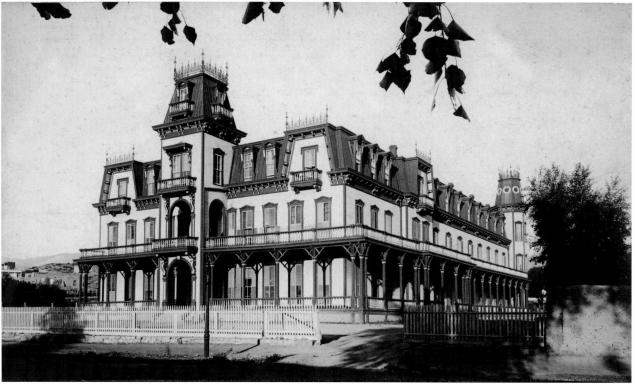

CHRISTIAN G. KAADT
STATE CAPITOL BUILDING, CA. 1895

DANA B. CHASE
PALACE HOTEL, SANTA FE, NEW MEXICO, CA. 1888

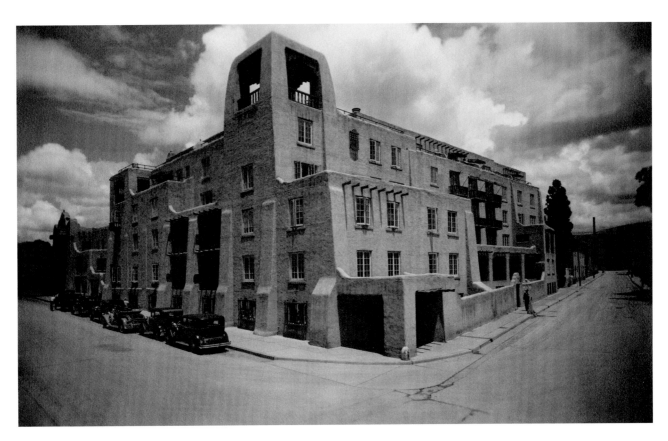

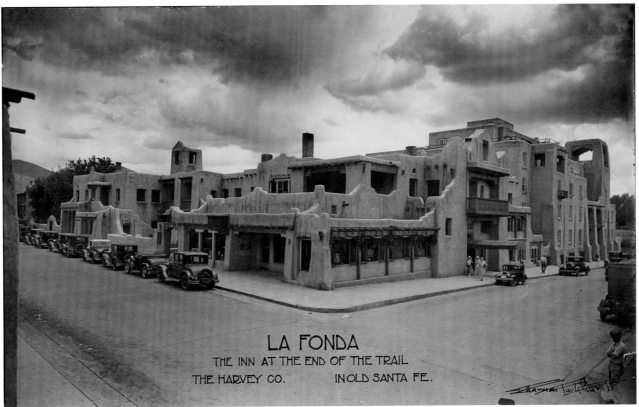

T. HARMON PARKHURST
LA FONDA HOTEL, N.D.

T. HARMON PARKHURST
LA FONDA, THE INN AT THE END OF THE TRAIL.
THE HARVEY CO. IN OLD SANTA FE, N.D.

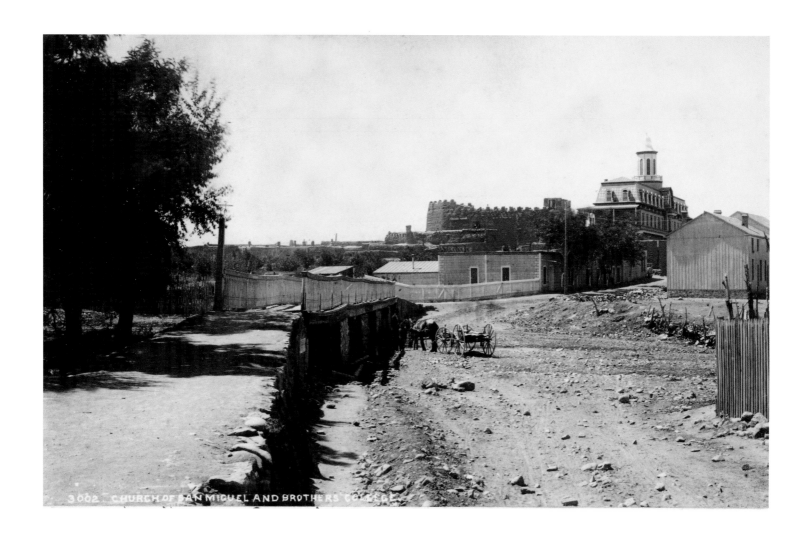

WILLIAM HENRY JACKSON
CHURCH OF SAN MIGUEL AND BROTHERS COLLEGE, CA. 1881

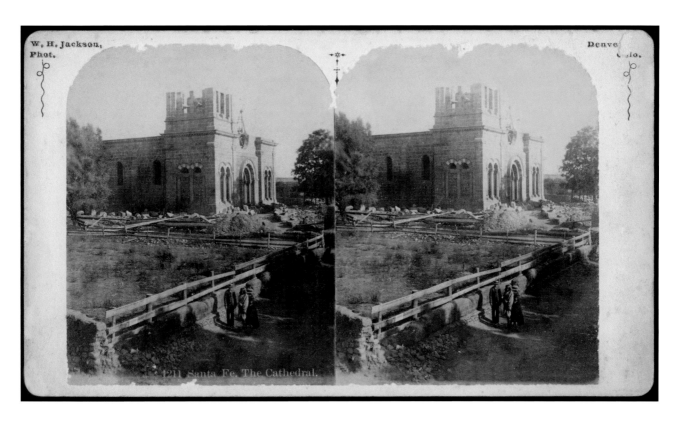

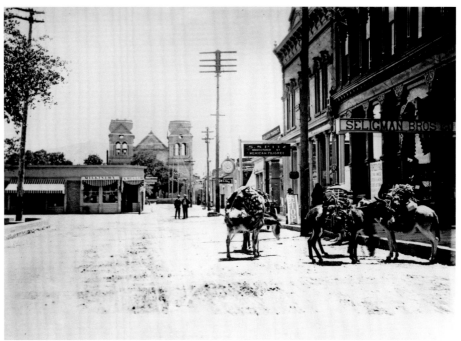

WILLIAM HENRY JACKSON

SANTA FE. THE CATHEDRAL, CA. 1881

AARON B. CRAYCRAFT

SELIGMAN BROTHERS AND COMPANY,

SAN FRANCISCO STREET, CA. 1910

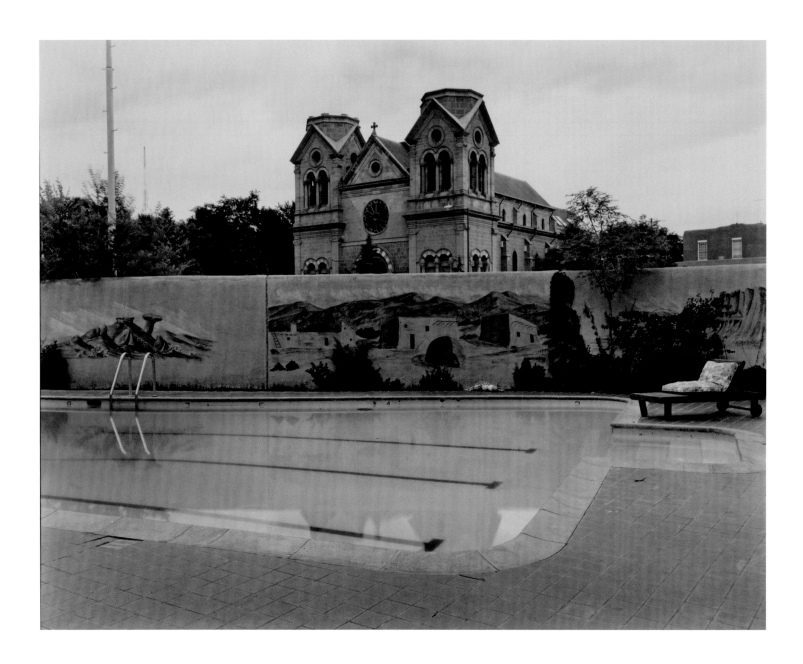

NICHOLAS NIXON

LA FONDA, SANTA FE, NEW MEXICO, 1973

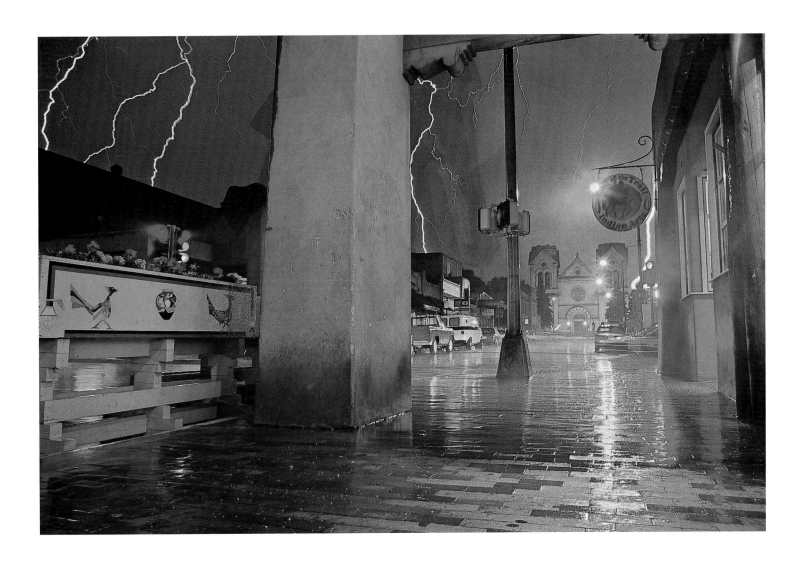

ROBERT LUIS CHAVEZ
HAILSTORM ON THE PLAZA, AUGUST 2003

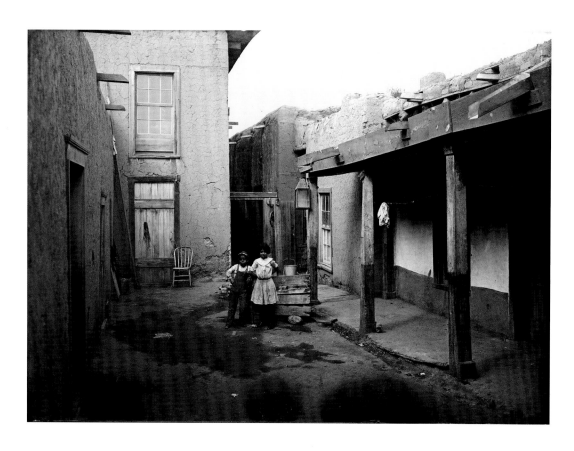

JESSE L. NUSBAUM
SANTA FE, 1912

JESSE L. NUSBAUM
ACEQUIA MADRE FROM COLLEGE STREET, CA. 1912

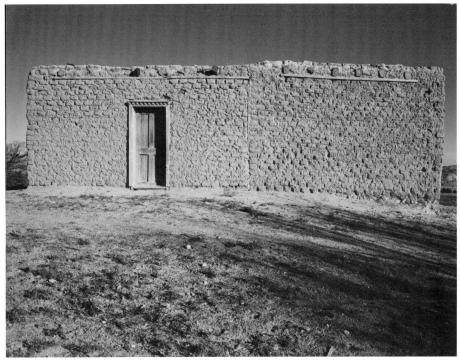

HERBERT A. LOTZ

VIEW FROM 1300 BLOCK OF CERRO GORDO, 1983–84

WRIGHT MORRIS

NEW MEXICO, NEAR SANTA FE, 1939

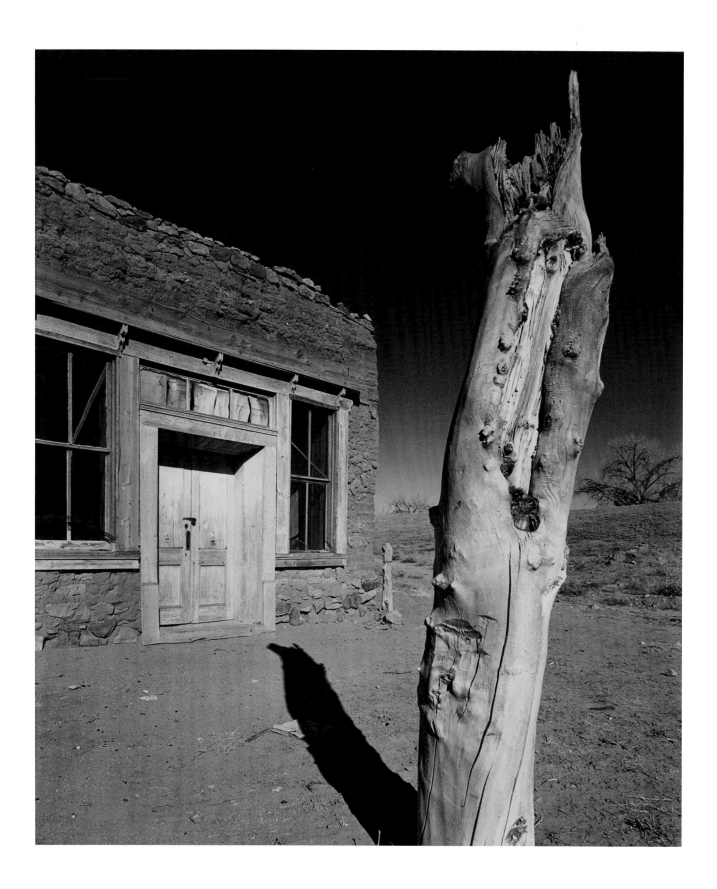

ERNEST KNEE

GALISTEO, NEW MEXICO, 1938

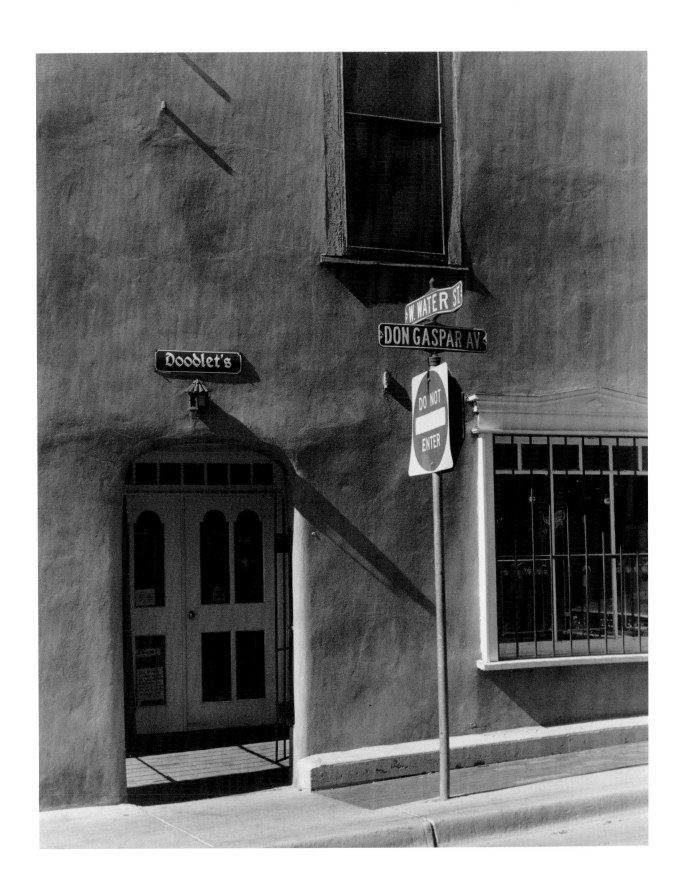

TODD WEBB

WATER STREET AT DON GASPAR,
SANTA FE, NEW MEXICO, 11/81

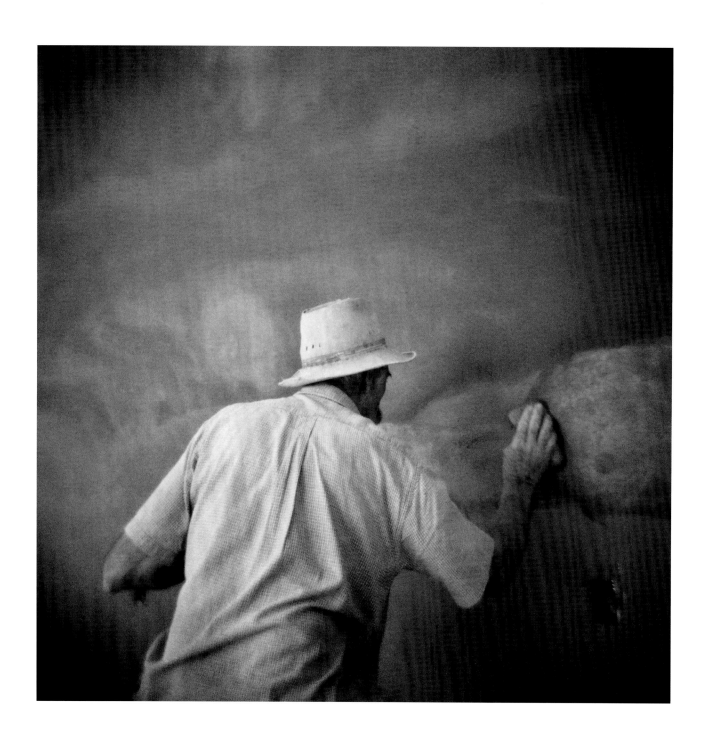

MELANIE WEST
MUD PLASTER, AUGUST 2007

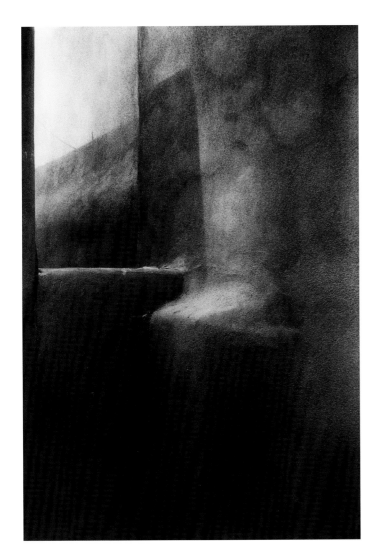

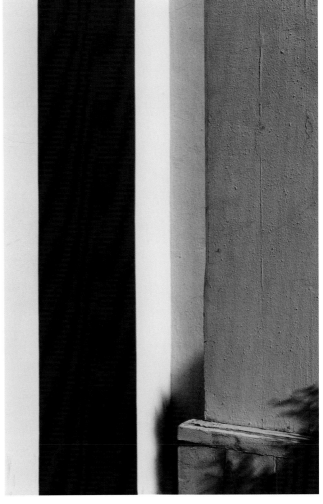

DUANE MONCZEWSKI
ADOBE WALLS, SANTA FE, 1992

DUANE MONCZEWSKI
COLUMN AND WALLS, SANTA FE, 1984

RAY BELCHER

REMIDIOS AND POST OFFICE, GALISTEO, NEW MEXICO, 1981/84

MELANIE MCWHORTER

DESCANSOS, ANTHILL, 2007

RICHARD WILDER

TRAILER RESIDENCE EAST OF ST. JOHN'S
COLLEGE, SANTA FE, NEW MEXICO, JULY 1982

CISSIE LUDLOW

DEVARGAS HOTEL, 1984

MARK NOHL
SANTA FE HOME, UPPER CANYON ROAD, N.D.

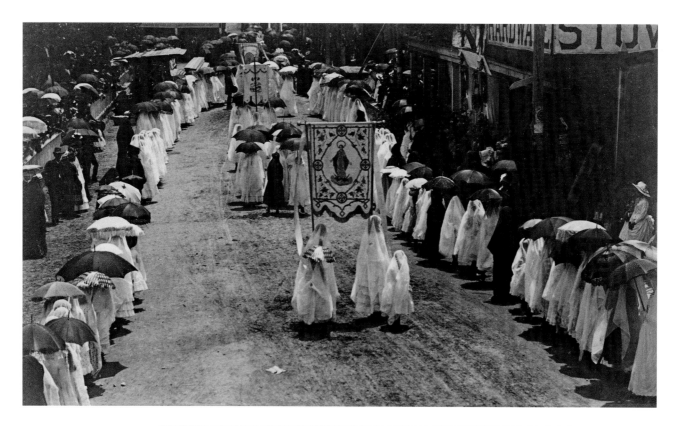

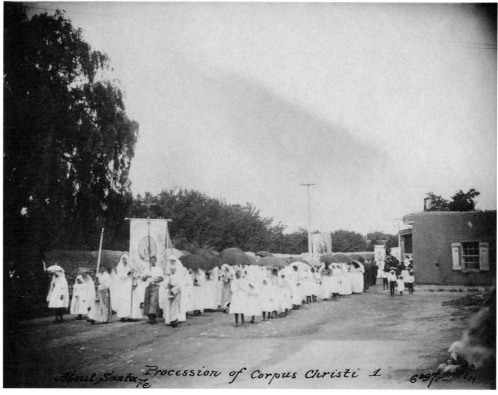

DANA B. CHASE

CORPUS CHRISTI PROCESSION, CA. 1890

PHILIP EMBURY HARROUN

PROCESSION OF CORPUS CHRISTI ABOUT SANTA FE, JUNE 1897

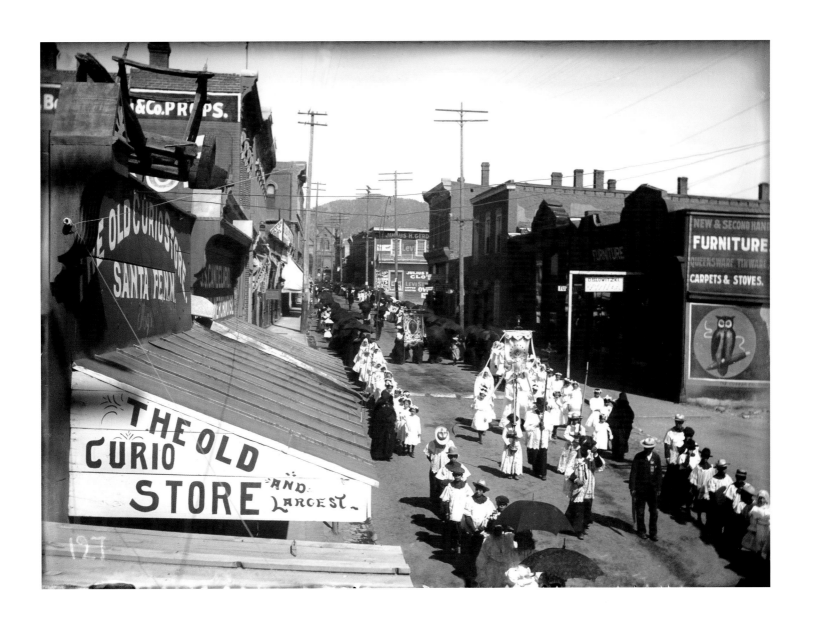

JESUS SITO CANDELARIO

LA CONQUISTADORA PROCESSION,
SAN FRANCISCO STREET, CA. 1908

LEE FRIEDLANDER

SANTA FE, 1975

LEE FRIEDLANDER

SANTA FE, 1975

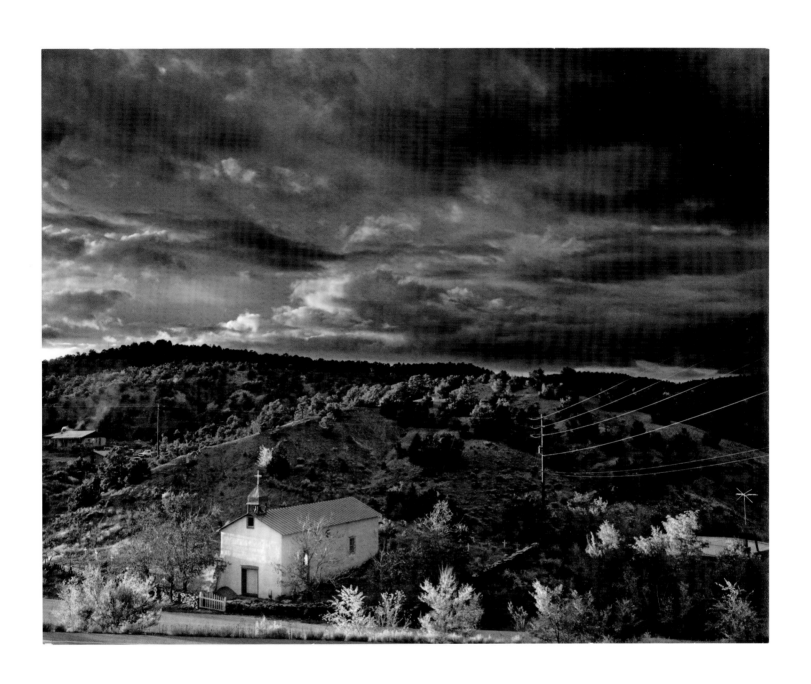

CRAIG VARJABEDIAN

SUNSET AND EVENING STORM, CANONCITO
AT APACHE CANYON, NEW MEXICO, 1985

DOUG KEATS

CRISTO REY CHURCH, SANTA FE, NEW MEXICO, 1990

DONALD WOODMAN

EL ORATARIO DE LORENZE LOPEZ CHAPEL ON CERRO GORDO,
SANTA FE, NEW MEXICO. NEON BY JAN BEAUBOEUF, 1984

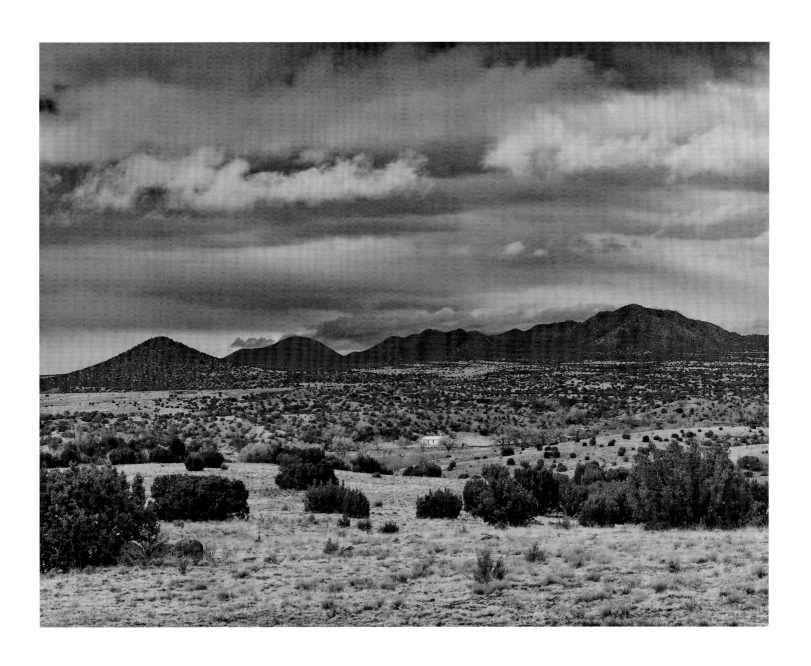

ALAN ROSS

CHURCH AND CLOUDS, LA CIENEGA, 2000

HISTORY

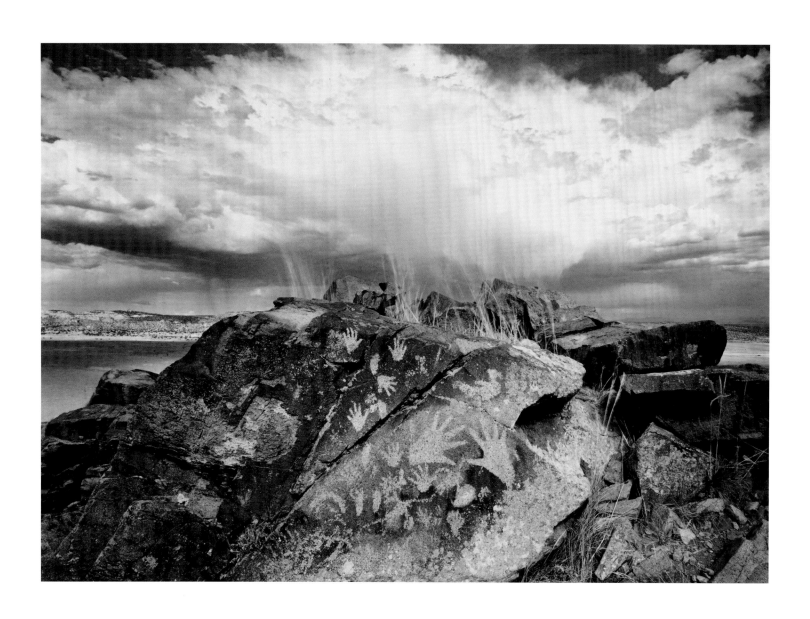

KENT BOWSER

STORM, GALISTEO BASIN, AUGUST, 1992

SANTA FE AND SANTA FEANS: A FOUR-HUNDRED-YEAR JOURNEY

DAVID GRANT NOBLE

Four centuries have come and gone since Pedro de Peralta and his Spanish colonists surveyed a parcel of land for a new *villa* along the northern bank of a winding stream flowing from the foothills of the Sangre de Cristo Mountains. Since then, the streets and alleys of New Mexico's capital city have witnessed a sweep of history unique in North America. Historians differ on just when members of New Mexico's founding colony first laid eyes on the site and commended its advantages for settlement. But no matter the exact date, they must have recognized its potential for farming, grazing, hunting, and obtaining wood for building and heating homes. They saw more, for the place has beauty and spirituality, and they named it Santa Fe.

As these seventeenth-century frontier folk became established in their new home, we may wonder what vision they had for the future. Given the challenges they had overcome since arriving in New Mexico in 1598, their aspirations may have projected no further than surviving the coming winter. But before long they were harvesting crops, laying in stores of food, and feeling comfortable in their new houses. Imagine a group of neighbors at the home of friends on some special day. Perhaps they roasted a side of venison, along with some freshly picked squash to wrap in corn tortillas. After eating, they may have gathered around the hearth to talk about their present lives and to discuss the years and generations ahead. What did they speculate Santa Fe's future might hold for their grandchildren, great-grandchildren, and generations beyond?

PREHISTORIC SANTA FE

One thing we know about Santa Fe's first European colonists is that they were aware of earlier inhabitants through the discovery of artifacts and interaction

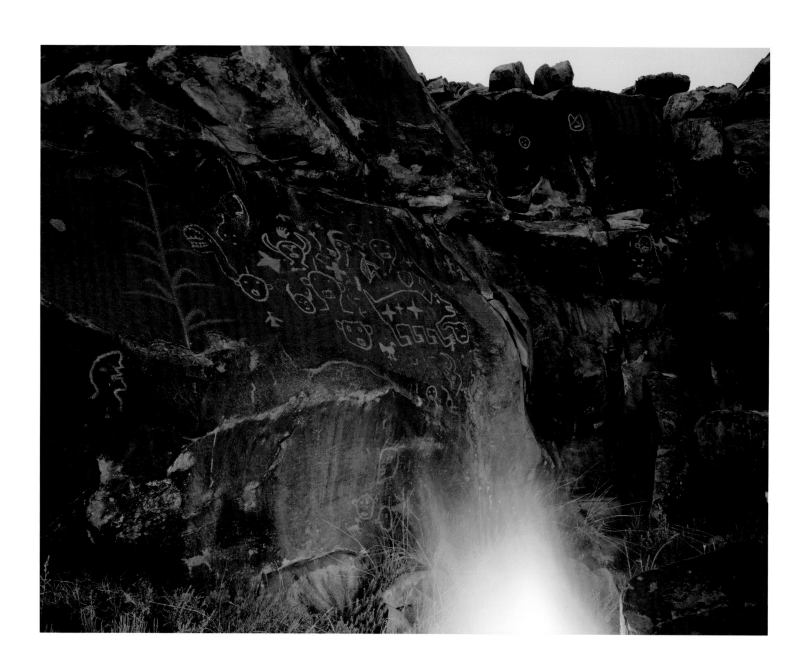

STEVE FITCH
A FIRE AND PETROGLYPHS AT DUSK NEAR SAN CRISTOBAL RUIN,
NEW MEXICO, JULY 28, 1983

with native peoples. Perhaps near their dwellings they saw adobe house mounds, potsherds, and bits and pieces of stone and bone implements—all evidence of earlier inhabitants. Or maybe their children lugged home stone metates still serviceable for corn grinding. Subsequently, over the past sixty years, and especially over the last twenty, archaeologists have learned much about pre-Columbian Santa Fe.

Before 6000 BCE, people we refer to as Paleo-Indians roamed North America. These nomadic hunters certainly would not have overlooked the rich natural resources around Santa Fe. Indeed, we know they fashioned spear points and other tools on a butte not far west of the present city limits. After the Paleo-Indians, Archaic-period hunter-gatherers also knew this fertile, well-watered, game-rich region. Small family groups made their camps on the slopes of the foothills and in the rolling piedmont south and west of town. Most of their campsites were simple affairs—a hearth, work area, and sheltered place to sleep—but some included more permanently constructed brush and mud dwellings. Typically, people used such camps seasonally, year after year, as they moved across the landscape collecting a wide variety of resources needed for survival.

Indigenous people in the Santa Fe and northern Rio Grande region did not begin to practice agriculture until after around 750 CE, much later than people in some other parts of the Southwest, where maize cultivation had commenced two to three thousand years before. Why the delay? Perhaps small numbers of people living in a resource-rich environment found that the familiar foraging ways provided plenty for all.

Between around 800 and the mid-1400s, Santa Fe and its environs were favored homes for Pueblo people. In recent years, archaeologists have excavated parts of an extensive prehistoric pueblo in downtown Santa Fe, perhaps the same site early settlers had seen and referred to as el pueblo quemado. Now more aptly named El Pueblo de Santa Fe, it is one of several similar large sites in and around the city that have been researched. Pindi Pueblo, five miles downriver, is another Pueblo site, as is Arroyo Hondo Pueblo south of town. It is now known that early Pueblo people lived in such settlements around Santa Fe until the mid-1400s, when the effects of drought and exhaustive use of natural resources motivated them to relocate.

EARLY COLONIAL SANTA FE

Santa Fe was the governmental center of colonial New Mexico. Pedro de Peralta's mandate from the viceroy in Mexico City demanded that he provide his

people with protection and create conditions in which they could "begin to live in order and decency." The colonists constructed government offices in and around the *casas reales,* later called the Palace of the Governors. They divided the nascent town into districts and elected councilmen, judges, a sheriff, and a notary. Each family received an allotment of land for a home, vegetable gardens, and livestock grazing. Farmers, who made up the majority of the population, preferred living away from the Plaza and close to their fields along the river.

Fully aware of their vulnerability, Santa Fe's settlers laid out their town defensively. The contiguous structures that surrounded the Plaza formed, in effect, a walled compound from which they could defend themselves from potential attackers, at least in theory. The Mexican Indians who had accompanied the colonists on their northward trek twelve years earlier resided across the river in a neighborhood still known as Barrio de Analco, where they built their own church, El San Miguel Mission.

Peralta's authority, which derived from his position as governor, chief judge, and commander of a small contingent of soldiers, was soon challenged by the Catholic Church, represented in New Mexico by Franciscan missionaries. An ensuing power struggle between the two institutions lasted for decades. The most contentious issue was the treatment of the Pueblo Indians, who had been reduced to a subservient status and were forced to provide tribute in the form of food, cloth, and supplies, as well as labor for church construction and other projects.

Many problems beyond church–state conflicts, including increasingly tense Spanish–Indian relations, corrupt authorities, drought, food shortages, the spread of infectious diseases, and raids by nomadic tribes from the Plains, plagued seventeenth-century inhabitants of New Mexico. As the governmental center, Santa Fe was deeply involved in all of them. These problems all contributed to the Pueblo Revolt, which began on August 11, 1680.

When Juan de Oñate first led Spanish colonists to New Mexico in 1598, he encountered independent, self-governing Indian villages up and down the Rio Grande Valley. Under Spanish domination, the Pueblo people experienced economic exploitation, social disruptions, religious oppression, and infectious diseases that greatly reduced their numbers. Their various attempts to rebel against Spanish rule met with failure. Then, in 1675, Spanish authorities arrested forty-seven Tewa Indians on charges of practicing sorcery. The Spanish executed three of them, while another committed suicide and the rest were sentenced to imprisonment and corporal punishment. This incident became a catalyst for unification of the Pueblos in a common cause. Under a San Juan leader named Popé, they planned to revolt.

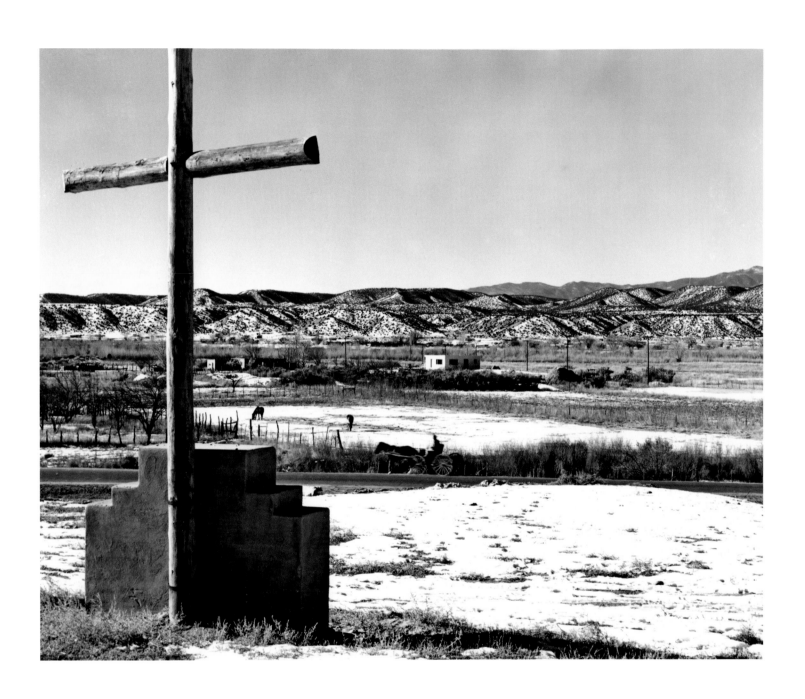

LAURA GILPIN
NEW MEXICO'S FIRST CAPITAL, SAN GABRIEL DEL YUNQUE
FOUNDED IN 1598 BY DON JUAN DE OÑATE, N.D.

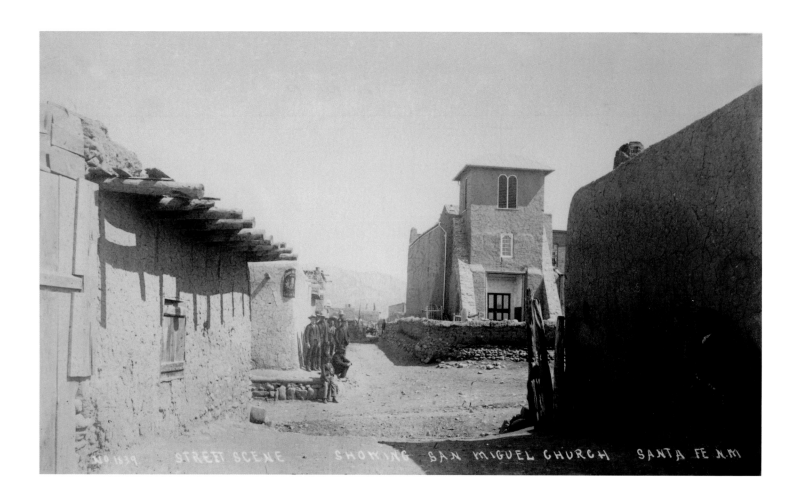

UNKNOWN PHOTOGRAPHER
STREET SCENE SHOWING SAN MIGUEL CHURCH,
SANTA FE, NEW MEXICO, CA. 1880

THE PUEBLO REVOLT

The Pueblo Revolt devastated the Spanish colonists living up and down the Rio Grande Valley. Survivors from the northern settlements fled to Santa Fe seeking protection in the fortified casas reales. Soon, however, thousands of Pueblo warriors gathered across the river and laid siege to the town, cutting off the colonists' water supply. After a battle on August 20, 1680, Governor Antonio Otermin accepted the hopelessness of the colonists' situation and led them south into exile in El Paso del Norte.

Santa Fe became a Pueblo town. Its new occupants razed houses and churches, desecrated Christian symbols, and remodeled the casas reales into a multistory Pueblo-style structure. Although little detailed information exists about life in Santa Fe during the subsequent twelve years, it is known that the Pueblo leadership changed, Popé died, preexisting rivalries among the Indians resurfaced, and their previous unity disintegrated. In 1692 a new Spanish governor, Don Diego de Vargas, led troops up the Rio Grande Valley and ceremonially repossessed Santa Fe. He returned the following year in the dead of winter with seventy families, tried unsuccessfully to negotiate with Santa Fe's Indian occupiers, and finally attacked and reconquered the town. Within four years, the entire New Mexican province was again under Spain's rule.

THE LATER COLONIAL PERIOD

After the reconquest, Spanish leaders developed a more tolerant and collaborative policy toward the Pueblo Indians. They learned a hard lesson in 1680 and now needed the Pueblos' support to defend Santa Fe and New Mexico from an increasing threat from nomadic tribes: the Ute, Apache, Comanche, and Navajo. Expert horsemen, warriors from these groups had begun raiding and plundering rural settlements and pueblos, especially in late summer following the harvest.

In the eighteenth century, waves of new settlers traveled up El Camino Real to Santa Fe. By 1790 the city's population surpassed twenty-five hundred. Many newcomers stayed only briefly before establishing farming settlements in the northern river valleys, often in proximity to existing Indian pueblos. Santa Fe also gained a presidio manned by regular troops (albeit not many), who were reinforced by local Spanish and Pueblo militias as emergencies arose. When circumstances required, military campaigns against Indian adversaries set forth from the Plaza to recover stolen livestock. The best-known expedition, led by Don Pedro de Villasur in 1720, rode eastward onto the Plains (to present-day Nebraska) to confront a force of Pawnees and French. The campaign ended in a

defeat that is documented in the Segessor Hide Paintings displayed in the Palace of the Governors Museum.

Colonial Santa Feans were a socially stratified lot. Those of pure Spanish heritage held the most elite positions in the government and church, while the lower-ranking *castas*, being of mixed blood, made their living as landless laborers, herders, and servants. Most people farmed and for practical reasons chose to live close to their fields. Farmsteads dotted the area along the Santa Fe River from upstream of the Plaza to La Cienega. To water their crops, farmers built an extensive system of irrigation ditches, several of which remain in use today, although no longer for agriculture. To improve defenses, various governors attempted to force outlying farmers to move into town; however, their efforts met with strong resistance and ultimately failed.

Although Santa Fe was New Mexico's capital city at the end of El Camino Real, official visitors often vividly expressed their disappointment at the shoddy appearance of the place: this was no Mexico City. The houses were roughly constructed, single-story earthen dwellings, and the alternately dusty or muddy and usually unsanitary *caminos* wandered about seemingly without plan. As for the people, they were a hardy, outgoing, and self-reliant lot, but many lived at minimal subsistence levels and were entirely unschooled.

THE MEXICAN PERIOD AND SANTA FE TRAIL

When Mexico won its freedom from Spain in 1821, the long-held ban on travel to New Mexico by foreigners was lifted. Official independence celebrations had not yet even taken place when a ragtag band of adventurers from Missouri with salable goods packed on their horses arrived on the Plaza, opening the Santa Fe Trail. Before long, the abundance of affordable, high-quality merchandise that poured into town outstripped local demand, and caravans made a shortcut straight down to Chihuahua, Mexico. Sturdy cotton cloth and fine fabrics made up the majority of the goods sold, but traders also brought jewelry, toiletries, sewing supplies, pots and pans, assorted metal tools, and rifles. When caravans arrived, residents around the Plaza rented their front rooms to the traders. As Santa Feans formed their own companies and joined the lucrative trading, a local merchant class, with growing commercial and cultural ties to the United States, began to emerge.

Santa Fe thrived as a commercial center during the Mexican period, 1821 to 1846. However, this northernmost department of the new republic to the south received little backing from the revolving administrations in Mexico

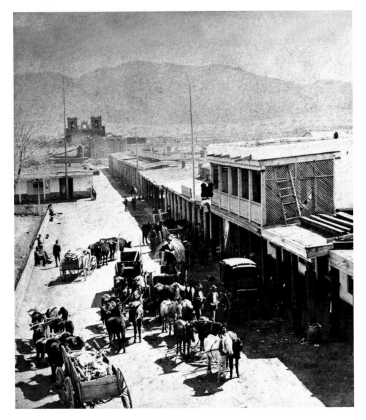

City, which discontinued support of the churches and clergy and even neglected the military. On the other hand, the old caste system, which had so stifled social and professional advancement for the lower classes, was abolished, and women enjoyed more independence and freedoms than their counterparts in the United States. In 1837, when New Mexicans learned they might be taxed for the first time, they rebelled, overthrew officials in Santa Fe, and installed their own governor. In a matter of months, however, Manuel Armijo, a former governor, led forces up from Albuquerque to restore order.

NICHOLAS BROWN
WAGON TRAIN AT THE END OF THE SANTA FE TRAIL, CA. 1870

HENRY T. HEISTER
SAN FRANCISCO STREET AT THE PLAZA, CA. 1878

UNKNOWN PHOTOGRAPHER
END OF THE SANTA FE TRAIL BEFORE RAIL-ROAD DAYS, N.D.

THE U.S. TAKEOVER

In 1803 the United States purchased the Louisiana Territory, thereby extending its borders to New Mexico. By 1846 New Mexicans and Americans had enjoyed a generation of lucrative trading and other interactions. Mexico was weak, however, and the United States was in an expansionist frame of mind. On August 18, 1846, fifteen hundred U.S. troops marched into downtown Santa Fe under the command of General Stephen Watts Kearny, who informed the citizenry that New Mexico was now annexed to the United States. With this, many Santa Fe residents saw a third national flag fly over the governor's palace in their lifetime. The

U.S. takeover came off peacefully, at least in Santa Fe, and was accepted by most members of the city's new middle class. Those who objected to the conquest understood that to voice their feelings would lead to severe consequences.

Kearny and his dragoons soon departed Santa Fe, to be replaced by a regiment of Missouri volunteers, a rowdy, undisciplined group of men not shy in expressing their disrespect for the locals. After more than two centuries of being in charge of their own affairs, it was not easy for Santa Feans to find themselves the subjects of a foreign government and the objects of ethnic bias. The business boom that accompanied the military occupation hardly compensated for humiliations endured. Meanwhile, trade over the Santa Fe Trail continued to grow, reaching $3,500,000 in 1860 and generating profits to all involved. In addition to its economic impact, the trail was also a conduit for the introduction of the English language, Protestantism, and capitalistic practices.

Now that New Mexico was a territory of the United States, more people besides soldiers and traders traveled west to "foreign" Santa Fe. Especially after the Civil War, newcomers included entrepreneurs with an eye to land acquisition—the larger the scale the better. These individuals soon realized that the old Spanish and Mexican land grants were legally vulnerable and ripe for the taking. A clique of Santa Fe–based businessmen, bankers, lawyers, judges, and even some governors and newspapermen formed a network called the Santa Fe Ring, which in the late 1860s effectively took charge of affairs in the territory. Its primary focus was acquiring land. The direct influence of the ring members continued for a generation; the negative consequences of their shenanigans, and those of the people who took their places, continued and still cause resentment among New Mexicans of Spanish descent.

The Santa Fe Trail closed in 1880, replaced by the Atchison, Topeka and Santa Fe Railroad. Later, an extension of the Denver and Rio Grande line reached Santa Fe. To the consternation of Santa Fe's business community, the Atchison, Topeka and Santa Fe Railroad decided to run its main line directly from Las Vegas to Albuquerque, bypassing the capital city. After six decades as an import–export hub, Santa Fe now faced an economic downturn. Investment capital dwindled, businesses closed or relocated, and both the population and the workforce sharply declined. Not a few unemployed Hispanics went back to farming. At about the same time, however, the city constructed a gasworks and reservoir, installed water mains, and finally incorporated. An era of modern services was arriving. In another positive development, a spur line of the railroad began bringing more people, including tourists, to town.

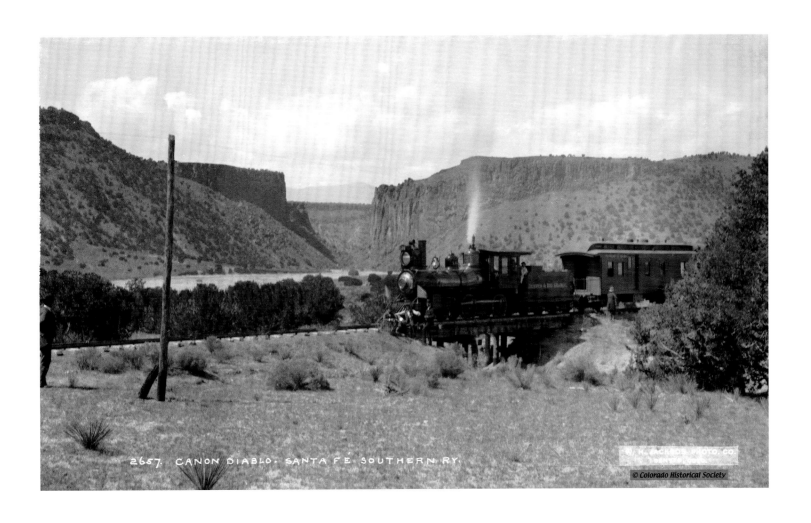

2657. CANON DIABLO. SANTA FE SOUTHERN RY.

WILLIAM HENRY JACKSON

CANON DIABLO, SANTA FE SOUTHERN RAILROAD, CA. 1886

THE TWENTIETH CENTURY

As Santa Fe advanced into the twentieth century and New Mexico gained statehood, some leading citizens recognized that the city's special multicultural and historical character held promise for attracting renewed prosperity. In the footsteps of Adolph F. Bandelier, anthropologists arrived to record Indian culture and investigate prehistoric ruins. Artists and writers came, too, and their works, often expressing a romantic flavor, became known in the world beyond. With the railroads promoting the beauty and exotic charms of travel in the Southwest, more tourists began to arrive in Santa Fe.

As Dr. Frances Levine details in her introduction to this book, the establishment of new cultural institutions promoted scientific research and artistic creativity, as well as cultural preservation and a "Santa Fe style" of architecture. Civic leaders successfully promoted Santa Fe's "exotic" character to foster economic renewal and to develop modern services needed to accommodate visitors. As a result, the city's population swelled, even during the years of the Great Depression. Admittedly, New Deal programs and burgeoning government agencies accounted for a good portion of this growth.

Hispanics, who had fared less well than Anglos economically during the post–Santa Fe Trail years, benefited from new white-collar employment opportunities in the 1930s. When the country entered World War II, many Hispanics joined up or found employment at Los Alamos National Laboratories and in other war-related industries. Farming declined regionally. In Santa Fe, the water company, which eventually built three reservoirs, released less and less water for irrigation. In 1936 farmers along the river were irrigating eight hundred acres. Forty years later, despite fighting for their inherited water rights, they were irrigating only sixty-two.

Trends visible early in the twentieth century picked up momentum at the war's end. More people had urban jobs, especially in various levels of government. Cultural institutions multiplied—the Santa Fe Opera was founded in 1957, and St. John's College in 1964—and tourism grew, with visitors now arriving in automobiles and staying for longer periods. Some purchased second or retirement homes and gained a stake in the community. Soon city leaders had to deal with how to intelligently manage growth and cope with the multitude of socioeconomic problems already familiar to many other American cities. These challenges included improving public education, attracting well-paying jobs, building infrastructure and affordable housing, managing urban sprawl, dealing with crime and economic disparities, and planning for long-term water resources.

AARON B. CRAYCRAFT
RESERVOIR, SANTA FE, CA. 1913

TONY O'BRIEN
SANTA FE OPERA HOUSE, N.D

Santa Fe's first settlers, both Native American and Spanish, confronted basic survival needs: food, shelter, and clothing. The fact that four hundred years later some Santa Feans still cope with these problems probably would not have surprised the early colonists. But as they sat around the hearth and speculated about the lives of their descendants, they could never have imagined the revolutionary cultural changes and the complexity that would characterize their town in the future. In the past century especially, the lives of Santa Feans have evolved at an ever-accelerating pace. Community leaders, both civic and spiritual, now deal with a host of challenges that even our grandparents could not have foreseen. At the same time, however, we cannot help but recognize and appreciate the historical continuities that characterize Santa Fe. Like the deep and spreading roots of a tree, they continue to support and nourish the inhabitants of our venerable and beautiful city.

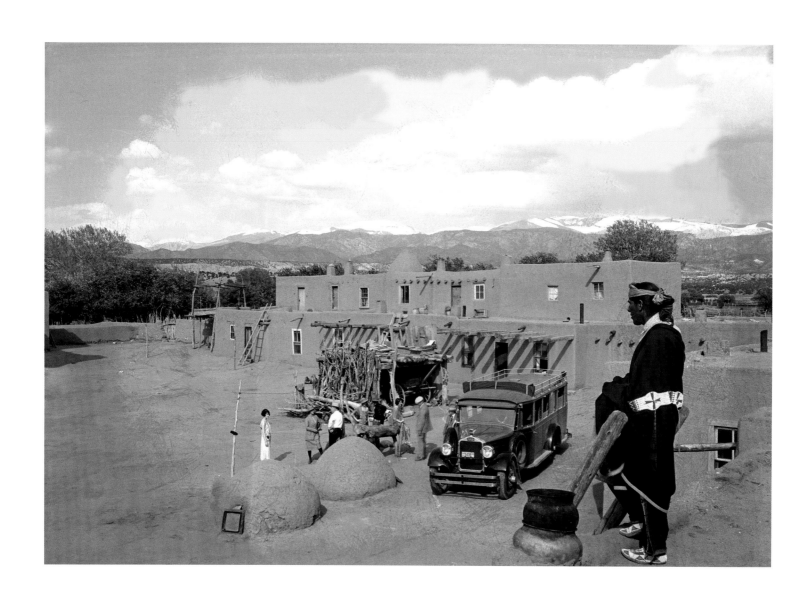

T. HARMON PARKHURST

TESUQUE PUEBLO, CA. 1925

AT THE END OF THE TRAIL: SANTA FE AND ITS PHOTOGRAPHIC EMERGENCE IN THE LATE NINETEENTH CENTURY

SIEGFRIED HALUS

In the 1880s, the establishment of the transcontinental railroad opened the Southwest to accelerated expansion, tourism, and artistic depiction by painters and photographers. The railroads publicized New Mexico as an alternative to the European grand tours, comparing its sites to those of Egypt, the Near East, and other exotic destinations. Southwestern tours offered unique experiences to travelers from California and the East, bringing them into contact with the historic town of Santa Fe, traditional native life, and the recently rediscovered ruins of ancient Anasazi settlements. Tourists, scholars, and archaeologists could now visit and explore the region with a measure of comfort. The expansion of railroads and subsequent photographic documentation of New Mexico would have far-reaching consequences for Santa Feans. The development of the railroad into the heart of the Southwest created interest not only for tourists but also for adventurers, traders, shopkeepers, cattle ranchers, and professional craftsmen and photographers, many heeding Horace Greeley's advice to "Go West, young man."

During this period, the visual depiction of Santa Fe as a romantic destination began in earnest. Photographers came to Santa Fe to document the Native American, Hispanic, and Anglo cultures that made up this historical community. In the words of Colorado photographer J. L. Clinton, written on the verso of a photographic card, "No city in America will so liberally reward the sightseer and curiosity hunter. It is of another civilization, and one feels as in a foreign land."

To maintain a competitive edge, nineteenth-century photographers had to contend with rapid developments in photographic technology. With each new mechanical or chemical innovation, photographers were required to make drastic adjustments, such as shifting from the use of the daguerreotype, which required

an extraordinary effort to produce an image that could not be replicated, to the use of paper negatives or glass-plate negatives, which could be used to produce multiple images. Their circumstance was not unlike what photographers are experiencing today in trying to adjust silver-based materials to accommodate digital technology.

To produce a daguerreotype, a photographer had to polish a copper plate coated with a thin veneer of silver, introduce vapors of iodine that produced a light-sensitive coating of silver iodide, and then place the plate in a light-proof container to make the exposure. Once the exposure was made, the silver plate was developed in a light-tight chamber with heated mercury, whose released vapors reacted with the exposed silver iodide to produce an image in an amalgam of silver mercury. The image was then fixed in a solution of salt or hyposulfite of soda and toned with gold chloride for color enhancement and permanence. Finally, the fragile daguerreotype was sandwiched between glass and a metal mat, sealed to avoid oxidation or tarnishing, and fitted into two hinged cases. Later, when William Henry Fox Talbot introduced the paper calotype process, his discovery led to the development of the glass-plate negative, which could be used to produce multiple images, resulting in declining use of the daguerreotype.

One pioneering photographer who documented frontier life in New Mexico beginning in 1878 was George Ben Wittick, who came to Santa Fe while working as a photographer for the Atlantic and Pacific Railroad, which eventually became the Atchison, Topeka and Santa Fe Railroad. Wittick settled in Fort Wingate—after having worked in Santa Fe, Gallup, and Albuquerque—where he made important studio portraits of Navajo people. The photographs Wittick made of Navajos are valued by anthropologists and historians for their detailed ethnographic information and cultural authenticity. One of a handful of photographers to work with a large-format studio camera, Wittick attracted numerous customers with his high-quality prints made from large negatives. He also produced stereographs, images that were popular from the mid-nineteenth century well into the twentieth century. The stereograph is the result of a simultaneous exposure in camera, with two lenses mounted in slightly different positions laterally. Once two prints are made, mounted on a stiff card, and viewed through a stereoscope, they combine to create a binocular or three-dimensional view. Wittick also made cabinet cards, usually portraits and scenic views, which became popular and are found today in many photographic archives and collections. Wittick died in 1903 from a rattlesnake bite that had been predicted earlier by a Hopi medicine man.

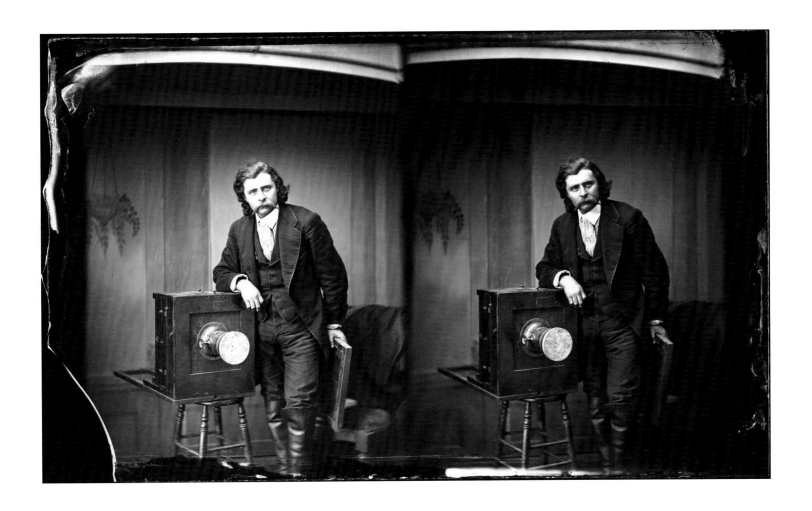

BEN WITTICK

BEN WITTICK WITH CAMERA, N.D.

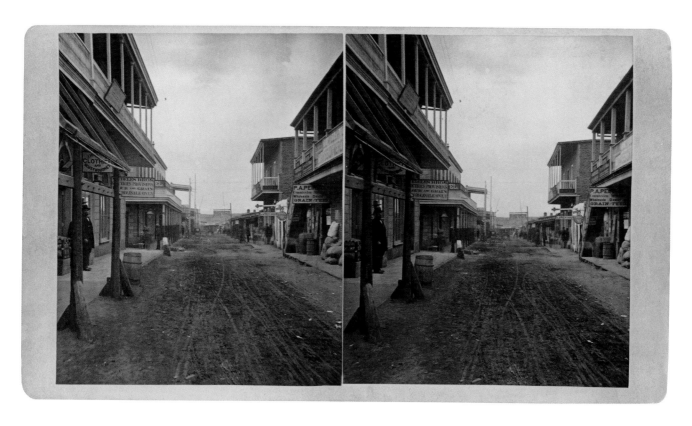

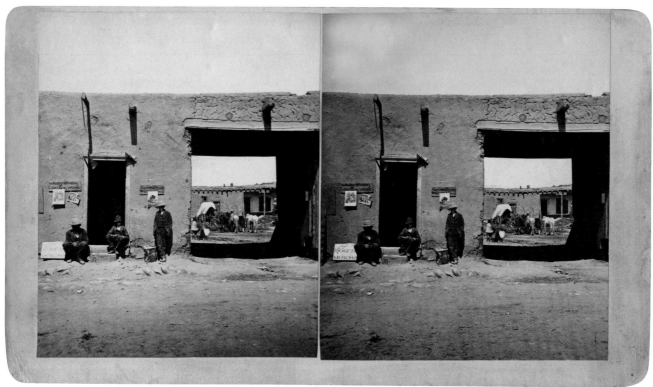

BEN WITTICK

SANTA FE LOOKING WEST ON SAN FRANCISCO
STREET, APRIL 1887

BEN WITTICK

ENTRANCE TO MEXICAN CORRAL, 1880

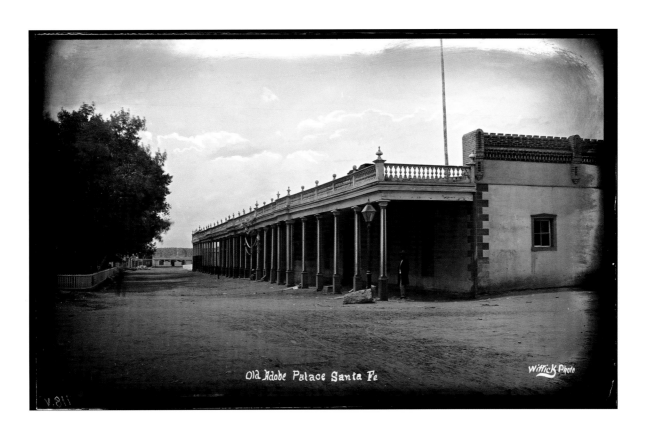

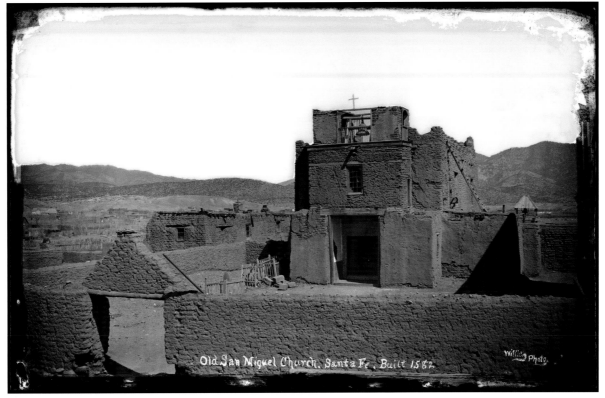

BEN WITTICK

OLD ADOBE PALACE, SANTA FE, NEW MEXICO, 1880

BEN WITTICK

OLD SAN MIGUEL CHURCH. SANTA FE, BUILT 1582, MAY 1880

Another photographer fascinated by New Mexico was Adam Clark Vroman. Vroman preferred to photograph with a large-format camera with a negative size of 6½" x 8½". His first trip to the Southwest was in 1895 to photograph the Snake Dances at Walpi. Not unlike numerous photographers before and after, Vroman was also attracted to the historic and architectural significance of Santa Fe. His photographic style was distinctive and had an authenticity that distinguished it from much other photography produced in the late nineteenth century. His images were exquisitely composed and artfully printed. They showed an understanding of spatial drama and the importance of detail. When making portraits, Vroman often positioned the camera to include deep spatial information about interiors; he frequently placed his subjects toward the back of a room, thereby suggesting equality between environment and subject. In 1899 Vroman photographed the already famous Palace of the Governors, including in the image utility poles and wires that remind us of the encroaching technology that the twentieth century would bring.

Vroman also made beautiful landscape images. Technological advances in film allowed him to photograph clouds with greater impact. By the middle of the 1880s, isochromatic film plates (a forerunner of orthochromatic film) were available. Because they were more sensitive to green and yellow light waves, less to blue, and not at all to red, they enabled Vroman to include dramatic cloud formations in his landscape work. His fascination with clouds and the sheer scale of the New Mexican landscape often led him to use up most of his film before he got to a planned destination. He contact-printed his images on platinum paper, which gave the prints a very long gray scale, delicate details, and warmth. Consequently, his beautifully printed photographs are sought after by collectors and museums. Andrew Smith of Andrew Smith Gallery in Santa Fe believes that Vroman was one of America's first modern photographers.

One of the most adventurous of the early photographers of the Southwest was Charles F. Lummis. In 1884 Harvard-educated Lummis began an epic journey on foot, across the American West from Ohio to Los Angeles, an extraordinary adventure into the unknown that would help define the image of the documentary photographer. In Ohio he left behind a wife and a job as newspaper editor. His trek across hostile territory brought him into contact with unique individuals who would shape the rest of his life and deliver him to his destiny among the people and cultures of the Southwest. Not unlike pilgrimages to Mecca and the Holy Land, or spirit quests among native peoples, Lummis's journey was both instructional and spiritual in nature. It included long periods of self-imposed silence, as well as photography of the cultural and native life of

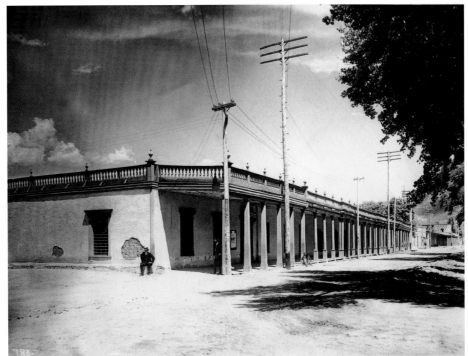

ADAM CLARK VROMAN

*SANTA FE, NEW MEXICO, SAN MIGUEL CHAPEL
ERECTED 1582, BURNED 1680, REBUILT 1692.
CONTAINS PICTURES 500 TO 700 YEARS OLD,
MARCH 8, 1900*

ADAM CLARK VROMAN

*GOVERNOR'S PALACE, SANTA FE, NEW MEXICO,
MARCH 8, 1900*

Santa Fe. Many others sought adventure on the western frontier, but few had the deep commitment that led Lummis to photograph New Mexico with such dedication and mastery.

When Lummis began his exhaustive photographic documentation of New Mexico and the Southwest in 1888, the era of the daguerreotype was over, the wet collodion process was waning, and most photographs were being produced on dry-plate negatives. By the 1880s, the monumental photographic contributions to the exploration of the American continent by such notable photographers as William Henry Jackson and Eadweard Muybridge were in full swing. Many of these photographers worked with the wet-plate process with extraordinary results, especially considering the hazards of transporting and handling large glass negatives. For most of his photographic career, however, Lummis made contact prints from dry-plate negatives, utilizing the cyanotype process (often referred to as sun printing), as well as salted paper prints. He worked with three traditional camera formats: 4" x 5", 5" x 7", and 8" x 10",

By the time Lummis was seriously documenting the environs of Santa Fe, he had begun to emphasize popular subject matter. He gravitated toward commercial interests and selected locations whose images would have greater sales value or wider distribution, such as the Oldest House, the cathedral, and the Palace of the Governors. But photographs of Indians were his mainstay and his greatest love, and this work began to occupy most of his time. Lummis first encountered Native Americans at San Ildefonso Pueblo in 1884, when he was invited by the pueblo governor to spend an extended period of time in the community. He appears to have established immediate rapport in the pueblo due to his disposition and authentic interest. In times of reclusiveness, he sought the relative solitude of Isleta and San Ildefonso pueblos; he developed lasting relationships with numerous residents and produced many photographs at these pueblos, as well as others. Early in his life, Lummis had had several strokes that resulted in loss of motion on the left side of his body, particularly his left arm. At Isleta Pueblo, he made quite an impression on many tribal members, since he arrived just after the death of one of their beloved tribal elders, who had also lost the use of his arm. In fact, some people at Isleta thought Lummis was a *brujo,* a witch, and they gave him the name Kha-tay-deh, or Withered Branch. While in the Southwest, Lummis communicated frequently with his old friend and former Harvard school chum Theodore Roosevelt, extolling the kindness and welcome he received at various pueblos. Lummis was disheartened by the popular press and literature of the period that universally characterized Indians as "savages." He let Roosevelt know in no uncertain terms that his Pueblo friends were

CHARLES LUMMIS
UNTITLED, N.D.

CHARLES LUMMIS
UNTITLED, N.D.

anything but savages and that a different federal policy toward Indians and their plight had to be developed.

Lummis's early photographs made at the pueblos had a traditional and somewhat pedestrian quality: his compositions were repetitious; he often weighted his subjects toward the middle ground, perhaps for expedience, with the exception of images made of larger events, such as feast days and social dances. However, Lummis's portraits of Pueblo people have a warmth and openness that reflect the deep social connections he developed while living at various pueblos. James C. Farris, in his controversial publication *Navajo and Photography* (2003), points out the inherent conflict Anglo photographers embodied when photographing Native Americans, especially Navajos. He postulates that the "taking" of such images represents a form of aggression and cultural possession. Lummis's portraits, however, with their sense of ease, uninhibited expression, and direct eye contact, leave observers with the distinct impression that there was genuine agreement and goodwill between photographer and subject. As Lummis's photographic skills and accolades for his work increased, his photographs gained considerable popularity, largely due to the Native American images and their documentary value. As a result, many of his photographs were used to illustrate books and journals to promote Indian causes, feed the curiosity of tourists, and spark interest in the new southwestern territories, thus promoting population expansion into Santa Fe.

Among the many photographers who came through New Mexico or worked exclusively in the Santa Fe area, Lummis can be seen as an early role model for what the future would require of a socially conscious photographer. Lummis exemplified the qualities required of a journalist, cultural researcher, and ethnographer. He represents for the nineteenth century a highly progressive, keenly inquisitive, and multidisiciplinary mind.

In addition to doing his own photographic work, Lummis collaborated with other prominent figures of the era. It was Lummis who first introduced Vroman to photography of the Southwest. They became close friends, and Lummis published many of Vroman's photographs in his journals and in his book *Land of Sunshine.* In 1888 Lummis befriended anthropologist Adolph Bandelier, and together they explored and documented Jemez Plateau—Lummis photographing and Bandelier recording his archaeological discoveries. Bandelier also published a novel, *The Delight Makers,* which chronicles his observations of the cultural practices of the Keres-speaking Pueblos in a powerful tale of early Anasazi life among the cliff dwellers of the Jemez Plateau. Lummis and Bandelier often stayed at Cochiti Pueblo, using it as a base for their many explorations.

During their treks, they developed a critical observational style in order to analyze vast amounts of material and numerous architectural remains.

In the 1920s and 1930s, when the Taos and Santa Fe art colonies began to flourish, more talented artists from the East and Europe came to northern New Mexico. They also focused on the Native American and Hispanic communities of the region, whose cultural and religious practices promoted in the popular literature inspired use of the term *enchantment* to describe the area. The mysterious spiritual quality of the land and its people still attracts photographers, who, whether consciously or unconsciously, come to Santa Fe seeking meaningful contact with its rich living cultures.

LEE FRIEDLANDER
SANTA FE, 2001

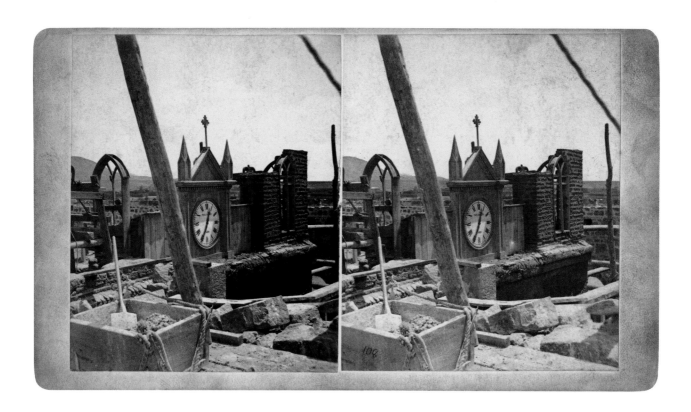

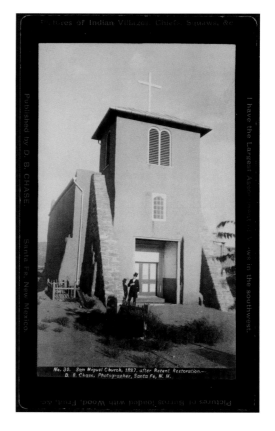

BEN WITTICK

OLD CLOCK AND BELLS, CATHEDRAL DE SAN FRANCISCO BEING BUILT, SANTA FE, JUNE 1880

DANA B. CHASE

SAN MIGUEL CHURCH AFTER RECENT RESTORATION, 1887

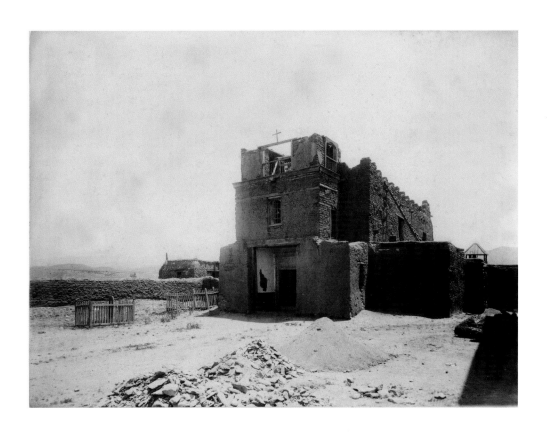

WILLIAM HENRY JACKSON
SAN MIGUEL CHURCH, 1881

T. HARMON PARKHURST
SAN MIGUEL CHURCH, N.D.

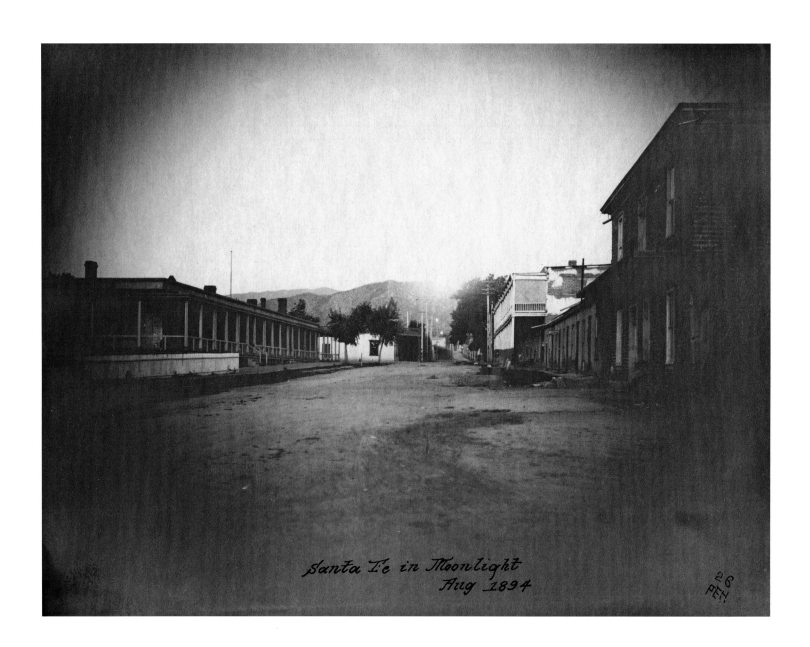

PHILIP EMBURY HARROUN

SANTA FE IN MOONLIGHT, AUGUST 1894

DAVID BRAM

LAMY FROM THE CERRO COLORADO, 2004

DOUG MAGNUS
RAILYARD AT NIGHT, 1970/2007

TERESA NEPTUNE
SANTA FE RAIL, SANTA FE, NEW MEXICO, 2004

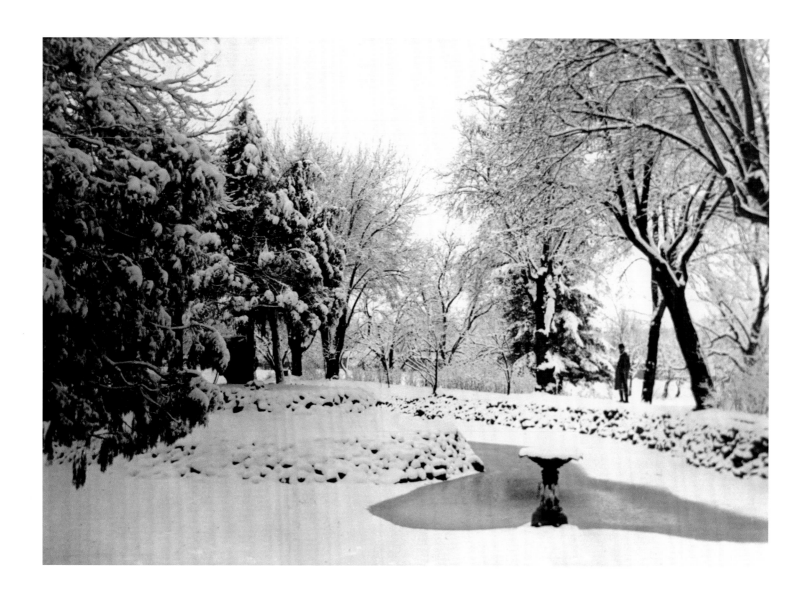

JESSE L. NUSBAUM

ARCHBISHOP LAMY'S GARDEN WINTER, SANTA FE, NEW MEXICO, N.D.

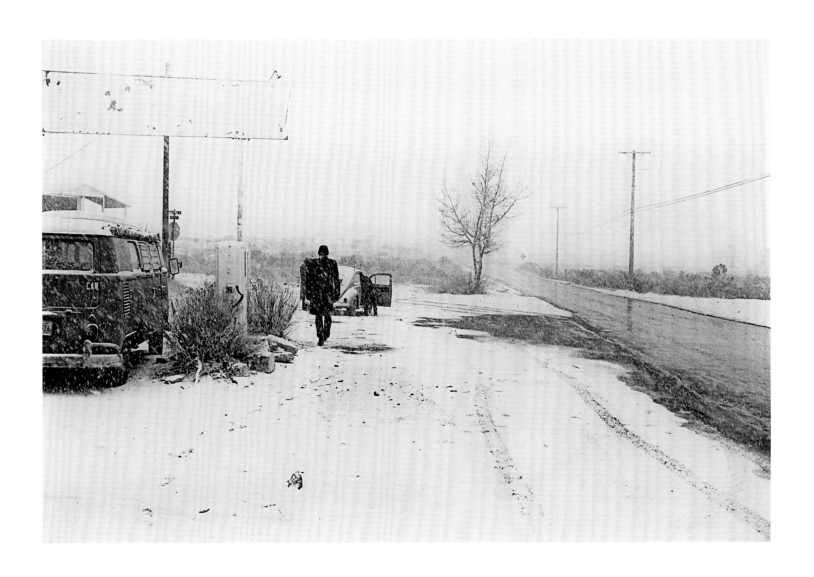

LAWRENCE MCFARLAND
JOHN RIPPLE IN A SNOW STORM AT THE GREASE PIT,
AQUA FRIA AND MAEZ, SANTA FE, NEW MEXICO, 1971

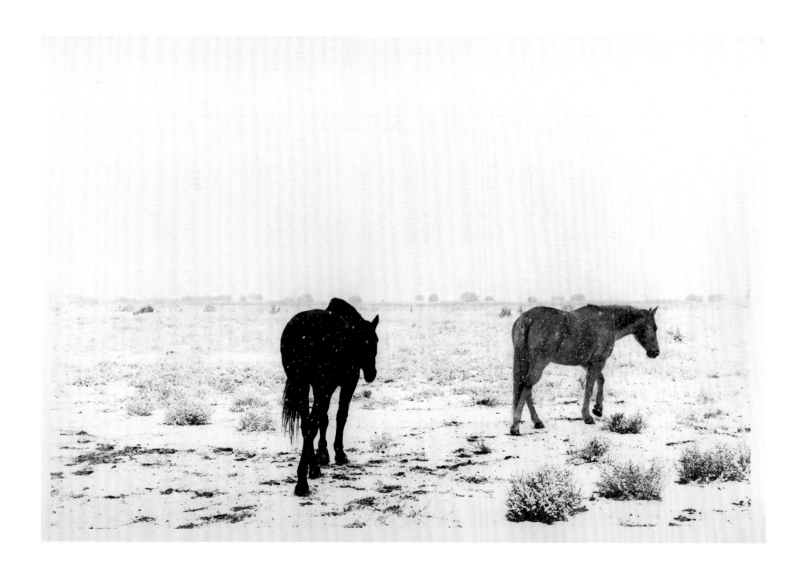

PATRICK PORTER
HORSES IN THE SNOW, GALISTEO BASIN, CA. 2000

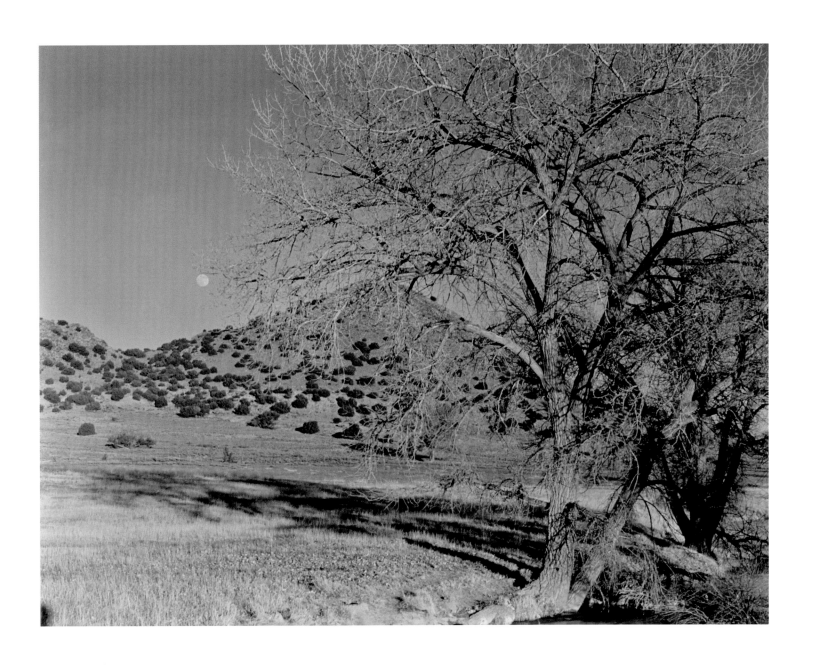

DAVID SCHEINBAUM

BONANZA CREEK ROAD, NEW MEXICO, 1984

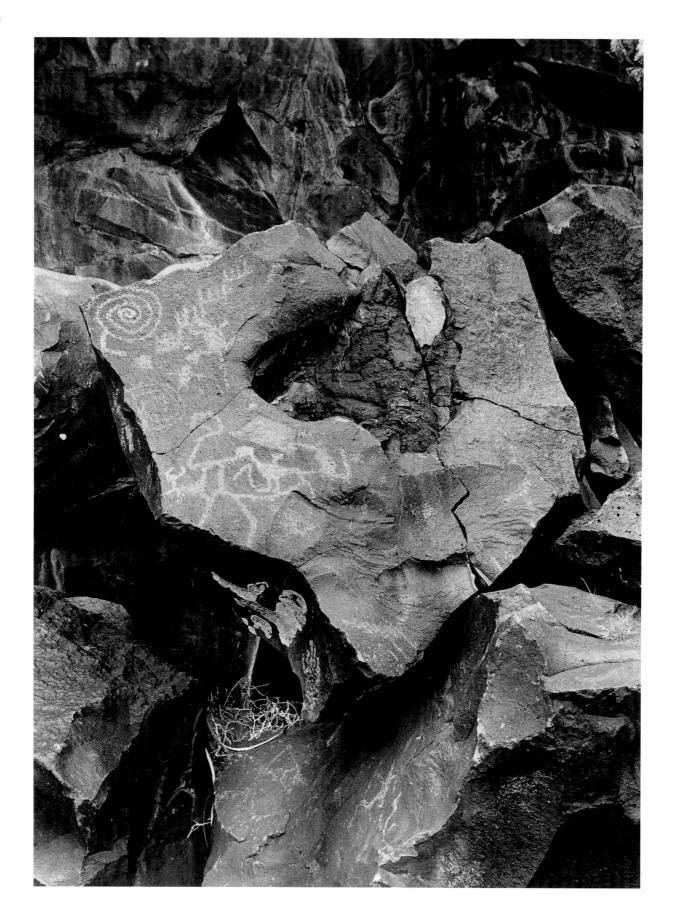

FORD ROBBINS

LEAF ROCK PETROGLYPH, 1994

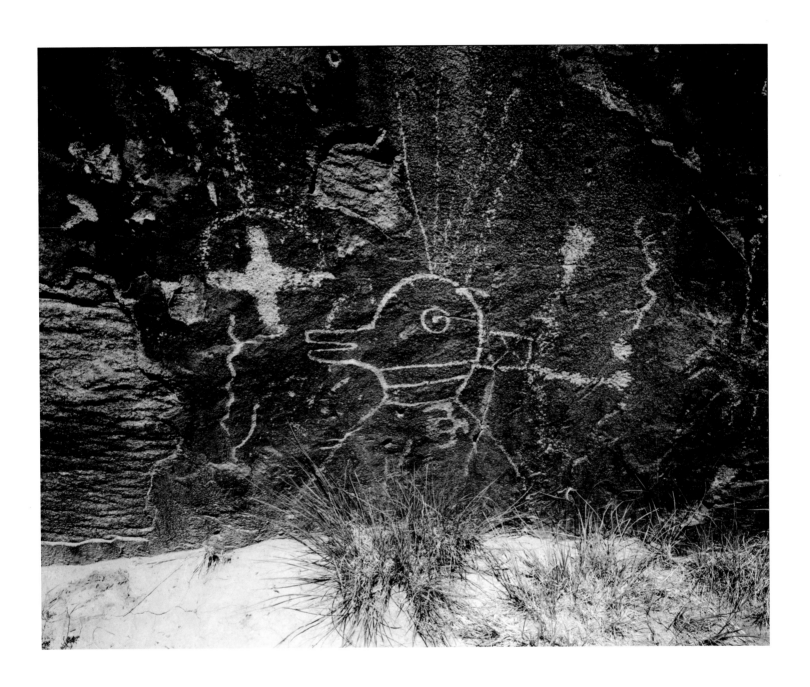

LINDA CONNOR
PETROGLYPHS, GALISTEO, 1989

EDWARD RANNEY

GALISTEO BASIN, NEW MEXICO LOOKING WEST TO COMANCHE GAP,
ORTIZ AND SANDIA MOUNTAINS, 2000

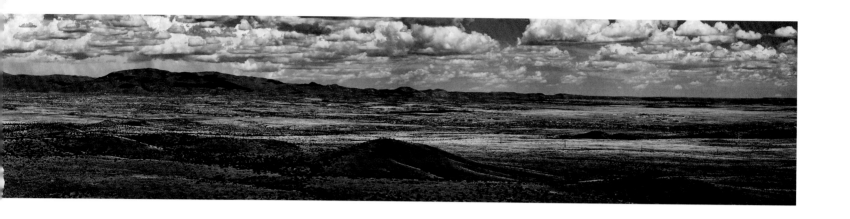

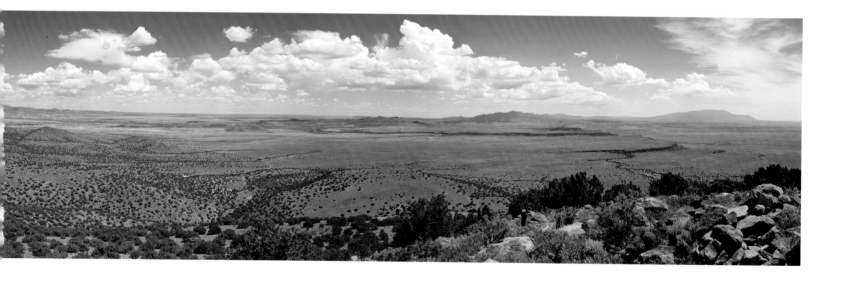

LYNN LOWN

SANTA FE PANORAMA, 2007

LYNN LOWN

FROM LA TETILLA PEAK, 2007

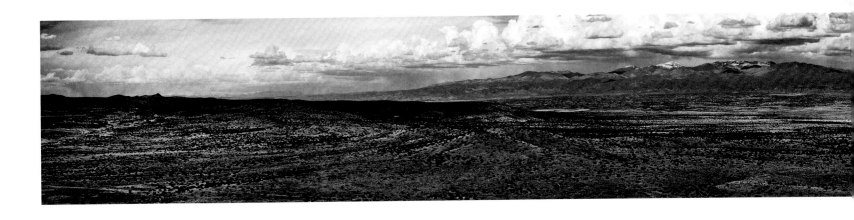

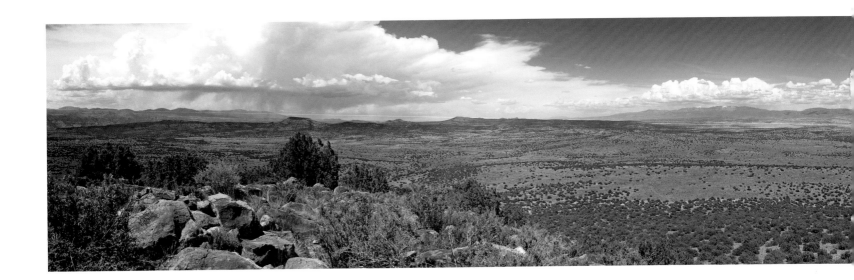

REFERENCES

LOOKING DOWN: SENSES OF PLACE IN SANTA FE

LUCY R. LIPPARD

Daly, Sue, and Steve Gross. *Santa Fe Houses and Gardens*. New York: Rizzoli, 2002.

Hammett, Kingsley. *Santa Fe: A Walk through Time,* Layton, UT: Gibbs Smith, 2004.

Jackson, John Brinckerhoff. "Looking at New Mexico." In *The Essential Landscape: The New Mexico Photographic Survey*. Edited by Steven A. Yates. Albuquerque: University of New Mexico Press, 1985.

———. *A Sense of Place, a Sense of Time*. New Haven, CT: Yale University Press, 1994.

Noble, David Grant, ed. *Santa Fe: History of an Ancient City*. Santa Fe, NM: School of American Research Press, 1989.

Sherman, John. *Santa Fe: A Pictorial History.* Virginia Beach, VA: Donning Company, 1983.

Wilson, Chris. *The Myth of Santa Fe: Creating a Modern Regional Tradition*. Albuquerque: University of New Mexico Press, 1997.

Yates, Steven A., ed. *The Essential Landscape: The New Mexico Photographic Survey*. Albuquerque: University of New Mexico Press, 1985.

IMAGING PLACE

MARY ANNE REDDING

Coke, Van Deren. *Photography in New Mexico: From the Daguerreotype to the Present*. Albuquerque: University of New Mexico Press, 1979.

Lewis, Nancy Owen, and Kay Leigh Hagan. *A Peculiar Alchemy: A Centennial History of SAR 1907–2007.* Santa Fe: School for Advanced Research Press, 2007.

Lippard, Lucy. *On the Beaten Track: Tourism, Art, and Place*. New York: New Press, 1999.

Lovato, Andrew Leo. *Santa Fe Hispanic Culture: Preserving Identity in a Tourist Town*. Albuquerque: University of New Mexico Press, 2004.

Neff, Emily Ballew. *The Modern West: American Landscapes 1890–1950*. New Haven, CT: Yale University Press, 2007.

Nicholson, Susan Brown. *The Encyclopedia of Antique Postcards/Price Guide*. Radnor, PA: Wallace-Homestead Book Co., 1994.

Phillips, Tom. *The Postcard Century*. London: Thames & Hudson, 2000.

Rudisill, Richard. *Photographers of the New Mexico Territory 1854–1912*. Santa Fe: Museum of New Mexico Press, 1973.

Sandweiss, Martha A. *Print the Legend: Photography and the American West*. New Haven, CT: Yale University Press, 2002.

Traugott, Joseph. *The Art of New Mexico: How the West Is One*. Santa Fe: Museum of New Mexico Press, 2007.

Wilson, Chris. *The Myth of Santa Fe: Creating a Modern Regional Tradition*. Albuquerque: University of New Mexico Press, 1997.

IN AND AROUND SANTA FE:
ANGLO PHOTOGRAPHERS AND TEWA PUEBLO PEOPLE

RINA SWENTZELL

Gilpin, Laura. *The Pueblos: A Camera Chronicle*. New York: Hastings House Publishers, 1941.

Rodee, Marian, ed. *When Cultures Meet: Remembering San Gabriel Del Yunge Oweenge*. Santa Fe, NM: Sunstone Press, 1987.

Starr, Kevin. *Perpetual Mirage: Photographic Narratives of the Desert West*. New York: Whitney Museum of American Art, 1996.

Wilson, Chris. *The Myth of Santa Fe: Creating a Modern Regional Tradition*. Albuquerque: University of New Mexico Press, 1997.

HISPANIC IDENTITY IN A TOURIST TOWN

ANDREW LEO LOVATO

Barnet, Sylvan. *A Short Guide to Writing about Art*. 9th ed. Upper Saddle River, NJ: Pearson Prentice Hall, 2008.

Karp, Ivan, Christine Mullen Kreamer, and Steven D. Lavine, eds. *Museums and Communities: The Politics of Public Culture*. Washington DC: Smithsonian Institution Press, 1992.

Lippard, Lucy. *On the Beaten Track: Tourism, Art, and Place*. New York: New Press, 1999.

Lovato, Andrew Leo. *Santa Fe Hispanic Culture: Preserving Identity in a Tourist Town*. Albuquerque: University of New Mexico Press, 2004.

Palmquist. Peter E., ed. *Photographers: A Sourcebook for Historical Research*. Revised 2nd ed. Nevada City, CA: Carl Mautz Publishing, 2000.

Rodriguez, Sylvia. "Art, Tourism, and Race Relations in Taos: Toward a Sociology of the Art Colony." *Journal of Anthropological Research* 45, no. 1:77–99.

Sherman, John. *Santa Fe: A Pictorial History*. Norfolk, VA: Donning Company, 1983 (1996).

Wilson, Chris. *The Myth of Santa Fe: Creating a Modern Regional Tradition*. Albuquerque: University of New Mexico Press, 1997.

CHECKLIST

Works in Italics are titled; in roman, described.

p. 156
Ansel Adams (1902–1984)
La Fonda Hotel, Santa Fe, New Mexico, 1928
Silver gelatin print, 8½ x 6½ in.
University of New Mexico University Libraries,
Center for Southwest Research
John Gaw Meem Collection, 000-675-055-022
© 2008 The Ansel Adams Publishing Rights Trust

p. 157
Ansel Adams (1902–1984)
La Fonda Hotel, Santa Fe, New Mexico, 1928
Silver gelatin print, 6¼ x 8¼ in.
University of New Mexico University Libraries,
Center for Southwest Research
John Gaw Meem Collection, 000-675-055-012
© 2008 The Ansel Adams Publishing Rights Trust

p. 82
Ansel Adams (1902–1984)
M. V. Conkey residence, Santa Fe, New Mexico, 1929
Silver gelatin print, 8½ x 6½ in.
University of New Mexico University Libraries,
Center for Southwest Research
John Gaw Meem Collection, 000-675-092-001
© 2008 The Ansel Adams Publishing Rights Trust

p. 83
Ansel Adams (1902–1984)
M. V. Conkey residence, Santa Fe, New Mexico, 1929
Silver gelatin print, 9½ x 7¾ in.
University of New Mexico University Libraries,
Center for Southwest Research
John Gaw Meem Collection, 000-675-092-003
© 2008 The Ansel Adams Publishing Rights Trust

p. 68
Sam Adams (1927–)
Pet Parade, Fiesta, Santa Fe, 1999
Silver gelatin print, 14 x 8 in.
Courtesy of the artist

p. 153
Anderson Studio (active ca. 1885–1905)
Mrs. Cleofas Martinez Jaramillo in her wedding hat, 1901
Cabinet card, 7¼ x 5¼ in.
Palace of the Governors/Photo Archives, 9920

p. 125
Lewis Baltz (1945–)
Santa Fe, 1972
Selenium-toned silver gelatin print, 6 x 9 in.
New Mexico Museum of Art, 1985.107.1

p. 130

Thomas Barrow (1938–)

Cancellations (Brown) Festival, 1973-74

Sepia-toned silver gelatin print, 9 x 13½ in.

Courtesy of the artist

p. 188

Ray Belcher (1944–)

Remidios and Post Office, Galisteo, New Mexico, 1981/84

Toned silver gelatin print, 14 x 17⅝ in.

Palace of the Governors/Photo Archives, 184559

p. 58

George C. Bennett (dates unknown)

View of Santa Fe from Fort Marcy looking northeast,

ca. 1879

Stereograph, 4 x 7 in.

Palace of the Governors/Photo Archives, 16604

p. 70

George C. Bennett (dates unknown)

The Palace of the Governors, ca. 1879

Stereograph, 4½ x 7 in.

Palace of the Governors/Photo Archives, 55003

p. 58

George C. Bennett (dates unknown)

William Henry Brown (1844–1886)

The Mountains South-east from Old Fort Marcy, ca. 1882

Stereograph, 4½ x 7 in.

Palace of the Governors/Photo Archives, 10124

p. 15

George C. Bennett (dates unknown)

William Henry Brown (1844–1886)

The Palace of the Governors, ca. 1881

Stereograph, 4 x 7 in.

Palace of the Governors/Photo Archives, 118546

p. 112

Gay Block (1942–)

Laura Gilpin's House, 1974

Silver gelatin print, 9¼ x 14 in.

Courtesy of the artist

p. 200

Kent Bowser (1949–)

Storm, Galisteo Basin, August 1992

Silver gelatin print, 10¾ x 14⅞ in.

Courtesy of the artist

p. 127

Kent Bowser (1949–)

Yucca Drive-in, Santa Fe, New Mexico, Fall 1994

Silver gelatin print, 7⅞ x 11⅞ in.

Courtesy of the artist

p. 233

David Bram (1969–)

Lamy from the Cerro Colorado, 2004

Silver gelatin print, 14 x 14 in.

Courtesy of the artist

p. 209

Nicholas Brown (dates unknown)

Wagon train at the end of the Santa Fe Trail, ca. 1870

Original unknown

Palace of the Governors/Photo Archives, 70437

p. 15

Nicholas Brown (dates unknown)

Palace of the Governors, Santa Fe, New Mexico, 1868

Glass-plate negative, 4 x 7 in.

Palace of the Governors/Photo Archives, 45819

p. 29

Nicholas Brown (dates unknown)

Santa Fe views: Plaza, Palace of the Governors,
and Presbyterian Church, ca. 1868

Carte de visites, 2 ½ x 4 in. each

Palace of the Governors/Photo Archives, 37895, 66789,
103020,103021

p. 129

Polly Brown (1941–)

Gay Pride on the Plaza, 1996

Silver gelatin print, 12 x 18 in.

Courtesy of the artist

p. 170

Polly Brown (1941–)

Farmer's Market, ca. 1998

Archival pigment print, 12 x 18 in.

Courtesy of the artist

p. 193

Jesús Sito Candelario (1864–1938)

La Conquistadora procession, San Francisco Street,
ca. 1908

Glass-plate negative, 5 x 7 in.

Palace of the Governors/Photo Archives, 160545

p. 51

John Candelario (1916–1993)

Candelario's Original Old Curio Store, ca. 1955

Film negative, 2¼ x 2¼ in.

Palace of the Governors/Photo Archives, 165861

p. 8

Paul Caponigro (1932–)

San Sebastian, New Mexico, n.d.

Silver gelatin print, 13¼ x 10⅛ in.

Courtesy of the artist and Andrew Smith Gallery Inc.,
Santa Fe

p. 117

Walter Chappell (1925–2000)

Feather Torso Ceremonial, Santa Fe, 1966

Silver gelatin print, 12⅝ x 9 in.

New Mexico Museum of Art, 1996.11.1

Photograph by Walter Chappell, 1925–2000, under license
and copyright

Courtesy of the estate of Walter Chappell © 2007

p. 192

Dana B. Chase (?–1897)

Corpus Christi Procession, ca. 1890

Boudoir card, 8½ x 5¼ in.

Palace of the Governors/Photo Archives, HP.2007.28.4

p. 230

Dana B. Chase (?–1897)

San Miguel Church after Recent Restoration, 1887

Boudoir card, 5¼ x 8½ in.

Palace of the Governors/Photo Archives, HP.2007.28.3

p. 60

Dana B. Chase (?–1897)

Santa Fe from Old Fort Marcy, ca. 1888

Albumen prints mounted on board.

No. 104 A: 6¾ x 8; No. 103 A: 6¾ x 9 in.

Palace of the Governors/Photo Archives, 57014, 57015

p. 54

Dana B. Chase (?–1897)

*Palace of the Spanish Viceroy, Now Residence of the
Governor, the Only Palace in the United States, from
the West,* ca. 1888

Albumen print mounted on board, 4 x 7 in.

Palace of the Governors/Photo Archives, 50278

p. 176

Dana B. Chase (?–1897)

Palace Hotel, Santa Fe, New Mexico, ca. 1888

Albumen print mounted on board, 4¼ x 7 in.

Palace of the Governors/Photo Archives, 56984

p. 154

Dana B. Chase (?–1897)

Oldest House in the United States, Santa Fe, New Mexico, ca. 1888

Boudoir card, 5¾ x 8½ in.

Palace of the Governors/Photo Archives, 14044

p. 181

Robert Luis Chavez (1962–)

Hailstorm on the Plaza, August 2003

Archival pigment print, 11 x 14 in.

Courtesy of the artist

p. 134

Blair Clark (1954–)

Handball Court, 2007

Archival pigment print, 11 x 14 in.

Courtesy of the artist

p. 88

William Clift (1944–)

La Mesita from Cerro Seguro, New Mexico, 1978

Silver gelatin print, 13 x 19 in.

Courtesy of the artist

p. 171

Van Deren Coke (1921–2004)

Santa Fe Shop Window, 1986

Cibachrome print, 16 x 13½ in.

New Mexico Museum of Art, 1989.82.4

Courtesy of the Van Deren Coke Trust

p. 76

John C. Collier, Jr. (1913–1992)

Santa Fe, New Mexico, 1943

Silver gelatin print, 7¼ x 9⅜ in.

New Mexico Museum of Art, 1990.70.318

(dates unknown)

p. 140

Pauline Commack

Art students and teachers on graduation day, Santa Fe Indian School, 1944

Original unknown

Palace of the Governors/Photo Archives, 82512

p. 241

Linda Connor (1944–)

Petroglyphs, Galisteo, 1989

Gold-toned printing-out paper, 8 x 10 in. contact print

Courtesy of the artist

p. 71

Aaron B. Craycraft (ca. 1856–1918)

Palace of the Governors, ca. 1914

Platinum print, 7½ x 9¼ in.

Palace of the Governors/Photo Archives, 16670

p. 213

Aaron B. Craycraft (ca. 1856–1918)

Reservoir, Santa Fe, ca. 1913

Platinum prints, 7½ x 9⅜ in. each

Palace of the Governors/Photo Archives, 10604, 10605

p. 145

Aaron B. Craycraft (ca. 1856–1918)

East side of Tesuque plaza, ca.1900

Platinum print, 5¼ x 9 in.

Palace of the Governors/Photo Archives, 40818

p. 165

Aaron B. Craycraft (ca. 1856–1918)

Southeast view of Tesuque Pueblo, ca. 1900

Platinum print, 7½ x 9¾ in.

Palace of the Governors/Photo Archives, 4814

p. 159

Aaron B. Craycraft (ca. 1856–1918)

Corpus Christi procession on Canyon Road, 1905

Platinum print, 5¾ x 7¾ in.

Palace of the Governors/Photo Archives, 23049

p. 179

Aaron B. Craycraft (ca. 1856–1918)

Seligman Brothers and Company, San Francisco Street, ca. 1910

Original unknown

Palace of the Governors/Photo Archives, 11340

p. 22

Thomas J. Curran (?–1919)

Bird's-Eye View of Santa Fe, New Mexico, from St. Catherine's Industrial Indian School, Looking East, 1891

Albumen print mounted on board, 13 x 17 in.

Palace of the Governors/Photo Archives, 30590

p. 24

Thomas J. Curran (?–1919)

Bird's-Eye View of Santa Fe, New Mexico, From the Capitol, Looking North, 1891

Albumen print mounted on board, 13 x 17 in.

Palace of the Governors/Photo Archives, 30591

p. 119

Thomas J. Curran (?–1919)

Cell House, Penitentiary, 1893

Albumen print mounted on board, 8¾ x 9¼ in.

Palace of the Governors/Photo Archives, 15206

p. 119

Thomas J. Curran (?–1919)

Santa Fe County Court House, Court Room, 1893

Albumen print mounted on board, 9½ x 9½ in.

Palace of the Governors/Photo Archives, 10232

p. 141

Edward S. Curtis (1868–1952)

Tesuque Buffalo Dancers, 1925

Photogravure on Holland Van Gelder, 15¼ x 11½ in.

Courtesy of Etherton Gallery, Tucson

p. 126

Tyler Dingee (1906–1961)

El Paseo Theatre, West San Francisco Street, 1959

Silver gelatin print, 5 x 7 in.

Palace of the Governors/Photo Archives, 91900

p. 77

Tyler Dingee (1906–1961)

Palace of the Governors commemorative stamp, issued June 1960

U.S. postage stamp, 1 x 1 in.

Palace of the Governors/Photo Archives, Ephemera

p. 167

Tyler Dingee (1906–1961)

Cochiti Pueblo students at St. Catherine's School, ca. 1950

Silver gelatin print, 5 x 7 in.

Palace of the Governors/Photo Archives, 120412

p. 135

Brian Edwards (1954–)

Stonefridge, January 7, 2006

Archival pigment print, 7¼ x 12¾ in.

Courtesy of the artist

p. 116

James L. Enyeart (1943–)

Lee Friedlander, 2003

Archival pigment print, 10⅞ x 14 in.

Courtesy of the artist

p. 202

Steve Fitch (1949–)

A Fire and Petroglyphs at Dusk near San Cristobal Ruin, New Mexico, July 28, 1983

Type-C print, 13¾ x 17½ in.

Courtesy of the artist

p. 166

Frasher

Candido Herrera, Tesuque Indian Pueblo Governor with Silver Headed Canes of Authority, Presented by Spanish Government in 17th Century and by Abraham Lincoln in 1863

Postcard, 3½ x 5½ in.

Palace of the Governors/Photo Archives, 74968

p. 194

Lee Friedlander (1934–)

Santa Fe, 1975

From the American Monument series

Silver gelatin print, 11 x 7½ in.

Collection Center for Creative Photography,
University of Arizona, 93:039:008

© 1993 Arizona Board of Regents

p. 194

Lee Friedlander (1934–)

Santa Fe, 1975

From the American Monument series

Silver gelatin print, 7¼ x 11 in.

Collection Center for Creative Photography,
University of Arizona, 94:040:001

© 1994 Arizona Board of Regents

p. 172

Lee Friedlander (1934–)

Santa Fe, 2005

Silver gelatin print, 15 x 14½ in.

Courtesy of the artist and Andrew Smith Gallery, Inc., Santa Fe

p. 229

Lee Friedlander (1934–)

Santa Fe, 2001

Silver gelatin print, 14⅞ x 14⅝ in.

Courtesy of the artist and Andrew Smith Gallery, Inc., Santa Fe

p. 161

Miguel Gandert (1956–)

Nuestra Senora de la Paz, 2006

Archival pigment print, 17 x 22 in.

Courtesy of the artist and Andrew Smith Gallery, Inc., Santa Fe

p. 4–5

Miguel Gandert(1956–)

Norman Mauskopf, Spanish Market, Santa Fe, 2006

Archival pigment print, 17 x 22 in.

Courtesy of the artist and Andrew Smith Gallery, Inc., Santa Fe

p. 91

Laura Gilpin (1891–1979)

Storm over La Bajada Hill, New Mexico, 1946

Silver gelatin print, 15⅜ x 19⅝ in.

© 1979 Amon Carter Museum, Fort Worth, Texas, bequest of Laura Gilpin

Courtesy of Scheinbaum and Russek, Ltd., Santa Fe, New Mexico

p. 205

Laura Gilpin (1891–1979)

New Mexico's First Capital, San Gabriel del Yunque

founded in 1598 by Don Juan de Oñate, n.d.

Silver gelatin print, 8 x 10 in.

Palace of the Governors/Photo Archives, 16740

©1979 Amon Carter Museum, Fort Worth, Texas

p. 81

Kirk Gittings (1950–)

The Hollenback House by John Gaw Meem, Santa Fe,

New Mexico, 1989

Archival pigment print, 24 x 20 in.

Courtesy of the artist

p. 132

Betty Hahn (1940–)

Ehrlichman Surveillance Series, Shidoni Sculpture

Gardens and Foundry, Tesuque, New Mexico, eight-part

series, 1982

Silver gelatin prints, 16 x 20 in. each

Courtesy of the artist

p. 232

Philip Embury Harroun (1867–1947)

Santa Fe in Moonlight, August 1894

Glass-plate negative/cyanotype, 8 x 10 in.

Palace of the Governors/Photo Archives, 14128

p. 192

Philip Embury Harroun (1867–1947)

Procession of Corpus Christi about Santa Fe, June 1897

Glass-plate negative/cyanotype, 6 x 9 in.

Palace of the Governors/Photo Archives, 14046

p. 160

James Hart (1952–)

Muralists Fabian Salazar and Frank Corriz, 1983

Silver gelatin print, 8 x 10 in. contact print

Courtesy of the artist

p. 63

James Hart (1952–)

La Tercera Entrada: "The Third Conquest," ca. 1983

Silver gelatin print, 8 x 10 in. contact print

Courtesy of the artist

p. 209

Henry T. Hiester (dates unknown)

San Francisco Street at the Plaza, ca. 1878

Stereograph, 3 ½ x 7 in.

Palace of the Governors/Photo Archives, 11329

p. 14

Henry T. Hiester (dates unknown)

Kneeling before the altar, a View of the Procession of

Corpus Cristi, October 18, 1878

Stereograph, 4 x 7 in.

Palace of the Governors/Photo Archives, 8133

p. 52

John K. Hillers (1843–1925)

Pueblo Tesuque, New Mexico, ca. 1890

Albumen print mounted on board, 14 x 17 in.

Palace of the Governors/Photo Archives, 31197

p. 144

John K. Hillers (1843–1925)

Water Carriers, Tesuque, New Mexico, ca. 1880

Albumen print mounted in album

Courtesy of the Special Collections and University

Archives, University of Oregon Libraries, Eugene,

PH203-16-17

p. 148

John K. Hillers (1843–1925)

A Tesuque Oxcart, 1880

Original unknown

Palace of the Governors/Photo Archives, 29892

p. 44

William Henry Jackson (1843–1942)

The Old "Palace," Santa Fe, ca. 1881

Cabinet card, 4½ x 7 in.

Palace of the Governors/Photo Archives, 6781

p. 231

William Henry Jackson (1843–1942)

San Miguel Church, 1881

Albumen print mounted on board, 9¾ x 13 in.

Palace of the Governors/Photo Archives, 147244

p. 57

William Henry Jackson (1843–1942)

Church of Sta. Guadalupe Santa Fe, 1881

Cabinet card, 4½ x 7 in.

Palace of the Governors/Photo Archives, 151120

p. 50

William Henry Jackson (1843–1942)

A Street Scene in Santa Fe, New Mexico, 1881

Boudoir card, 5 x 8 in.

Palace of the Governors/Photo Archives, 158579

p. 211

William Henry Jackson (1843–1942)

Canon Diablo, Santa Fe Southern Railroad, ca. 1886

Glass-plate negative, 5 x 8 in.

Colorado Historical Society, William Henry Jackson
Collection, CHS.1592

p. 23

William Henry Jackson (1843–1942)

Santa Fe, from Fort Marcy Hill, 1881

Cabinet card, 4½ x 7 in.

Palace of the Governors/Photo Archives, 10126

p. 30

William Henry Jackson (1843–1942)

Santa Fe. From the College, ca. 1881

Cabinet card, 4½ x 7 in.

Palace of the Governors/Photo Archives, 10128

p. 174

William Henry Jackson (1843–1942)

The Plaza, Santa Fe, ca. 1881

Cabinet card, 4½ x 7 in.

Palace of the Governors/Photo Archives, 15277

p. 179

William Henry Jackson (1843–1942)

Santa Fe. The Cathedral, ca. 1881

Stereograph, 4 x 7 in.

Palace of the Governors/Photo Archives, 147078

p. 178

William Henry Jackson (1843–1942)

Church of San Miguel and Brothers College, ca. 1881

Albumen print mounted on board, 9¾ x 13 in.

Palace of the Governors/Photo Archives, 15230

p. 169

Zig Jackson (1957–)

Urban Offering, Santa Fe, New Mexico, 2001

Silver gelatin print, 15¼ x 19⅛ in.

Courtesy of the artist and Andrew Smith Gallery, Inc.,
Santa Fe

p. 114

Bill Jay (1940–)

Paul Caponigro, ca. 1974

Silver gelatin print, 7½ x 4¾ in.

Courtesy of the artist

p. 110

Kate Joyce (1979–), and Julie Dean (1957–)

Untitled from *Santa Fe Neighborhoods,* 1996–2007

Archival pigment prints on Hahnemuhle paper,

10 x 15 in. each

Courtesy of the artists

p. 143

Christian G. Kaadt (1868–1905)

Juan Pino, Tesuque Pueblo, ca. 1900

Cabinet card, 6¼ x 4¼ in.

Palace of the Governors/Photo Archives, 4797

p. 118

Christian G. Kaadt (1868–1905)

View of Santa Fe from the capitol, east/northeast,

ca. 1895

Platinum prints, 4½ x 6½ in. each

Palace of the Governors/Photo Archives, 10151, 10164

p. 32

Christian G. Kaadt (1868–1905)

City of the Holy Faith, Santa Fe, New Mexico, ca. 1895

Boudoir card, 5 x 8 in.

Palace of the Governors/Photo Archives, 30768

p. 50

Christian G. Kaadt (1868–1905)

Gold's Old Curiosity Shop, Santa Fe, New Mexico,

ca. 1896

Boudoir card, 5 x 7¾ in.

Palace of the Governors/Photo Archives, 10728

p. 176

Christian G. Kaadt (1868–1905)

State capitol building, ca. 1895

Boudoir card, 5 x 8 in.

Palace of the Governors/Photo Archives, 10392

p. 124

Christian G. Kaadt (1868–1905)

Lower San Francisco Street, Santa Fe, New Mexico,

ca. 1900

Cabinet card, 4⅝ x 6½ in.

Palace of the Governors/Photo Archives, 11341

p. 150

Christian G. Kaadt (1868–1905)

Wedding portrait: Felipe and Melinda Valdez, ca. 1900

Boudoir card, 9 x 6½ in.

Palace of the Governors/Photo Archives, 151035

p. 196

Doug Keats (1948–)

Cristo Rey Church, Santa Fe, New Mexico, 1990

Fresson print, 11 x 15 in.

Courtesy of the artist

p. 64

Edward A. Kemp (dates unknown)

Lamy Depot and Harvey Indian Detour cars waiting arrival

of Train, ca. 1930

Silver gelatin print, 6½ x 8½ in.

Palace of the Governors/Photo Archives, 53651

p. 184

Ernest Knee (1907–1982)

Galisteo, New Mexico, 1938

Silver gelatin print, 8 x 10 in.

Palace of the Governors/Photo Archives, 132823

p. 104

Rolf Koppel (1937–)

Verklärte Nacht (Off Canyon Road), 1975

Silver gelatin print, 14 x 14⅛ in.

Courtesy of the artist

p. 104

Rolf Koppel (1937–)

Verklärte Nacht (Acequia & Monte Sol), 1976

Silver gelatin print, 14 x 14⅛ in.

Courtesy of the artist

p. 42

Howard Korder (1957–)

New Subdivision, Santa Fe, New Mexico, 2007

Archival pigment print, 7 x 10½ in.

Courtesy of the artist

p. 43

Howard Korder (1957–)

Arroyo Mascaras, Santa Fe, New Mexico, 2006

Archival pigment print, 7 x 10½ in.

Courtesy of the artist

p. 128

Lisa Law (1943–)

Zozobra, Santa Fe, New Mexico, September 9, 2004

Archival pigment print, 8 x 10 in.

Courtesy of the artist

p. 121

Paul Logsdon (1939–1989)

Country Club Gardens Mobile Home Park on Airport Road, Looking Southwest, Santa Fe, New Mexico, 1984

Silver gelatin print, 8 x 10 in.

Palace of the Governors/Photo Archives, 122349

p. 120

Paul Logsdon (1939–1989)

New Mexico State Penitentiary, Looking Southeast, ca.1984

Silver gelatin print, 8 x 10 in.

Palace of the Governors/Photo Archives, 122343

p. 183

Herbert A. Lotz (1944–)

View from 1300 Block of Cerro Gordo, 1983–84

Silver gelatin print, 7¾ x 7¼ in.

Palace of the Governors/Photo Archives, 122369

p. 115

Lynn Lown (1947–)

Greg MacGregor, 1975

Carbon pigment print on rag paper, 9½ x 9½ in.

Courtesy of the artist

p. 113

Lynn Lown (1947–)

Laura Gilpin, 1976

Carbon pigment print on rag paper, 11 x 9 in.

Courtesy of the artist

p. 244

Lynn Lown (1947–)

Santa Fe Panorama, 2007

Ultrachrome pigment on canvas, 12 x 80 in.

Courtesy of the artist

p. 244

Lynn Lown (1947–)

From La Tetilla Peak, 2007

Carbon pigment on canvas, 12 x 108 in.

Courtesy of the artist

p. 190

Cissie Ludlow (1947–)

DeVargas Hotel, 1984

Archival pigment print, 9¾ x 14½ in.

Courtesy of the artist

p. 225

Charles Lummis (1859–1928)

Untitled, n.d.

Cyanotype, 4⅜ x 7 in.

Palace of the Governors/Photo Archives, 136250

p. 225

Charles Lummis (1859–1928)

Untitled, n.d.

Cyanotype, 4⅜ x 7 in.

Palace of the Governors/Photo Archives, 15229

p. 122–23

Greg MacGregor (1941–)

Sweeney Center Construction Site, looking East, 2007

Archival pigment print, 10 x 50 in.

Courtesy of the artist

p. 72

Greg MacGregor (1941–)

Palace of the Governors Construction Site, 2007

Archival pigment print, 14 x 20 in.

Courtesy of the artist

p. 234

Douglas Magnus (1946–)

Railyard at Night, 1970/2007

Silver gelatin print, 6⅜ x 9⅝ in.

Courtesy of the artist

p. 106

Roxanne Malone (1941–)

Power Garden Grid, 2000

Agfa silver photogram, 20 x 24 in.

Courtesy of the artist

p. 12

Norman Mauskopf (1949–)

Jerry Olson and Chief, Santa Fe, New Mexico, 1984

Silver gelatin print, 12 x 18 in.

Courtesy of the artist

p. 163

Norman Mauskopf (1949–)

Fourth of July, Santa Fe, New Mexico, 2002

Silver gelatin print, 12 x 18 in.

Courtesy of the artist

p. 63

Norman Mauskopf (1949–)

Indian Market, Santa Fe, New Mexico, 1992

Silver gelatin print, 12 x 18 in.

Courtesy of the artist

p. 237

Lawrence McFarland (1934–)

John Ripple in a Snow Storm at the Grease Pit,
Aqua Fria and Maez, Santa Fe, New Mexico, 1971

Archival pigment print, 10 x 15 in.

Courtesy of the artist

p. 189

Melanie McWhorter (1973–)

Descansos, Anthill, 2007

Archival pigment print, 8 x 8 in.

Courtesy of the artist

p. 187

Duane Monczewski (1952–)

Adobe Walls, Santa Fe, 1992

Toned silver gelatin print with graphite, 7¾ x 5¼ in.

Courtesy of the artist

p. 187

Duane Monczewski (1952–)

Column and Walls, Santa Fe, 1984

Toned silver gelatin print, 8 x 5¼ in.

Courtesy of the artist

p. 134

Margaret Moore (1958–)

Flamingos in Tesuque, 1995

Archival pigment print, 16 x 20 in.

Courtesy of the artist

p. 183

Wright Morris (1910–1998)

New Mexico, near Santa Fe, 1939

Silver gelatin print, 7¼ x 9¾ in.

Collection Center for Creative Photography,

University of Arizona, 2003:006:016

© 2003 Arizona Board of Regents

p. 67

Joan Myers (1944–)

Santa Fe Panorama, 1982

Archival pigment print, 14½ x 46 in.

Courtesy of the artist and Andrew Smith Gallery, Inc.,

Santa Fe

p. 67

Joan Myers (1944–)

Santa Fe Panorama, 2007

Archival pigment print, 16½ x 46 in.

Courtesy of the artist and Andrew Smith Gallery, Inc.,

Santa Fe

p. 36

Joan Myers (1944–)

La Bajada Road (aerial), 2004

Archival pigment print, 22 x 14½ in.

Courtesy of the artist and Andrew Smith Gallery, Inc.,

Santa Fe

p. 39

Joan Myers (1944–)

Old Pecos Trail, Santa Fe (aerial), 2007

Archival pigment print, 14½ x 22 in.

Courtesy of the artist and Andrew Smith Gallery, Inc.,

Santa Fe

p. 40

Joan Myers (1944–)

Water Tank, Santa Fe (aerial), 2007

Archival pigment print, 14½ x 22 in.

Courtesy of the artist and Andrew Smith Gallery, Inc.,

Santa Fe

p. 41

Joan Myers (1944–)

Plaza, Santa Fe (aerial), 2007

Archival pigment print, 14½ x 22 in.

Courtesy of the artist and Andrew Smith Gallery, Inc.,

Santa Fe

p. 115

James Nachtwey (1948–)

Meridel Rubenstein, n.d.

Silver gelatin print, 10 x 6¾ in.

Courtesy of Meridel Rubenstein

p. 235

Teresa Neptune (1958–)

Santa Fe Rail, Santa Fe, New Mexico, 2004

Ultrachrome print, 12 x 18 in.

Courtesy of the artist

p. 109

Beaumont Newhall (1908–1993)

From the series *This Is the Garden*, 1985

Type-C print, 13⅞ x 9¼ in.

© 1993, the estate of Beaumont and Nancy Newhall

Courtesy of Scheinbaum and Russek, Ltd., Santa Fe,

New Mexico

p. 180

Nicholas Nixon (1947–)

La Fonda, Santa Fe, New Mexico, 1973

Silver gelatin print, 8 x 10 in.

Purchased with funds from a National Endowment for

the Arts grant and with funds from the Friends of Art,

University of New Mexico Art Museum, Albuquerque,

76.152 © Nicholas Nixon, courtesy Fraenkel Gallery,

San Francisco

p. 131

David Grant Noble (1939–)

Preparing a Sweat Lodge, South of Downtown Santa Fe,
1973/74

Silver gelatin print, 7¼ x 7¼ in.

Courtesy of the artist

p. 111

Anne Noggle (1922–2005)

Santa Fe Summer #1, 1976

Silver gelatin print, 12¼ x 18½ in.

Courtesy of Jim Holbrook and Andrew Smith Gallery, Inc.,
Santa Fe

p. 191

Mark Nohl (1950–)

Santa Fe home, Upper Canyon Road, n.d.

Color transparency, 4 x 5 in.

Palace of the Governors/Photo Archives, New Mexico
Magazine Collection

p. 66

Jesse L. Nusbaum (1887–1975)

Santa Fe from Fort Marcy, ca. 1911

Glass-plate negatives, 5 x 7 in. each

Palace of the Governors/Photo Archives, 16753, 10156,
16726, 61532

p. 182

Jesse L. Nusbaum (1887–1975)

Acequia Madre from College Street, ca. 1912

Glass-plate negative, 5 x 7 in.

Palace of the Governors/Photo Archives, 61469

p. 74

Jesse L. Nusbaum (1887–1975)

House behind the Jail—on or near Guadalupe Street, 1912

Glass-plate negative, 5 x 7 in.

Palace of the Governors/Photo Archives, 16747

p. 173

Jesse L. Nusbaum (1887–1975)

Santa Fe Plaza, ca. 1914

Glass-plate negative, 5 x 7 in.

Palace of the Governors/Photo Archives, 61463

p. 75

Jesse L. Nusbaum (1887–1975)

*Old House with portal, Mexican settlement below
Sunmount, New Mexico,* 1912

Glass-plate negative, 5 x 7 in.

Palace of the Governors/Photo Archives, 61507

p. 182

Jesse L. Nusbaum (1887–1975)

Santa Fe, 1912

Glass-plate negative, 5 x 7 in.

Palace of the Governors/Photo Archives, 61510

p. 153

Jesse L. Nusbaum (1887–1975)

*Masonic Consistory Class Fall Reunion, Santa Fe,
New Mexico, 1912*

Glass-plate negative, 5 x 7 in.

Palace of the Governors/Photo Archives, 61385

p. 155

Jesse L. Nusbaum (1887–1975)

State capitol building, 1912

Glass-plate negative, 5 x 7 in.

Palace of the Governors/Photo Archives, 61408

p. 155

Jesse L. Nusbaum (1887–1975)

Governor's mansion, ca. 1912

Glass-plate negative, 5 x 7 in.

Palace of the Governors/Photo Archives, 16722

p. 16

Jesse L. Nusbaum (1887–1975)

Wood-loaded wagon on Palace Avenue in front of the
Palace of the Governors, ca. 1915

Glass-plate negative, 5 x 7 in.

Palace of the Governors/Photo Archives, 61543

p. 33

Jesse L. Nusbaum (1887–1975)

Panoramic view of Santa Fe showing Clark home, Federal
courthouse, and cathedral, ca. 1912

Glass-plate negative, 5 x 7 in.

Palace of the Governors/Photo Archives, 61533

p. 166

Jesse L. Nusbaum (1887–1975)

Candido Herrera, Tesuque Pueblo, 1912

Glass-plate negative, 5 x 7 in.

Palace of the Governors/Photo Archives, 61793

p. 124

Jesse L. Nusbaum (1887–1975)

Southwest corner of the Plaza, ca. 1910

Glass-plate negative, 5 x 7 in.

Palace of the Governors/Photo Archives, 11332

p. 236

Jesse L. Nusbaum (1887–1975)

*Archbishop Lamy's Garden Winter, Santa Fe,
New Mexico,* n.d.

Glass-plate negative, 5 x 7 in.

Palace of the Governors/Photo Archives, 139222

p. 155

Jesse L. Nusbaum (1887–1975)

New Governor's Mansion, Santa Fe, New Mexico, 1913

Postcard, 3½ x 5½ in.

Palace of the Governors/Photo Archives, 16723

p. 214

Tony O'Brien (1946–)

Santa Fe Opera House, n.d.

Archival pigment print, 16 x 20 in.

Courtesy of the artist

p. 56

Timothy O'Sullivan (1840–1882)

San Miguel Church, ca. 1871–74

Albumen print, 7½ x 10 ⅝ in.

Courtesy of Edward Ranney

p. 78–79

T. Harmon Parkhurst (1883–1952)

Ortiz Street, ca. 1915

Glass-plate negatives, 5 x 7 in. each

Palace of the Governors/Photo Archives, 144776, 144777,
59837

p. 143

T. Harmon Parkhurst (1883–1952)

Motion-picture cameraman with drummer and Eagle
Dancers, Tesuque Pueblo, ca. 1917

Platinum print, 3 x 5 ⅚ in.

Palace of the Governors/Photo Archives, 4721

p. 216

T. Harmon Parkhurst (1883–1952)

Tesuque Pueblo, ca. 1925

Film negative, 7 x 11 in.

Palace of the Governors/Photo Archives, 4829

p. 138

T. Harmon Parkhurst (1883–1952)

Tesuque Pueblo, ca. 1920

Glass-plate negative, 5 x 7 in.

Palace of the Governors/Photo Archives, 12523

p. 143

T. Harmon Parkhurst (1883–1952)

The Smoker, José Angel, Tesuque Pueblo, n.d.

Glass-plate negative, 5 x 7 in.

Palace of the Governors/Photo Archives, 4792

p. 144

T. Harmon Parkhurst (1883–1952)

José La Cruz Herrera, Tesuque Pueblo, n.d.

Glass-plate negatives, 5 x 7 in. each

Palace of the Governors/Photo Archives, 12516, 46131

p. 166

T. Harmon Parkhurst (1883–1952)

Candido Herrera, Tesuque Pueblo, April 27, 1924

Film negative, 7 x 11 in.

Palace of the Governors/Photo Archives, 4783

p. 146

T. Harmon Parkhurst (1883–1952)

Indian Detours Personnel and Equipment,

Palace of the Governors, ca. 1927

Silver gelatin print, 6½ x 10½ in.

Palace of the Governors/Photo Archives, 53568

p. 147

T. Harmon Parkhurst (1883–1952)

Fiesta, 1919

Glass-plate negative, 5 x 7 in.

Palace of the Governors/Photo Archives, 52377

p. 160

T. Harmon Parkhurst (1883–1952)

Fiesta, 1921

Film negative, 7 x 11 in.

Palace of the Governors/Photo Archives, 74298

p. 65

T. Harmon Parkhurst (1883–1952)

Fiesta Parade, East San Francisco Street, ca. 1925

Film negative, 7 x 11 in.

Palace of the Governors/Photo Archives, 118249

p. 148

T. Harmon Parkhurst (1883–1952)

Teofolo Ortega, Tesuque Pueblo, ca. 1919

Glass-plate negative, 7 x 5 in.

Palace of the Governors/Photo Archives, 47271

p. 177

T. Harmon Parkhurst (1883–1952)

La Fonda, The Inn at the End of the Trail.

The Harvey Co. in Old Santa Fe, n.d.

Silver gelatin print, 12¼ x 20 in.

Palace of the Governors/Photo Archives, 10692

p. 97

T. Harmon Parkhurst (1883–1952)

Santa Fe River, Canyon Road—Castillo Street Bridge,

ca. 1912

Silver gelatin print, 16 x 20 in.

Palace of the Governors/Photo Archives, 56660

p. 231

T. Harmon Parkhurst (1883–1952)

San Miguel Church, n.d.

Glass-plate negative, 5 x 7 in.

Palace of the Governors/Photo Archives, 10097

p. 177

T. Harmon Parkhurst (1883–1952)

La Fonda Hotel, n.d.

Silver gelatin print, 6¾ x 10⁵⁄₁₆ in.

Palace of the Governors/Photo Archives, 10690

p. 155

T. Harmon Parkhurst (1883–1952)

State capitol building, ca. 1912

Glass-plate negative, 5 x 7 in.

Palace of the Governors/Photo Archives, 10382

p. 155

T. Harmon Parkhurst (1883–1952)

Governor's mansion, n.d.

Glass-plate negative, 5 x 7 in.

Palace of the Governors/Photo Archives, 10244

p. 159

T. Harmon Parkhurst (1883–1952)

Corpus Christi procession, n.d.

Glass-plate negative, 5 x 7 in.

Palace of the Governors/Photo Archives, 8139

p. 125

T. Harmon Parkhurst (1883–1952)

Staab and Galisteo buildings, West San Francisco Street
at Galisteo Street, ca. 1933–34

Film negative, 8 x 10 in.

Palace of the Governors/Photo Archives, 51463

p. 30

T. Harmon Parkhurst (1883–1952)

View of Santa Fe, n.d.

Film negative, 7 x 11 in.

Palace of the Governors/Photo Archives, 10185

p. 17

T. Harmon Parkhurst (1883–1952)

Palace of the Governors, ca. 1915

Glass-plate negative, 5 x 7 in.

Palace of the Governors/Photo Archives, 13050

p. 168

T. Harmon Parkhurst (1883–1952)

Union bus depot, n.d.

Film negative, 7 x 11 in.

Palace of the Governors/Photo Archives, 51111

p. 149

T. Harmon Parkhurst (1883–1952)

Drying Wheat, Pueblo of Tesuque, n.d.

Silver gelatin print, 10⅞ x 13⅞ in.

Palace of the Governors/Photo Archives, 3986

p. 175

Jack Parsons (1939–)

Christmas, Santa Fe Plaza, 1993

Archival pigment print, 8 x 10 in.

Courtesy of the artist

p. 89

Alan Pearlman (1936–)

Land for Sale, Santa Fe, 2004

Archival pigment print, 9 x 15 in.

Courtesy of the artist

p. 37

Alan Pearlman (1936–)

Highway Construction, Santa Fe, 2004

Archival pigment print, 6 x 15 in.

Courtesy of the artist

p. 2

Bernard Plossu (1945–)

La Cienegilla, 1982

Silver gelatin print, 8 x 10 in.

Palace of the Governors/Photo Archives, 118141

p. 152

Horace Swartley Poley (ca. 1864–1949)

Governor Vigil, Tesuque, ca. 1910

Glass-plate negative, 4 x 5 in.

Denver Public Library, Western History Collection, P-1480

p. 3

Eliot Porter (1901–1990)

Sangre de Christo Mountains at Sunset, Tesuque, New Mexico, July 1958

Vintage dye-transfer print, 8 ⁵⁄₁₆ x 8 ⁷⁄₁₆ in.

© 1990 Amon Carter Museum, Fort Worth, Texas, bequest of Eliot Porter

Courtesy of Scheinbaum and Russek, Ltd., Santa Fe, New Mexico

p. 108

Eliot Porter (1901–1990)

Frozen Apples, Tesuque, New Mexico, 1966

Dye-transfer print, 10¼ x 8 in.

© 1990 Amon Carter Museum, Fort Worth, Texas, bequest of Eliot Porter

Courtesy of Scheinbaum and Russek, Ltd., Santa Fe, New Mexico

p. 84

Eliot Porter (1901–1990)

Chair and Window, Tesuque, New Mexico, 1961

Silver gelatin print, 9 ⁷⁄₁₆ x 7 ³⁄₁₆ in.

New Mexico Museum of Art, 1984.594.2

© 1990, Amon Carter Museum, Fort Worth, Texas, bequest of Eliot Porter

Courtesy of Scheinbaum and Russek, Ltd., Santa Fe, New Mexico

p. 238

Patrick Porter (1946–)

Horses in the Snow, Galisteo Basin, ca. 2000

Silver gelatin print, 16 x 20 in.

Courtesy of the artist

p. 243

Edward Ranney (1942–)

Galisteo Basin, New Mexico Looking West to Comanche Gap, Ortiz and Sandia Mountains, 2000

Silver gelatin print, 12 x 47 in.

Courtesy of the artist

p. 90

Edward Ranney (1942–)

Water Storage Tank, Looking Northeast to the Sangre de Cristo Mountains, Chaquaco, New Mexico, 1974

Silver gelatin print, 8 x 10 in. contact print

Courtesy of the artist

p. 35

Edward Ranney (1942–)

La Bajada Drainage, near Waldo, 1979

Silver gelatin print, 13 x 18 in.

Courtesy of the artist

p. 95

Edward Ranney (1942–)

San Cristobal Pueblo, Galisteo Basin, 2007

Silver gelatin print, 7½ x 11 in.

Courtesy of the artist

p. 105

Eric Renner (1941–)

December 27, 1979, 11 A.M.

Silver gelatin print, 16 x 20 in.

Courtesy of the artist

p. 62

J. R. Riddle (dates unknown)

Bandstand, Plaza, Santa Fe, ca. 1888

Original unknown

Palace of the Governors/Photo Archives, 76049

p. 153

J. R. Riddle (dates unknown)

(Sometimes attributed to J. L. Clinton)

Street in Santa Fe, New Mexico, 1888

Cabinet card, 4½ x 7 in.

Palace of the Governors/Photo Archives, 76034

p. 175

J. R. Riddle (dates unknown)

(Sometimes attributed to J. L. Clinton)

Plaza in Santa Fe, New Mexico, ca. 1888

Cabinet card, 4½ x 7 in.

Palace of the Governors/Photo Archives, 11269

p. 240

Ford Robbins (1942–)

Leaf Rock Petroglyph, 1994

Silver gelatin print, 9¾ x 7⅝ in.

Courtesy of the artist

p. 99

Alan Ross (1948–)

Road & Plains/Cerrillos Hills, Thunderstorm, Santa Fe, 1995

Silver gelatin print, 14 x 18 in. each

Courtesy of the artist

p. 197

Alan Ross (1948–)

Church and Clouds, La Cienega, 2000

Silver gelatin print, 14 x 18 in.

Courtesy of the artist

p. 105

Meridel Rubenstein (1948–)

Celebration Nest, 1978

Toned silver gelatin print, 15 x 12 in.

Courtesy of the artist

p. 133

Meridel Rubenstein (1948–)

Postcards, Fathers and Sons, Cerrillos Flats, New Mexico, 1978

Toned silver gelatin print, 13⅝ x 17 in.

Courtesy of the artist

p. 103

Andre Ruesch (1961–)

Big Water at 760 Feet, March 2002

Archival pigment print, 9 x 12 in.

Courtesy of the artist

p. 85

Janet Russek (1947–)

Eliot Porter's Chair with Light and Bird's Nest, Tesuque, New Mexico, 1987

Silver gelatin print, 6 x 8 in.

© 1987 Janet Russek

Courtesy of Scheinbaum and Russek, Ltd., Santa Fe, New Mexico

p. 109

Janet Russek (1947–)

Beaumont and Christi Newhall's Bench, Santa Fe, 1985

Silver gelatin print, 4 x 5 in. contact print

© 1985 Janet Russek

Courtesy of Scheinbaum and Russek, Ltd., Santa Fe, New Mexico

p. 86

David Scheinbaum (1951–)

Eliot Porter, Tesuque, New Mexico, 1983

Silver gelatin print, 6¼ x 9¼ in.

© 1983 David Scheinbaum

Courtesy of Scheinbaum and Russek, Ltd., Santa Fe,

New Mexico

p. 239

David Scheinbaum (1951–)

Bonanza Creek Road, New Mexico, 1984

Silver gelatin print, 8 x 10 in. contact print

© 1984 David Scheinbaum

Courtesy of Scheinbaum and Russek, Ltd., Santa Fe,

New Mexico

p. 114

Robert Shlaer (1942–)

Beaumont Newhall at Home, Santa Fe, New Mexico, 1988

Daguerreotype, 6¼ x 5¼ in.

Palace of the Governors/Photo Archives, 145047

p. 47

Robert Shlaer (1942–)

Nude, Lamy, New Mexico, August 1, 2004

Daguerreotype, 4 x 5 in.

Courtesy of the artist

p. 106

Nancy Spencer (1947–)

Dave's Not Here, 1995

Zone plate photograph, 17 x 22 in.

Courtesy of the artist

p. 92

Paul Strand (1890–1976)

Badlands, Near Santa Fe, New Mexico, 1930

Platinum print, 3 ⅝ x 4 ¹¹⁄₁₆ in.

New Mexico Museum of Art, 2003.13.1

p. 107

Nancy Sutor (1953–)

Comanche Gap 1, 1983

Hand-colored cyanotype, 22 x 30 in.

Courtesy of John and Linda Dressman

p. 102

Carlan Tapp (1946–)

Black Ferrill #1, Galisteo Basin, 2007

Archival pigment print, 11 x 14 in.

Courtesy of the artist

p. 70

U. S. Army Signal Corps

Palace of the Governors, ca. 1865–70

Original unknown

Palace of the Governors/Photo Archives, 9099

p. 28

Unknown Photographer

Ancient La Fonda Which Stood on Site of Present Hotel,

Santa Fe, New Mexico, n.d.

Postcard, 3½ x 5½ in.

Palace of the Governors/Photo Archives, 13040

p. 209

Unknown Photographer

End of the Santa Fe Trail Before Railroad Days, n.d.

Postcard, 3½ x 5½ in.

Palace of the Governors/Photo Archives, 11329

p. 145

Unknown Photographer

Tesuque Indian Pueblo, n.d.

Postcard, 3½ x 5½ in.

Palace of the Governors/Photo Archives, 150926

p. 140

Unknown Photographer

Santo Domingo Pueblo students, U.S. Indian School, Santa Fe, n.d.

Original unknown

Palace of the Governors/Photo Archives, 176598

p. 142

Unknown Photographer

A Modern Adobe in Santa Fe, ca. 1880–90

Albumen print, 4½ x 7 in.

Denver Public Library, Western History Collection, Z-4148

p. 147

Unknown Photographer

San Ildefonso Eagle Dance, Palace of the Governors' courtyard, Fiesta, 1919

Film negative, 3½ x 5½ in.

Palace of the Governors/Photo Archives, 149973

p. 71

Unknown Photographer

The Plaza, Palace St., Governors' Palace, Santa Fe, New Mexico, ca. 1885

Boudoir card, 5 x 8 in.

Palace of the Governors/Photo Archives, HP.2007.29.1

p. 205

Unknown Photographer

Street Scene Showing San Miguel Church, Santa Fe, New Mexico, ca. 1880

Boudoir card, 5 x 8 in.

Courtesy of Gerald Peters Gallery

p. 152

Unknown Photographer

Elias, Pueblo Indian from Tesuque, New Mexico, n.d.

Silver gelatin print, 7 x 5 in.

Denver Public Library, Western History Collection, X-30327

p. 174

Unknown Photographer for the Atchison, Topeka and Santa Fe Railway

The Plaza, Santa Fe, New Mexico, ca. 1885

Boudoir card, 5 x 8 in.

Palace of the Governors/Photo Archives, HP.2007.28.5

p. 195

Craig Varjabedian (1957–)

Sunset and Evening Storm, Canoncito at Apache Canyon, New Mexico, 1985

Silver gelatin print, 20 x 24 in.

Courtesy of the artist and Gerald Peters Gallery, Santa Fe

p. 100

John Vavruska (1951–)

Viewing the Lakes Fire from the Cross of the Martyrs, August 27, 2002

Film negative, 4 x 5 in.

Courtesy of the artist

p. 148

Carlos Vierra (1876–1937)

Nympha Vigil and Marcus Vigil, Tesuque Pueblo, n.d.

Silver gelatin print, 6 x 4 in.

Palace of the Governors/Photo Archives, 4782

p. 25

Carlos Vierra (1876–1937)

Aerial views of Santa Fe, ca. 1921

Silver gelatin prints, 6½ x 9¾ in. each

Palace of the Governors/Photo Archives, 23080, 23082, 23084, 23085

p. 223

Adam Clark Vroman (1856–1916)

Santa Fe, New Mexico, San Miguel Chapel Erected 1582, Burned 1680, Rebuilt 1692. Contains Pictures 500 to 700 Years Old, March 8, 1900

Platinum print, 6½ x 8½ in.

Palace of the Governors/Photo Archives, 156675

p. 223

Adam Clark Vroman (1856–1916)

Governor's Palace, Santa Fe, New Mexico, March 8, 1900

Platinum print, 6½ x 8½ in.

Palace of the Governors/Photo Archives, 156676

p. 61

Adam Clark Vroman (1856–1916)

Over Santa Fe from Fort Marcy, ca. 1900

Platinum print, 6¼ x 15¼ in.

Courtesy of Gerald Peters Gallery, Santa Fe

p. 185

Todd Webb (1905–2000)

Water Street at Don Gaspar, Santa Fe, New Mexico, 11/81

Silver gelatin print, 16 x 20 in.

Courtesy of Evans Gallery, Portland

p. 186

Melanie West (1970–)

Mud Plaster, August 2007

Silver gelatin print, 16 x 16 in.

Courtesy of the artist

p. 101

Edward Weston (1886–1993)

Moriarty to Lamy Road, 1937

Silver gelatin print, 7½ x 9⅝ in.

New Mexico Museum of Art, 1982.61.23

p. 98

Edward Weston (1886–1993)

Santa Fe–Albuquerque Highway, 1937

Silver gelatin print, 7½ x 9⅜ in.

New Mexico Museum of Art, 1982.61.3

p. 126

Richard Wilder (1952–)

West San Francisco Street from the Corner of Galisteo Street, October 1984

Silver gelatin print, 8 x 10 in. contact print

Palace of the Governors/Photo Archives, 122314

p. 188

Richard Wilder (1952–)

Trailer Residence East of St. John's College, Santa Fe, New Mexico, July 1982

Silver gelatin print, 8 x 10 in. contact print

Palace of the Governors/Photo Archives, 122836

p. 62

Ben Wittick (1845–1903)

Ninth Cavalry Band, Santa Fe Plaza, July 1880

Glass-plate negative, 5 x 8 in.

Palace of the Governors/Photo Archives, 50887

p. 221

Ben Wittick (1845–1903)

Old Adobe Palace, Santa Fe, New Mexico, 1880

Glass-plate negative, 5 x 8 in.

Palace of the Governors/Photo Archives, 15376

p. 59

Ben Wittick (1845–1903)

View from Old Fort Marcy, May 1880

Glass-plate negative, 5 x 8 in.

Palace of the Governors/Photo Archives, 15837

p. 59

Ben Wittick (1845–1903)

Santa Fe Looking West from Old Fort Marcy, ca. 1880

Glass-plate negative, 5 x 8 in.

Palace of the Governors/Photo Archives, 15838

p. 221

Ben Wittick (1845–1903)

Old San Miguel Church. Santa Fe, Built 1582, May 1880

Glass-plate negative, 5 x 8 in.

Palace of the Governors/Photo Archives, 15856

p. 220

Ben Wittick (1845–1903)

Entrance to Mexican Corral, 1880

Stereograph, 3⅞ x 6⅞ in.

Palace of the Governors/Photo Archives, 11004

p. 220

Ben Wittick (1845–1903)

Santa Fe Looking West on San Francisco Street, April 1887

Stereograph, 3⅞ x 7 in.

Palace of the Governors/Photo Archives, 86864

p. 230

Ben Wittick (1845–1903)

Old Clock and Bells, Cathedral de San Francisco Being Built, Santa Fe, June 1880

Stereograph, 3⅞ x 7 in.

Palace of the Governors/Photo Archives, 149374

p. 219

Ben Wittick (1845–1903)

George Ben Wittick with camera, n.d.

Glass-plate negative, 5 x 8 in.

Palace of the Governors/Photo Archives, 39391

p. 55

Ben Wittick (1845–1903)

Loretto Chapel, Santa Fe, New Mexico, April 1881

Glass-plate negative, 5 x 8 in.

Palace of the Governors/Photo Archives, 15854

p. 48–49

Ben Wittick (1845–1903)

Views of Santa Fe from Wittick Collection

Studio viewing album number 3, n.d. (two pages)

Palace of the Governors/Photo Archives

Wittick Collection bound album, volume 3 of seven, 12½ x 17 x 1½ in.

p. 196

Donald Woodman (1945–)

El Oratario de Lorenze Lopez Chapel on Cerro Gordo, Santa Fe, New Mexico. Neon by Jan Beauboeuf, 1984

Archival pigment print, 22 x 27½ in.

Courtesy of the artist and Zane Bennett Gallery, Santa Fe

p. 135

Donald Woodman (1945–)

Bobcat Bite, n.d.

Archival pigment print, 13¼ x 22 in.

Courtesy of the artist and Zane Bennett Gallery, Santa Fe

p. 69

Wendy Young (1963–)

Pet Parade, 1998

Silver gelatin print, 11 x 14 in.

Courtesy of the artist